Sacred Objects in Secular Spaces

Also available from Bloomsbury

Religious Objects in Museums, Crispin Paine

Religious Statues and Personhood, Amy Whitehead

Buddhism and Iconoclasm in East Asia, Fabio Rambelli and Eric Reinders

Sacred Objects in Secular Spaces

Exhibiting Asian Religions in Museums

Edited by
Bruce M. Sullivan

Bloomsbury Academic
An imprint of Bloomsbury Publishing Plc

B L O O M S B U R Y
LONDON • NEW DELHI • NEW YORK • SYDNEY

Bloomsbury Academic

An imprint of Bloomsbury Publishing Plc

50 Bedford Square	1385 Broadway
London	New York
WC1B 3DP	NY 10018
UK	USA

www.bloomsbury.com

BLOOMSBURY and the Diana logo are trademarks of Bloomsbury Publishing Plc

First published 2015

British Library Cataloguing-in-Publication Data
A catalogue record for this book is available from the British Library.

ISBN: HB: 978-1-4725-9081-7
PB: 978-1-4725-9080-0
ePDF: 978-1-4725-9082-4
ePub: 978-1-4725-9083-1

Library of Congress Cataloging-in-Publication Data
A catalog record for this book is available from the Library of Congress.

Typeset by Deanta Global Publishing Services, Chennai, India
Printed and bound in India

Contents

Part 1 Exhibiting Hindu and Sikh Religious Objects in Museums

Part 2 Exhibiting Buddhist Religious Objects in Museums

List of Illustrations Printed in this Volume

26 Archival photograph, detail of 1938 exhibition *Chinese Bronzes from American Collections*. © The Metropolitan Museum of Art.

27 Archival photograph, detail of 1959 special exhibition *An Aristocracy of Robes*. © The Metropolitan Museum of Art.

28 View of gallery 206. © The Metropolitan Museum of Art.

29 View of gallery 251 with *Dissected Buddha by Gonkar Gyatso*. © The Metropolitan Museum of Art.

30 Pair of bowls with Buddha and Tibetan script, China, Qing dynasty (1644–1911), nineteenth to early twentieth century. Jadeite. Crow Collection of Asian Art, 1988.54 (Courtesy of the Crow Collection of Asian Art 2013).

31 3-D *Mapping Cultures, Tibet* exhibition mapped landscape (photo by Ivette Vargas-O'Bryan 2013).

32 Six-armed Mahakala (Nag po chen po), Tibet, late nineteenth century. Bronze. Crow Collection of Asian Art, L2011.86 (Courtesy of the Crow Collection of Asian Art 2013).

33 Artist unknown, Japan. *Kesa*, mantle for a Buddhist priest, nineteenth century; slit tapestry weave (kesa), [k'o-ssu] type. 80 × 45 in. (203.2 × 114.3 cm). Collection of Phoenix Art Museum. Gift of Helen Wilson Sherman (1991.123).

34 Artist unknown, Sri Lanka. Buddha's Footprint (Buddhapada), eighteenth century; opaque watercolor on cloth. Framed: 89 × 45 × ⅞ in. (226.1 × 114.3 × 2.2 cm); 81¼ × 38½ in. (206.4 × 97.8 cm). Collection of Phoenix Art Museum. Gift of Barry Fernando MD and Coleene Fernando MD in honor of the museum's 50th Anniversary. (2008.265).

35 Artist unknown, China. Large square panel with crossed vajras, eight auspicious emblems, lotus blossoms, and other Buddhist symbols. Ming Dynasty silk lampas; red silk ground of dyed yarns in ⅔ twill weave, interwoven in tabby weave with gold-colored silk yarns. 36¼ × 36¹¹⁄₁₆ inches (92 × 93.1 cm); framed 43 × 43 inches (109.2 × 109.2 cm). Collection of Phoenix Art Museum. Gift of Amy S. Clague (2005.152).

36 St. Mungo Museum of Religious Life and Art, Buddha and bodhisattva statues and stained-glass windows; photo by Charles D. Orzech, reproduced courtesy of Glasgow Museums.

37 St. Mungo Museum of Religious Life and Art, Shiva Nataraja beside stained-glass window; photo by Charles D. Orzech, reproduced courtesy of Glasgow Museums.

38 St. Mungo Museum of Religious Life and Art, Zen rock garden with Catholic cathedral in background and a clootie tree in foreground; photo by Charles D. Orzech, reproduced courtesy of Glasgow Museums.

39 Durga from Bengal, probably about 1840 (British Museum 1845,1105.1); courtesy of the British Museum.

40 Inscription from the Firuz Minar at Gaur, fifteenth century (British Museum 1826,0708.1); courtesy of the British Museum.

List of Illustrations Available to View Online at Bloomsbury.com

(http://www.bloomsbury.com/sacred-objects-in-secular-spaces-9781472590800/)

50 Gurchet Singh, who led the family in 2002, is pictured here with the Rath. His son Boota Singh now leads the family as caretaker of the site and the family's objects. Photo by Anne Murphy.

51 Bhai Boota Singh of the Bhai Rupa family stands with the objects that he brought from India at the Gurdwara Sahib Dasmesh Darbar (Surrey, BC). Photo by Anne Murphy.

52 Objects were displayed with short captions. Photo by Anne Murphy.

53 Plan of Victoria & Albert Museum ground floor showing in yellow highlights Rooms 17–20 (large rectangle) and Gallery 47f (small rectangle). Courtesy of Victoria & Albert Museum.

54 Room 19 panels. Left: religious theme panel in white lettering on blue wall. Right: historical and geographical information on the area white lettering on black Corian® panel. Courtesy of Victoria & Albert Museum.

55 The cosmic Buddha Vairochana, approx. 1300; Tibet; Colors on cotton. Museum purchase, City Arts Fund, 1991.1. Courtesy of Asian Art Museum, San Francisco.

56 The cosmic Buddha Ratnasambhava, approx. 1300; Tibet; Colors on cotton. Museum purchase, City Arts Fund, 1991.2. Courtesy of Asian Art Museum, San Francisco.

57 The cosmic Buddha Amoghasiddhi, approx. 1300; Tibet; Colors on cotton. Museum purchase, City Arts Fund, 1991.3 Courtesy of Asian Art Museum, San Francisco.

58 Plaque with scenes of the life of the Buddha, 1000–1200; Bihar state, India. Pyrophyllite. Gift of Dr. and Mrs. David Buchanan, 2010.330. Courtesy of Asian Art Museum, San Francisco.

59 Taima mandara, 1300–1400; Japan. Ink, colors, and gold on silk. The Avery Brundage Collection, B61D11+. Courtesy of Asian Art Museum, San Francisco.

60 The cosmic Buddha Vairochana, 1100–1200; Tibet. Colors on cotton. Acquisition made possible by the Avery Brundage estate, Sharon Bacon, Mona J. Bolcom, Dr. Edward P. Gerber, Jane R. Lurie, Margaret Polak, Therese and Richard Schoofs, Dr. and Mrs. William Wedemeyer, and anonymous friends of the Asian Art Museum, 1992.58. Courtesy of Asian Art Museum, San Francisco.

61 Screenshot of collaborators on the "Mapping Cultures, Tibet" project; photo by Jessica Nikasio, 2013.

62 Students from "Mapping Cultures, Tibet" with CCAA director of education Karin Oen; photo by Kasumi Chow, 2013.

63 "Mapping Cultures, Tibet" project layout in the Crow Collection's Exhibition *Taking Shape: Fresh Perspectives on Asian Bronzes*, spring 2013 (Courtesy of Agathe Dupart, the Crow Collection of Asian Art 2013).

64 Avalokiteshvara (Spyan ras gzigs), Sino-Tibetan culture, eighteenth century. Bronze. Crow Collection of Asian Art, 1985.7 (Courtesy of the Crow Collection of Asian Art 2013).

Notes on Contributors

Janet Baker (PhD in Art History, University of Kansas), Curator of Asian Art, Phoenix Art Museum. She organized, edited, and contributed to *Sacred Word and Image: Five World Religions* (2012) and *Guardian of the Flame: Art of Sri Lanka* (2003), and contributed to *A Tradition Redefined: Modern and Contemporary Chinese Ink Paintings from the Chu-tsing Li Collection, 1950-2000* (2008). She also organized *Quiet Rage, Gentle Wail: Prints and Masks from Japan's Noh Theatre* (2014), and has produced Phoenix Art Museum's two electronic publications to date.

John Clarke (PhD in Art History, SOAS, University of London), Curator of the Himalayan and Southeast Asian collections in the Asian Department of the Victoria & Albert Museum. He is the author of *Jewellery of Tibet and the Himalayas* (2004) and *Tibet: Caught in Time* (1997), and numerous articles on the arts of Tibet.

Richard H. Davis (PhD in South Asian Languages & Civilization, The University of Chicago), Professor, Religion and Asian Studies, Bard College. He is the author of *Lives of Indian Images* (1997), *Gods in Print: Masterpieces of India's Mythological Art* (2012), *The Bhagavad Gita: A Biography* (2014), *Ritual in an Oscillating Universe: Worshiping Siva in Medieval India* (1991), *Images, Miracles, and Authority in Asian Religious Traditions* (1998), and other works, including chapters in *What's the Use of Art?* and *The Sensuous and the Sacred: Chola Bronzes from South India.*

Jeff Durham (PhD in Religious Studies, University of Virginia), assistant Curator of Himalayan Art, Asian Art Museum of San Francisco. He is the author of a chapter in *Phantoms of Asia* (2012), and an article in the journal *Lotus Leaves*.

Denise Patry Leidy (PhD in Art History, Columbia University), Curator of Asian Art, Metropolitan Museum of Art. She is the author of *The Art of Buddhism: An Introduction to Its History and Meaning* (2009), and *Treasures of Asian Art: The Asia Society's Mr. and Mrs. John D. Rockefeller 3rd Collection* (1994), and coauthor of *Mandala: The Architecture of Enlightenment* (2000), *Wisdom Embodied: Chinese Buddhist and Daoist Sculpture in The Metropolitan Museum of Art* (2012), *Silla: Korea's Golden Kingdom* (2013), and other works. Dr. Leidy serves on the editorial boards of *The Metropolitan Museum Journal* and *Arts of Asia*.

Anne Murphy (PhD, Columbia University), associate Professor in the Department of Asian Studies at the University of British Columbia, works on the cultural and religious history of Punjab. She is the author of *The Materiality of the Past: History and Representation in Sikh Tradition* (2012), chapters in *Teaching Religion and Violence* (2012), and *The Punjab Reader* (2012); and articles in *Journal of the American Academy of Religion*, *Sikh Formations*, and *History and Theory*; she edited the volume *Time, History, and the Religious Imaginary in South Asia* (2011).

Charles D. Orzech (PhD in History of Religions, The University of Chicago), Reader in Religion, Conflict & Transition, School of Critical Studies, University of Glasgow. He is the author of *Politics and Transcendent Wisdom: The Scripture for "Humane Kings" in the Creation of Chinese Buddhism* (1998), contributor to and General Editor of *Esoteric Buddhism and the Tantras in East Asia* (2010), and author of chapters in *Buddhism in Practice*, *Tantra in Practice*, and *Religions of China in Practice*, and articles in *Cahiers d'Extrême-Asie*, *History of Religions*, and other journals.

Deepak Sarma (PhD, Philosophy of Religion, The University of Chicago), Professor of Religious Studies, Case Western Reserve University. He is the author of *An Introduction to Madhva Vedanta* (2003), *Epistemologies and the Limitations of Philosophical Inquiry: Doctrine in Madhva Vedanta* (2004), *Hinduism: A Reader* (2007), *Classical Indian Philosophy: A Reader* (2011), and other works, including articles in *Brill's Encyclopedia of Hinduism*, *Method and Theory in the Study of Religion*, *Journal of the American Academy of Religion*, and other journals. Dr. Sarma was a guest Curator at the Cleveland Museum of Art (2011).

Bruce M. Sullivan (PhD in South Asian Languages & Civilization, and History of Religions, The University of Chicago), Professor, Comparative Study of Religions & Asian Studies, Northern Arizona University. He is the author of *Krsna Dvaipayana Vyasa and the* Mahabharata: *A New Interpretation* (1990), two volumes of Sanskrit drama translations and studies (1995 and 2001, with coauthor N. P. Unni), and *Historical Dictionary of Hinduism* (1997), as well as articles in *Journal of the American Academy of Religion*, *Asian Theater Journal*, *Journal of Hindu Studies*, *Implicit Religion*, and other journals.

Ivette M. Vargas-O'Bryan (PhD in the Study of Religion, Harvard University), Associate Professor, Religious Studies, Austin College. She is the coauthor of *Disease, Religion and Healing in Asia: Collaborations and Collisions* (2015), and author of articles in *Journal of the International Association of Buddhist Studies* and *Religions of South Asia*, and chapters in edited volumes on Tibetan Buddhist religious and medical traditions.

Michael Willis (PhD in Art History, The University of Chicago), Curator of early South Asian and Himalayan collections, The British Museum. He is the author of *The Archaeology of Hindu Ritual: Temples and the Establishment of the Gods* (2009), *Buddhist Reliquaries from Ancient India* (2000), *Tibet: Life, Myth and Art* (1999), and other works, including articles in *South Asian Studies* and *Journal of the Royal Asiatic Society*, and two edited volumes.

Acknowledgments

It is my pleasure to thank the ten scholars and curators who joined with me to create this volume. Their expertise and goodwill made the task of being the editor of a volume not only possible but also enjoyable. The assistance of the many museums that are discussed in these pages, and particularly the willingness to provide images for our use, is greatly appreciated and merits our thanks. We hope that greater public awareness of their collections results in increased attendance. I thank Northern Arizona University's Vice Provost for International Education, Harvey Charles, and Dean of the College of Arts and Letters, Michael Vincent, for financial support for my research and this publication. Bloomsbury's Lalle Pursglove and Anna MacDiarmid were both cheerful and helpful throughout the process of bringing this book into being. I especially want to thank my wife Melissa Marcus, with whom the idea for this volume was originally conceived, and who has been supportive and helpful throughout the entire (sometimes challenging) project.

Introduction to *Sacred Objects in Secular Spaces: Exhibiting Asian Religions in Museums*

BRUCE M. SULLIVAN

This volume describes and analyzes an array of issues related to the exhibition in museums of objects of religious significance from Hindu, Buddhist, and Sikh traditions, bringing together curators and scholars with expertise in Asian art and religions. For these religious traditions, the centrality of objects in ritual activity is evident and has often been the focus of academic studies. Whether the image of a Buddha or a Hindu deity or the relics associated with a saint or guru, objects regarded as religiously significant are vital to religious practices.[1] For a variety of reasons, some such objects have come to be in museums today. This volume examines what this means for the museums in which these objects reside, the objects themselves, visitors to museums, and the religious traditions that imparted to these objects their original forms and functions. The very title of this volume is based on a dichotomy between what is perceived to be sacred or holy and to be secular or profane. Chapters in this volume explore and problematize the idea that the objects in museums can be regarded as sacred and that the museum necessarily elides all sacred qualities from objects it exhibits.

What is "the sacred" and how does it differ from what is not perceived to be sacred? As David Chidester writes, something "is sacred because it is a focus for extraordinary attention, the locus of ritual sacrifice, the nexus of ritualized exchanges, and the matrix of religious contestation" (2011: 88). Referencing Jonathan Z. Smith (1978), Chidester argues that the sacred is created by ritualized attention to actions, resulting in an intensification of meaning. Sacrifice, etymologically related to the word sacred, is involved in both producing the sacred and contributing to its power. Because of the power and meanings attributed to the sacred, objects regarded as sacred have economic as well as religious significance and may be exchanged. Finally, due to the value and meanings attributed to objects seen as sacred, ownership of them is often contested, and legal cases may ensue (Chidester 2011). All these issues related to objects regarded by some as sacred are found in this volume's studies of museums and their collections.

Scholars of religion, and curators of museums, have long recognized that many objects in museums were originally on display in temples, shrines, or monasteries

and were at one time religiously significant to the communities that created and used them. How, though, are such objects to be understood, described, exhibited, and handled now that they are in museums? Are they objects representing cultural heritage? Are they to be understood as objects that are still sacred or as formerly sacred objects that are now art objects, or are they simultaneously objects of religious and artistic significance, depending on who is viewing the object? Or is the sacredness of an object dependent on some variable other than its community of response? Location, and therefore context, are of profound importance to an object's meaning, as observed by Charles Lachman: "It might be fair to say that the sculpture on a temple altar and the sculpture in a museum vitrine are not the 'same' object in different locales, but rather different objects all together" (2014: 375). These objects raise questions not only about their own identities, but also about the ways we understand the religious traditions in which these objects were created and which they represent in museums today.

Art historian Carol Duncan elucidated how a modern museum is analogous to a temple, albeit a secular temple. Visitors to museums enact a ritual procedure, and "a museum's central meanings, its meanings *as a museum*, are structured through its ritual" (Duncan 1995: 2). The visitor enters a liminal time and space in the museum and has a transformative experience comparable to those that religions promote (revelation, enlightenment, spiritual elevation). That a museum exhibits objects of religious significance only enhances the similarity between museums and religious sites. Might not museums add new levels of meaning to objects they exhibit? Indeed, can museums exhibit objects to meet the diverse interests of adherents of a religion as well as the general public, who are not adherents of that religion? Through their exhibitions, can museums provide new functions for religiously significant objects or show how they function in ritual and religious contexts? How far can or should a museum go to exhibit objects in ways that recall or emulate the sacred spaces such objects formerly inhabited?

The Newark Museum's installation of Tibetan Buddhist objects as an altar is an example of the interpenetration of sacred and secular. The museum has described its exhibition as follows:

> A Tibetan Buddhist altar is traditionally constructed as a sacred space to house images of the Buddha and his teachings. The altar serves as a focus of Buddhist religious ritual and as a place for profound contemplation. Offerings are placed on the altar as an expression of the practitioner's devotion to the principle of enlightenment. … The Newark Museum's Tibetan Buddhist altar was created as part of a special project, Tibet, the Living Tradition (1988-91). Phuntsok Dorje, a Tibetan artist trained at Rumtek Monastery in Sikkim, was artist-in-residence in 1989 and 1990. Working with the Museum staff and a team of Tibetan consultants and scholars, Mr. Dorje designed and created the altar. … His Holiness, the 14th Dalai Lama performed a consecration ceremony for the altar on September 23, 1990.[2]

As the currently available guide for visitors observes, "Since the first exhibition of Tibetan art in 1911, countless visitors (including the Tibetan Trade Delegation in 1948),

have revered the art of Tibet at the Newark Museum. With an unparalleled collection of sacred and secular objects including paintings, sculptures, ritual implements, costumes and textiles, no other museum equals this comprehensive experience."[3] If Newark demonstrates the extent to which a museum can be similar to a temple, by simulating a sacred space, it also educates visitors regarding the traditional ritual functions of the objects curated and exhibited.

Even more explicit in its invitation to regard one of its exhibition objects as an icon available for worship is England's Birmingham Museum and Art Gallery. The Suntanganj Buddha, a metal icon from India some fifteen centuries old and standing 2.3 meters in height, is the museum's foundational object and remains a major attraction for visitors. It is also the central object in an annual celebration by local Buddhists of Buddha's Day (*Vaisakha* or *Wesak*), a day commemorating the birth, *nirvana*, and death of the Buddha (Paine 2013: 38–9; Wingfield 2010). Rituals conducted by Buddhist monks in the gallery emphasize the renewed interest in the religious significance of this museum object by some museum visitors, even if, as Paine indicates, the intent of the museum's staff is primarily "to expand the diversity of the museum's audience."

The increasing interest of scholars of religion in material culture is evident over the past two decades. One of the earliest and most important calls for the study of objects of religious significance is Gregory Schopen's article "Archaeology and Protestant Presuppositions in the Study of Indian Buddhism" (1991). His subsequent, extensive work, collected in a series of volumes (1997, 2004, 2005, 2014), has shown how our understanding of a religion, Buddhism in particular, is altered by close attention to objects and hindered by exclusive attention to texts. A study by Ronald Grimes (1992) entitled "Sacred objects in museum spaces" was influential in focusing attention on the museum as a site for the exhibition of objects of religious significance. He advocates that museums be sites for contemplation but not for worship and observes: "A contemplative posture is not necessarily an approving one, nor does it imply the superiority, moral or spiritual, of object to viewer. Contemplation is not worship, but rather dwelling in the possibility that what one imagines is out there (in the display case) is also in here (in the heart), and vice versa" (Grimes 1992: 429).

Other scholars of religion have more recently made important contributions to the study of religious objects, both in their traditional contexts and in museum settings. John Cort, using Jainism as his example, in 1996 stated the necessity for scholars to analyze and incorporate more systematically the material culture of a religion: "To the extent that human life is by its very nature embodied, physical, and material, the study of religion therefore must involve itself with the study of the material expressions of religion" (Cort 1996: 631). The groundbreaking work *Lives of Indian Images* by Richard H. Davis contrasted the earlier lives of specific icons from India with their later lives as museum exhibits, tracing how they have been "revalorized over time by various communities of response" (Davis 1997: xi). He extends his prior work (including 1997, 1998, 2007, 2012) with his chapter in this volume. Jacob Kinnard has articulated how Buddhists view and understand the sacredness of an image of the Buddha (1999)

and has shown how a single object can be perceived as having different identities by different communities of response, Hindu and Buddhist (2000). Anne Murphy's pioneering work on the representation of Sikhism through the exhibition of objects (2012) is extended by her chapter in this volume. Benjamin Fleming and Richard Mann's edited volume *Material Culture and Asian Religions: Text, Image, Object* (2014) is a wide-ranging collection of fifteen studies on texts, coins, amulets, and other material objects. The excellent study by Richard Mann (2014) of the history of material culture in relation to the study of the Hindu and Buddhist religious traditions brilliantly makes a case for the importance of objects both to our understanding of religious practice and to providing a more complete historical context for these religions. David Morgan's studies (2014, 2012, 2010, 2005) of "religious visual culture" and the material culture of religion articulate an approach to the study of religion through objects and our perceptions of them. As editors of *Material Religion: The Journal of Objects, Art and Belief*, Morgan, Birgit Meyer, Crispin Paine, and S. Brent Plate have overseen ten successful years of publishing studies of religiously significant objects and the communities that respond to them. The December 2014 issue (vol. 10, no. 4) is on the theme "Matter of Contention: Sacred Objects at the Crossroads of Religious Traditions." Even if one might agree with Brent Plate (2012: 162) that "the study of religion has continued to focus heavily on the interpretation of sacred texts," one can certainly see that greater attention is being directed toward, and greater significance is being attached to, material culture than ever before in the study of religion.

The methodological turn toward material culture is not peculiar to religious studies but is seen throughout the humanities and social sciences generally (Bräunlein 2012). Analysis of the representation of religion in museums is beginning to become an interdisciplinary field of study (O'Neill 1996; Paine 2000, 2012; Sullivan and Edwards 2004; Hughes and Wood 2009; Robson 2010; Buggeln 2012; Minucciani 2013). This volume contributes to that ongoing effort of interpretation, with a focus on Asian religions as represented in museums in countries where those religions are minorities. As such, this volume meets a need for analysis and interpretation of museum exhibition of Asian religions, an underdeveloped and undertheorized area of study. Considering how and why religion is addressed (or, alternatively, evaded) in museum exhibitions of Asian religious objects will deepen our understanding of "the sacred" as manifest in objects and as a category in religious studies.

Chapters in this volume demonstrate a wide array of perspectives on museum exhibitions of Asian religious objects. Curators and scholars analyze particular exhibitions regarding what might constitute an appropriate or even "authentic" experience of religiously significant objects in the context of a museum. Jeff Durham's chapter concerns the exhibition *Enter the Mandala*, which he designed at the Asian Art Museum, San Francisco. He examines issues arising from the constructed nature of a museum exhibit, comparing this to the meditative visualization of a Tibetan Buddhist practitioner and finding similarities between the two. Ivette Vargas-O'Bryan analyzes a collaborative project on Tibetan religious objects involving Austin College

students and the Crow Collection of Asian Art, showing how electronic media encouraged cultural preservation as well as the deeper understanding of a religious tradition. Janet Baker discusses the experience of curating *Sacred Word and Image: Five World Religions* and ways in which it affected her curatorial practices and her understanding of religious traditions, as well as the public reception of the exhibition. Deepak Sarma's involvement as guest curator with the Cleveland Museum of Art's exhibition on Kalighat painting led him to write on the marketing of the exhibition through an image of the goddess Kali in the historical context of colonialism and globalization. He expresses his misgivings about the enterprise, his feeling of complicity in generating and maintaining stereotypes of Hinduism, his ambivalence about commercialization, and the pedagogical outcomes.

Another example of the marketing of a tradition is explored in the chapter by Bruce M. Sullivan, namely, the rapid adoption by many museums of the practice of yoga on the premises; museums' use of a religious practice for commercial purposes, the diversity of what "yoga" means in these contexts, and the role of religiously significant objects in public programs by some museums are explored. In addition, surprising reasons for museums offering yoga classes and the responses of participants in museum-sponsored yoga classes are analyzed. By examining museums of "world religions," Charles Orzech sees three approaches to the construction of a narrative about religion in museums and considers ways in which the comparative enterprise is manifested through exhibition of objects. Anne Murphy examines a range of Sikh religious objects, including weapons and other relics associated with religious figures, and demonstrates how the Sikh community has produced itself through the representation of the past in a diversity of museum settings in India and North America.

A single museum's exhibition of Asian objects is the topic for two chapters. Denise Patry Leidy of the Metropolitan Museum (New York) and John Clarke of the Victoria and Albert Museum (London) discuss how their exhibitions and museum spaces have changed over time. Clarke reflects on how increased interaction with Buddhists has affected the museum's exhibition in the Ho Family Foundation Gallery of Buddhist Sculpture, demonstrating the many considerations for a curator reconfiguring a gallery. Leidy's chapter shows how a deeper understanding of Buddhism has affected the growth, administrative organization, and exhibition of the collection at the Met.

The chapter by Michael Willis critiques the museum's presentation of itself as a repository of treasured artifacts, with a focus on the British Museum's collection of Asian religious objects. In revealing details about the acquisition of particular objects, he queries the appropriateness of the very category of the sacred for "objects now in permanent institutional care." Richard Davis opens the discussion in Chapter 1 by presenting the very different biographies of two bronze images from the same town in India, one of which is exhibited in the Norton Simon Museum in Los Angeles and the other repatriated to India, where it is hidden away in storage. He demonstrates how "identities can be reframed in different settings and renegotiated in encounters with different audiences" through a pair of icons that have experienced very different lives.

The eleven chapters in this volume cannot comprehensively "cover" the topic addressed. This is the start of a conversation about Asian religious objects on exhibition in museums. Richard Davis, in his chapter on Indian images, contends that these images "want to have their stories told." This volume is dedicated to exploring some of the stories that can be told about objects of religious significance and the museums that exhibit them.

Part 1 Exhibiting Hindu and Sikh Religious Objects in Museums

1 What Do Indian Images Really Want? A Biographical Approach

RICHARD H. DAVIS

During the medieval period the destructive hands of the fanatical foreign invaders fell on these temples and places more than any other thing. Plucked out of their settings by rough and crude hands, the images of desecrated temples now lie on the sides of roads, canals and tanks dumbly proclaiming the sad tale of their destruction. Some of the bronzes not useful for worship are now found stowed in lumber rooms clothed with cobwebs and verdigris and some of the stones in the outer walls of temples were exposed to the vagaries of weather, they are fast wearing away.

Palaniappan 1982: 129

Writing in 1953, T. N. Palaniappan, the district collector of Thanjavur, observed a multitude of sculpted images in bronze and stone that had been alienated from their original religious purposes. He attributed the alienation to both foreign invasion and local carelessness. And he believed he could hear these formerly sacred objects calling out to him in "mute entreaties," asking for more respectful treatment. He reflected:

> Even a civil servant like myself, who is lost in the daily routine of humdrum life and finds very little time for other interests or activities, much less for fine art, could not escape being attracted by these disturbed and neglected pieces of art and could not resist their mute entreaties for better treatment and for being given an opportunity to entertain the art lover and to serve the people of Independent India. (129)

Palaniappan also recognized the power of the international art market to transform these detached religious objects into commodities.

> I was distressed to hear that several pedlars in artware were and still are, by all means which human ingenuity could devise acquiring and selling valuable pieces of bronze and even stone for fabulous prices to the rich to adorn their drawing halls. It is sad to reflect that much mischief had clearly already been done and several valuable pieces had been spirited away not only to the bigger cities in this land but also to lands beyond the sea. (129)

In the patriotic spirit of the early 1950s, Palaniappan was particularly troubled by the export of South Indian religious icons beyond the borders of newly independent India.

As district collector, Palaniappan enjoyed some power to respond to the entreaties of the images, as he goes on to narrate. An archaeologist from Calcutta had spotted a large stone image of Brahma sitting neglected along a river bank outside of Thanjavur, and he had proposed relocating it to a museum in Calcutta. The local public raised an outcry against the removal of Brahma to the north, and this led Palaniappan to formulate a plan. "I felt the time had come to collect all such mutilated and neglected pieces of art in stone and bronze and house them in a safe place in a palace at Tanjore in order to protect and preserve the remnants of our artistic inheritance from the ravages of time and the hands alike of the irreverent vandal and the unscrupulous pedlar in art-ware" (130). Brahma was moved to a hall in the old palace of the Thanjavur rulers. The old Hindu god of creation would now become the nucleus for a new museum of religious art. Other scattered and dislodged bronzes and stone sculptures were collected, and on December 9, 1951, the Tanjore Art Gallery was inaugurated. Where the Thanjavur kings had formerly held court, bronze sculptures of Shiva, Parvati, and all the Hindu gods would now receive gallery visitors and art lovers. Since renamed the Rajaraja Chola Art Gallery after the greatest of the Thanjavur rulers, the museum contains one of the preeminent collections of medieval South Indian religious art in the world.

Palaniappan's observations and his response forcefully raise the question also posed by W. J. T. Mitchell in his provocatively titled 1996 essay "What Do Pictures Really Want?" Is it possible, in our thoughts and actions, to take into consideration the possible agency of art objects themselves? But Mitchell defensively admits that his question may seem "bizarre" or worse. "I'm aware," he writes, "that it involves a subjectivizing of images, a dubious personification of inanimate objects; that it flirts with a regressive, superstitious attitude toward images, one that if taken seriously would return us to practices like totemism, fetishism, idolatry, and animism" (1996: 71). Addressing an audience of "modern, enlightened people" who share his ontological assumptions, Mitchell condescendingly portrays the attribution of agency to images as primitive, childish, or pathological. After so carefully subverting the premises of his own question, Mitchell ends up with the disappointing conclusion: "What pictures want in the last instance, then, is simply to be asked what they want, with the understanding that the answer may well be, nothing at all" (1996: 82).

Perhaps we can do better. What do Indian images really want? What should we hear when we encounter South Indian bronze images in secular places like auction houses, galleries, or museums? The public-spirited Indian official Palaniappan believed he could hear the appeals of those images, and he responded accordingly. The alienated religious objects of Thanjavur district wanted to be preserved in safety, they wished to remain near their original home, and they desired to interact with art lovers and the Indian public. Others might answer differently, with equal confidence. Some would argue that these images, being religious in origin, desire to be reinstalled in temples, so they can once again receive the worship appropriate to them. Others might contend that, as masterpieces of Indian sculpture, these images form part of the global heritage of art, and they therefore wish to be exhibited as broadly as

possible for the aesthetic appreciation and edification of people throughout the world. These are moral questions, and they also entail legal, economic, and political considerations.

I do not propose any single or definitive answer to this question. I believe that the bronze sculptures of medieval South India might well give different answers, just as people do. As a student of South Asian art and religion, my own approach has been a biographical one. Objects have life stories, just as humans do. Many objects are born and live their entire lives without leaving their own villages, just as many humans do. But some objects experience lives of travel and change, disruption and transformation, influence and celebrity, and it is the lives of such mutable objects that make for the most interesting biographies. Biographies highlight the ways that identities can be reframed in different settings and renegotiated in encounters with different audiences. Indian images, I contend, want to have their stories told.[1]

In this chapter, I tell the story of two objects from a small village in southern India, the Nataraja and Somaskanda bronzes from Sivapuram, over the course of ten centuries. These religious icons have led particularly eventful lives. After their early life spent in a small Hindu temple, they were buried underground for several centuries. Following their disinterment in 1951, the images enjoyed a brief moment of fame in the early 1970s, when the Nataraja was sold to a wealthy art collector, Norton Simon, for nearly $1,000,000. It then became a disputed object in a highly publicized repatriation case pitting Simon against the government of India. After an out-of-court settlement, the Nataraja returned to South India and now lives in quiet retirement in Tamil Nadu, though I for one hope that this is not the final chapter in the life of this object. The Somaskanda, meanwhile, receives visitors in the splendid Asian galleries of the Norton Simon Museum in Pasadena, California, along with many other religious icons from India, where it is immune from future repatriation claims. In most cases, it is not possible to trace the full biographies of the Indian images that populate the galleries of the Norton Simon Museum or other similar museums in the West. But thanks to the brief celebrity of the Nataraja of Sivapuram, we know a good deal about the lives of these two icons.

Original Setting: Divinity and Procession

Sivapuram is a small ancient village in the fertile rice-growing delta region of central Tamil Nadu. The temple to Shiva there dates back at least to 800 CE, when the famous Shaiva poet-saints Appar and Jnanasambandha visited the shrine and celebrated the manifestation of the divine they encountered there. In their songs, the poets proclaim that the great god Shiva, supreme ruler and creator of the cosmos, can also be seen in Sivapuram. "That One is Shiva. And he is our opulent one of Sivapuram." Appar so concludes each verse of his eight hymns. In the Shaiva devotional ethos of medieval South India, God is simultaneously transcendent and local (Davis 2006).

Sometime in the late tenth century, probably during the reign of Rajaraja Chola (985–1012 CE), the small Shaiva shrine of Sivapuram was rebuilt in more permanent

materials (Meister and Dhaky 1983: 229). It is quite possible that the bronze sculptures of Shiva Nataraja and Somaskanda were fabricated as part of this renovation to serve the expanded liturgical program of the temple. The precise dating of these two images has long been disputed among Indian art historians, but most would place them in the latter part of the tenth century.[2]

Whatever the exact date, we can be certain of the lives for which these images were originally intended. For medieval South Indian worshippers of Shiva, this new temple and many others like it were places of divine presence, where Shiva made himself physically present in material icons, so that his human worshippers might offer their tokens of devotion and honor. In Mitchell's ontology, this amounted to a "dubious personification of inanimate objects." That did not pose a problem for the prevailing Shaiva theology of divine presence. However, neither Nataraja nor Somaskanda would have been the primary cult icon in the temple at Sivapuram. That role was occupied by a Shiva-linga, a plain, nonanthropomorphic cylindrical shaft, which, according to Shaiva theology, represented Shiva in his most complete manifest form. In Sivapuram, as in nearly all South Indian Shaiva temples of the period, a Shiva-linga stood fixed in the center of the temple sanctum. The bronze images of Shiva, depicting him in a more anthropomorphic manner (albeit with four arms, pointing to his more-than-human nature), enabled the god to be visible, mobile, and accessible to all.

As part of the construction of the temple, the Shiva-linga and the bronze icons would have undergone elaborate consecrations or ritual "establishments" (*pratistha*) that activated them as fit supports for the divine presence of Shiva. This procedure transmutes a physical fabricated object into a divine icon, worthy of Shiva. Once the linga is ritually established and imbued with Shiva's divine presence, priests and worshippers can present it with the regular offerings of worship known as *puja* (Davis 1991: 122–3). For the more portable bronze images, their moment of glory would arrive at the time of temple festivals (*utsava*).

During regular festivals, bronze images like the Somaskanda and Nataraja would process beyond the temple walls, so that all devotees could see them. They would appear not as simple bronze icons, however, but ornamented as the lords they were considered to be: adorned with silk garments, crowns, myriad ornaments of gold inlaid with bright jewels, and fresh flower garlands. And they would ride in palanquins or atop zoomorphic "vehicles" (*vahana*), carried on the shoulders of their temple attendants. According to medieval ritual guides like the twelfth-century *Mahotsavavidhi*, Somaskanda was treated as the preeminent processional form of Shiva (Davis 2002, 2010).

Ritual Burial and Dormancy

Some people sail through life on a straight course. For others, disruptions like divorce, unemployment, disease, and war bring about major changes in their lives and may lead to personal transformations. So too with religious images. Many Chola-period

bronzes are still in their original temple locations and still appear in regular festival processions. But not at Sivapuram.

The disruptions that would alter the life of the two Sivapuram bronzes began with a layoff from ritual employment. At least six bronze icons were removed from the Sivapuram temple and buried. In addition to the Nataraja and Somaskanda, there were images of Ganesha, two standing icons of the goddess Parvati, and an image of Jnanasambandha, the Shaiva poet-saint who had once sung hymns at Sivapuram. Art historians estimate that the Ganesha image dates from the late tenth century, contemporary with the Nataraja and Somaskanda, while the others were probably fabricated in later centuries (Srinivasan 1963: 147–55, 200–1).

The burial of religious icons must have been quite common in South India, for many hundreds have been accidentally discovered under the ground in the last two centuries, often by farmers plowing rice fields or workmen digging foundations. Nearly 400 have been found in Nagapattinam alone, from 1856 to 2004 (Ramachandran 1954; Subramanian 2011). In fact, many of the South Indian bronzes seen in secular museums in India and the West have spent time below ground. Ironically, burial acts as a good preserver of bronze sculptures, as the curator Martin Lerner observed of the Sivapuram Nataraja, since it removes them from the regular rubbings, bathing, and other ritual attentions paid to an image in regular worship (Lerner 1976).

These interments have nothing to do with death. "Dead" metal images, those no longer suitable for religious purposes, are generally melted down in a fire, much as human corpses are cremated rather than buried in India. Rather, burial was a strategy of image concealment. "When there is danger on account of thieves or enemy armies, or when there is disorder in the community," advises one medieval ritual text, "one should conceal the metal images used for festivals, bathing rites, processions, and tribute offerings." Burial was not the only option for concealment. Other long-lost bronzes have been accidentally discovered in concealed secret storerooms, such as the extraordinary troop of eighty-seven bronzes discovered hiding in the forgotten recesses of the Shiva temple at Cidambaram (Nagaswami 1979).

We do not know for certain when the community leaders of Sivapuram decided to bury their valuable festival icons. Many observers have suggested the fourteenth century, when the armies of the Delhi Sultanate invaded South India and plundered wealthy Hindu temples like Cidambaram and Sri Rangam. This is what Palaniappan had in mind when he spoke of "fanatical foreign invaders" with their "rough and crude hands" plucking sacred images out of their temples. I am suspicious of the common tendency to blame all disruptions to Indian religious sites on "the Muslims." Threats to valuable temple possessions may come from many directions, local as well as foreign. For example, one inscription on the Sivapuram temple wall, dated 1239 CE, records that a temple priest and his accomplice stole the jewels worn by the temple goddess and gave them to their concubine, took the temple gong, and hid a temple image. When the king's agents came to serve a summons on them, the thieves beat them and threw them in the water.[3] The history of the fertile Kaveri delta is replete with wars over the control of its agricultural resources, any one of which could have

posed a danger to the valuable treasures of an unprotected village temple. Over the centuries there have been ample threats to temple property.

If we do not know precisely when the underground concealment took place, however, we can reconstruct how it was done. According to the guidelines of a medieval South Indian work, the *Vimanarcanakalpa*, the defensive burial of threatened icons should involve careful ritual procedures (Davis 1997: 127–8). The priest has a pit dug and prepared with a bed of sacrificial grass. Then he approaches the divine image in the temple and makes a solemn request to the god: "As long as there is danger, please lie down in this bed with the goddess Earth." The priest transfers the animating energy from the icon to be buried into a *kurca*, a specially prepared bundle of fifty blades of sacrificial grass, which will serve as a temporary object of worship while the icon hides underground. The icon itself is lowered gently into the pit. Incense is burned, mantras are recited, and the hole is filled with grass and dirt. The divine icon goes into hibernation. The divine presence that previously animated the icon now lies dormant.

For medieval and modern Hindus, a supreme god like Shiva is by definition eternal, but the material embodiments that god inhabits on earth are inescapably subject to decay and destruction. The ritual value of an icon, for the Shaivas, has to do with divine presence, which requires both physical completeness and regular human interaction. Priestly guidebooks recognize that images of Shiva could become unsuitable for his divine presence for a variety of reasons. If broken or burned or defaced or worn out, if improperly made in the first place, if dislocated by flood or violent attack or theft, or if simply left unworshipped for too long, an icon will lose its animating presence. In some cases, as when an image loses its identifying features, the loss is irrevocable and there is nothing to do but melt down the bronze. Images that remain relatively intact are recoverable, however, and the texts spell out a ritual of reconsecration (*jirnoddhara*) to restore a disrupted icon to its proper ritual status. This is the premise behind the ritual burial of an icon. As soon as danger is passed, it is assumed, humans will recover the dormant icon, ritually reconsecrate it, and return it to normal worship. Divine presence can be regenerated through proper ritual. However, things may happen above ground that prevent its timely disinterment.

Bronze Recoveries and Palaniappan's Choice

Evidently, the residents of Sivapuram were unable to recover their buried bronzes, because the icons remained underground for centuries. In 1951, a local farmer, Kasturi Rangaraiya Annamuttu, came upon a hoard of six bronze images by chance while carrying out renovations to the temple. Like Rip Van Winkle, the Nataraja, the Somaskanda, and their companions had slept a long time, and the world around them had changed dramatically. Not so much had changed in Sivapuram, perhaps, which remained a small rice-growing village with an active Shiva temple. In the world beyond the village, however, new institutions offered new possibilities for an ancient bronze image.

Two modern historical developments were especially pertinent to the subsequent life of the Sivapuram bronzes. By the mid-twentieth century, the international world of art—with its own networks of exchange, institutions of acquisition and display, and disciplinary forms of knowledge—had embraced ancient Indian religious sculpture as a legitimate and desirable category of art. A "taxonomic shift" (to use James Clifford's term) had occurred (Clifford 1988: 196–9). Chola-period icons could now be treasured beyond India, not as consecrated supports for Shiva's divine presence but for their aesthetic quality and sculptural beauty.

At the same time, local agencies of preservation and display had been created in India. In southern India, the Government Museum in Madras had been founded initially by the colonial British, and was celebrating its centennial in 1951 as an avowedly nationalistic institution in newly independent India, charged with educating the people of southern India about their glorious heritage. The then prime minister of India, Jawaharlal Nehru, visited the museum that year as part of the grand celebration and expressed his hope that this institution devoted to ancient art would help reawaken the artistic genius of South India in modern times (Government Museum 1952). In the era of decolonization, independent India could value religious objects of the distant past in a new way, neither as cult objects nor exactly as aesthetic ones but as part of the cultural patrimony of the Indian nation.

With all these possible lives and identities to choose from, what would happen to the Somaskanda, the Nataraja, and their companions from Sivapuram? A statute dating back to the British colonial period, the Indian Treasure Trove Act of 1878, specified what *should* happen. Under its provisions, the finder of buried treasure should bring the recovered materials to the attention of the proper local authority, which in this case would be the district collector. If the collector determines that the object has been buried for over a hundred years and has no present owner, he can make a determination as to the subsequent ownership of the treasure.

Of course, this procedure is not always to the benefit of the one who happens to find buried religious objects. Other arrangements may be made. In the case of recovered images, they are sometimes simply returned to the local temple, on the assumption that this would have been the original proprietor. This is what happened at the village of Esalam, whose residents uncovered a trove of twenty-three bronze images in 1987. The finders placed all the images back in the temple and provided for their renewed worship (Nagaswamy 1987). Often what happens is that the finder, observing the ancient maxim of "finders keepers," makes some unofficial contacts to find a willing buyer, and the object enters the underground art market as a commodity. This is how many of the religious objects now in museums began their journeys. Since the initial arrangements are necessarily clandestine, their passages from India to the West generally remain obscure. In just a few cases, such as the Sivapuram bronzes, litigation and police investigation provide a glimpse of how underground images travel to the West and are transformed in the process.

In 1951, Annamuttu followed the legal route. Officials were notified, and the district collector of Thanjavur, T. K. Palaniappan, arrived on the scene to play his role in

determining the fate of the Sivapuram bronzes. Two Indian parties made claims for the bronzes. The curator of archaeology at the Madras Government Museum, P. R. Srinivasan, sought to acquire the bronzes for the museum's display of great works of South Indian metal sculpture. As a repository of antiquities, the museum had amassed a collection of over 800 bronzes, the large majority coming as treasure trove finds. In the 1950–1 administrative years alone, the museum added forty-seven metal images to its collection, forty-three of them from treasure troves.[4] But at Sivapuram, the local Shiva temple was still in active worship. Muthuswami Mudaliyar, trustee of the temple, put in a plea that the bronzes be returned to the temple. The temple officials wished to reconsecrate the bronzes and return them to their former liturgical roles.

Palaniappan had a decision to make. What did these recovered, once sacred bronzes of the gods really want? Would he give greater weight to government officials from the state capital or to local residents of a small village in his district? His decision would determine the ensuing lives of the objects themselves. To illuminate Palaniappan's choice, we can draw on key terms from the influential essay of the German Marxist critic Walter Benjamin (1985), "The Work of Art in the Age of Mechanical Reproduction." Benjamin distinguishes two principal ways in which humans receive and value art objects. The first he terms the "cult value" of an object embedded within its tradition, the value of which consists in the role it plays in a ritual setting. He contrasts this with the "exhibition value" of a work of art, wherein the value of an object derives from its availability to the gaze of an audience and the degree to which it repays a viewer's visual attentiveness. In effect, the district collector would decide whether the Sivapuram bronzes would be honored in Madras for their exhibition value, as museum objects within a display of traditional Indian sculpture, or in Sivapuram for their cult value, as devotional objects incorporated back into local temple liturgy. Palaniappan resolved in favor of Sivapuram.

Celebrity

This could have been the end of the story. The bronzes might have returned permanently to uneventful lives as processional icons in a rural South Indian temple, holy only to the local devotees. In other cases, such as that of the bronzes of Esalam, this has happened without mishap. But like a 1950s' Hollywood starlet spotted at a drugstore soda fountain, the Sivapuram bronzes had been discovered. The Institut français d'Indologie in Pondichery had them photographed *in situ* in June 1956. In 1959, curator Srinivasan published a report in *Lalit Kala*, an Indian arts journal, on the Sivapuram bronzes. He warmly praised the Nataraja and Somaskanda images as masterworks of the early tenth century and singled out the Nataraja for its "boldness of conception and dexterity of execution" (Srinivasan 1959: 67 and Figures 1 and 2).

Srinivasan's dating of the Nataraja was especially significant. By assigning it an early tenth-century date, he estimated that the Nataraja was one of the very earliest examples of this particular iconic form of Shiva. Since the early twentieth century, historians of Indian art, such as E. B. Havell and A. K. Coomaraswamy, and the

sculptor Auguste Rodin had proclaimed the Chola-period bronze rendering of Shiva Nataraja as the most elegant and profound of themes in Hindu sculpture. By the 1950s, the Nataraja theme was taking on a broader significance as an icon of India's traditional Hindu heritage. So to claim the Sivapuram Nataraja as possibly the earliest known realization of this theme was to place it among the most important and valuable of all works of Indian art (Kaimal 1999).

We should note here that Srinivasan's assessment, which set the terms of subsequent discourse concerning the Nataraja, involved placing the image in a chronological and aesthetic canon of other Indian artworks, according to archaeological and art-historical disciplinary practices. Though the Nataraja was, in 1959, a cultic icon, Srinivasan characterized it entirely in terms of its exhibition value. Let us also note that at this point, a shift in prestige occurred between the two bronzes. In cultic terms, the Somaskanda enjoyed priority over Nataraja as the primary festival image for Shiva processions. However, once the two bronzes entered into the arena of art-historical evaluation and exhibition value, the Nataraja would claim greater status, leading to a separation in their subsequent lives.

Duplicated Bronzes and Diverging Narratives

The same life may give rise to differing narratives, as we know from biographies of humans. So too with the bronzes of Sivapuram. Certain facts are agreed upon by all observers, but at several points in their lives, events are more obscure and open to speculative reconstruction. Indian investigators developed one version, while those associated with Norton Simon in the United States developed another, and the two accounts diverge at one or two key points. Lives, particularly controversial ones, are open to interpretation.[5]

In the 1950s, all agree, the recovered Sivapuram bronzes were residing in the temple at Sivapuram. But by 1965, the Nataraja was in Mumbai, staying in the apartment of Bomman Behram, a collector and dealer in antiquities. Visiting art historians like Sherman Lee and Stella Kramrisch saw the Nataraja there. At the same time, local worshippers at Sivapuram were offering puja to images they believed to be the ancient ones. The bronzes had evidently been duplicated. How did this occur? Who did it? And how did the Nataraja travel from Tamil Nadu to Mumbai? U. V. Chandramouleeswaran, superintendent of police in Tamil Nadu, who was directly involved with the investigation in India, related to me one plausible answer to these questions.

In 1961, Queen Elizabeth visited Madras. This required proper commemoration, and state officials hired Lance Dane, a retired British officer, photographer, and amateur art collector living in India, to prepare a souvenir volume for the visit. Dane photographed the Sivapuram Nataraja and placed it on the volume's cover. According to Chandramouleeswaran, Dane's visit to Sivapuram apparently set in motion the next great shift in the lives of the Sivapuram bronzes: their duplication, or in Benjamin's terms, their "mechanical reproduction."

Dane suggested to the temple officials in Sivapuram that their bronzes were in poor condition and needed cleaning. They sent the icons out to Ramasami Sthapathi, a reputable bronze maker in the nearby city of Kumbhakonam, a center of icon manufacture. However, instead of simply cleaning the bronzes, Ramasami fabricated exact duplicates of them. He returned the shiny counterfeits to the temple, for which "cleaning" he received Rs 500. Then he sold the originals to a low-level antiquities dealer named Tilaka for Rs 17,000. Tilaka transported them to Mumbai and sold them to Dane.[6] Dane then sold the Nataraja to Bomman Behram for Rs 25,000. According to Chandramouleeswaran, Dane sold the others in 1966, but their journeys from there remain largely untraced.

Ramasami's duplication of the Sivapuram bronzes highlights issues of originality, authenticity, and what Benjamin calls the "aura" of the art work. In principle, any work of art is physically reproducible. Bronze sculpture can be manufactured in quantity, as the Greeks did, by casting multiple copies from a master mold. However, South Indian bronze makers have always used the lost-wax method, which ensures that each bronze icon is the outcome of a unique sculptural process. Ramasami's innovation in creating an exact duplicate of an ancient original, and passing off the duplicate as an original, required knowledge of new worlds within which Indian bronzes could be valued. He understood, or was told, that original authentic icons of the tenth century were coveted in a new way by a cosmopolitan audience. By doubling the Sivapuram icons, Ramasami could enable the icons to serve two ends simultaneously: the duplicates would serve the cultic needs of village devotees in Sivapuram, while the originals could meet the aesthetic desires of international art collectors and viewers. And Ramasami himself could realize a tidy profit in the process.

Will the real Sivapuram Nataraja please stand up? The 1960s' television game show To Tell the Truth depended on the premise that only one individual could truthfully embody a particular biography. Other claimants therefore must be impostors, and it was the task of the interrogators to identify the honest contestant. So too with artworks; as Benjamin argues, only an original work can claim "its unique existence at the place where it happens to be," its own distinctive history and aura. Reproductions lack that aura. For the international market in antiquities, this distinction between authentic original and inauthentic reproduction matters a great deal. The original Sivapuram bronzes eventually reached the United States and realized an enormous sale price, but if Ramasami had tried instead to sell his duplicates, they would have been classified as fakes. For exhibition value, the authenticity of the original is all important.

Is the same true with Indian cult objects? After Ramasami returned his duplicates to Sivapuram, they were incorporated into the ordinary ritual life of the temple. Neither the priest, the officials, nor the worshippers raised any objection, initially. It was a visiting British art historian, Douglas Barrett, who first observed publicly in 1965 that the icons under worship in the Sivapuram temple were duplicates, not originals. Barrett noted that the original Nataraja from Sivapuram was currently in Bombay, displayed in a private collection. He also pointed out that the whereabouts of the

original Somaskanda and Ganesha bronzes of Sivapuram was not known (Barrett 1965: 32). It is not certain whether this revelation made any difference to Sivapuram villagers. Theologically perhaps it did not, since Shiva can graciously manifest himself equally in icons old and new, well and poorly made.

However, there was one later indication that the expropriation of their ancient images did dismay the residents of Sivapuram. Several persons involved in the investigation reported a "local tradition" to me. As it happened, Ramasami Sthapathi suffered paralysis not long after duplicating the bronzes and could no longer practice his trade. Lance Dane was jailed, and the Bombay art collector Bomman Behram died. According to the locals, these afflictions were the result of Shiva taking his vengeance on those who had trifled with his icons. Perhaps authenticity is just as important to Shiva as it is to a wealthy art collector.

Journey to the West and Hot Pursuit

We know that between 1965 and 1972, both the Nataraja and Somaskanda bronzes from Sivapuram traveled from India to the United States. (The other Sivapuram bronzes have not to my knowledge been located.) How did they get there? Thanks to the celebrity of the Nataraja, nearly all attention has been devoted to tracing its itinerary. The Somaskanda flew largely under the investigative radar.

Certain facts of the Nataraja's journey are agreed upon by all. Bomman Behram sold the icon to Manu Narang, an art dealer based in Mumbai and New York. From Mumbai, the icon traveled to New York in 1969. The Bureau of Customs in the Port of New York recorded the Nataraja's arrival in a "consumption entry" dated April 24, 1969. Within a few weeks, Ben Heller, a prominent New York art dealer, had acquired the image. He advertised it broadly at a price of $1,000,000. When the wealthy collector Norton Simon began to enter the field of Indian art, Heller offered it to him. The Sivapuram Nataraja, Heller claimed, was one of the three greatest Natarajas in the world, and the other two were held in museums and were unavailable for sale (Muchnic 1998: 172). In December 1972, Simon bought the image from Heller for $900,000. At the time, this was this highest price ever paid for any work of Indian art.

This brief outline leaves open the question: How did the Nataraja leave India? It did enter the United States legally. However, it also had to leave India, and the police found no record of its having done so. In the new world to which the medieval bronzes of Sivapuram had awoken, the government of India defined them as "antiquities," since they were over 100 years old. Although the bronzes were not the property of the government, the Indian state did assert an interest in controlling the lives of such aged objects as part of the national heritage. As the Indian Antiquities (Export Control) Act of 1947 decreed, "No person shall export any antiquities except under the authority of a license granted by the Central Government."[7] No such government license had been granted for the export of the Nataraja from India.

The simplest answer involves corruption. The 44-inch-high bronze statue weighs over 1,200 pounds. It could not be stuffed unobtrusively into a suitcase. To transport

the Nataraja, Manu Narang must have bribed Indian customs officials responsible for controlling exports. This is not an uncommon event. As Indian government officials with the Archaeological Survey and the Central Bureau of Investigation have estimated, not more than ten percent of exports are actually examined at the ports, and customs officers are often in cahoots with art smugglers (Devraj 1999: 3). But Chandramouleeswaran related a more complicated account. According to the Indian police investigator, a consignment of old clothes left Delhi on April 23, 1969, identified as "personal effects, value Rs 5000." It was sent from T. R. Mehta in Delhi to P. C. Johnston in the United States. But Mehta's address in Delhi was fictitious, and P. C. Johnston could not be traced. Between Indian customs in Delhi and JFK airport in New York, Chandramouleeswaran observed playfully, the clothes "magically transformed into Shiva." At the airport, the shipment containing the Nataraja was received by Ben Heller. Heller strongly denied Chandramouleeswaran's account when I related it to him. And as charming as I find the magical transformation of old clothes into Dancing Shiva, I believe the simpler story of bribery at Indian customs is more plausible.

Less is known about the travels of the Somaskanda image. Some affirm that it was spotted at the apartment of Bomman Behram in the 1960s. Presumably it made a clandestine trip similar to that of the Nataraja. The Somaskanda resurfaced in July 1972, when Ben Heller sold it for $225,000 to Norton Simon.

Meanwhile, since Barrett's published observations, the Indian government had begun to pursue one of its errant icons. In February 1969, the commissioner of the Hindu Religious and Charitable Endowments office in Madras filed a complaint with the Tanjore district police superintendent. This set in motion a police investigation by the crime investigation department. Their work would retrace the journey of the Sivapuram Nataraja and eventually catch up with it in the United States. The deputy superintendent of police in Madras, Krishnaraj, traveled to the United States to press the Indian case.

We should not take this governmental decision to pursue this antique image for granted. The illicit trade in smuggled Indian antiquities is enormous, and Indian law-enforcement agencies with limited resources cannot investigate every case that comes to their attention. However, in the early 1970s, the government of India chose to prosecute several high-profile cases in hopes that a few well-publicized recoveries might help discourage the market in stolen Indian art. Thanks to its celebrity as a million-dollar sculpture, the Sivapuram Nataraja was an obvious choice. The Somaskanda did not warrant similar attention.

Whom will Nataraja Choose?

By 1973, the Indian investigation had caught up with the Nataraja, but the icon had been sent off to London for conservation work. At this point the story becomes complicated. In addition to Heller, Simon, and the Indian police, other parties became involved.

Lawyers were engaged. Suits and countersuits were filed. Officials from the Indian embassy in Washington pressed the interest of their government. Daniel Moynihan, the then American ambassador to India, tried to mediate the negotiations (Glueck 1974). The Metropolitan Museum of Art in New York had planned to mount a big exhibition of Simon's Asia collection, with the newly purchased Nataraja as its centerpiece. As the controversy over the Nataraja grew, the museum's director, Thomas Hoving, decided to back out and cancel the entire show (Hoving 1993: 370–3).

Shiva himself became personally involved in the dispute as a legal plaintiff. In 1974, the Indian government filed a civil suit for the return of the statue, and Shiva figured as one of the plaintiffs. In this, the Indian claimants were adapting a legal formulation from Anglo-Indian (and still earlier, Roman) law, which postulates that a deity can indeed be legally considered as recipient and owner of property in an "ideal" sense, as a "juristic personality." The god Shiva, as "owner" of the Sivapuram temple originally built as a residence for him, could make a legal claim for the return of alienated temple property, such as the temple's processional images. In a similar case that came to trial in London a few years later, the presiding Queen's Bench Justice, Ian Kennedy, accepted the juristic personhood of Shiva and ruled that the god could indeed make a legal claim, even beyond India's territorial borders, for the return of his stolen icon.[8]

At the heart of the complicated dispute, though, lay the conflicting desires of two suitors. Each saw very different virtues in the object of their desire. Each put forward a vision of what would be best for the Nataraja, and these visions would lead the disputed icon to very different lives.

The first suitor, Norton Simon, had become interested in the art of South Asia during a 1971 honeymoon in India with his second wife, the Hollywood actress Jennifer Jones. Simon pursued his new passion with characteristic gusto and with a connoisseur's eye for artistic quality. He especially admired the sensuous, voluptuous qualities in Indian sculpture. As he put it in an unpublished 1974 manuscript,

> One of the main appeals of that art form is the sense of sculpture in the round; there is homage and reverence for the human body to an intense degree. While there are interesting factors in the mythology and iconographical concepts, I found my main interest in the devotion to the aesthetics of the human body. The fact that the sculptors were able to produce such joy in single bronze castings and in single stone carvings is a marvel. (Quoted in Campbell 2010: 124)

Simon quickly acquired well over a hundred works of South and Southeast Asian art, and he saw the Sivapuram Nataraja as the crowning trophy of his remarkable collection. In Heller's view, the Nataraja "ranks as one of the world's masterpieces of sculpture," and Simon shared this opinion, as did a number of scholars of Indian art.[9]

Simon certainly recognized the obstacles to attaining this object of his affections. First was the question of provenance. "Hell yes it was smuggled," he bluntly told a *New York Times* reporter. "I spent between $15 and $16 million over the last two years on Asian art, and most of it was smuggled" (Shirey 1973: 1). The next day, however,

he backed off from this brash statement in another interview, this time with the *Los Angeles Times*, emphasizing the legal importation of the statue into the United States (Seldis 1973: 3). This interview, however, did not address the circumstances of the icon's exportation from India. Whether the object was smuggled or not, Simon firmly believed that he was purchasing it from its rightful owner, and he wished to make the Nataraja his own.

If the connoisseur Simon sought the beautiful Nataraja for its exhibition value, the second suitor, the Indian government, claimed that it sought the object for its cult value. The Nataraja was a religious icon, and if successful in the suit, the government stated that it would return the bronze image to its original community and to its ritual life in the temple for which it had originally been intended. This is why Shiva was involved. As part of the Indian legal strategy, the god Shiva, as the legally recognized proprietor of the Sivapuram temple, would sue for the return of his own processional property, while India merely acted as Shiva's juridical agent.

Honorable as these intentions may have sounded, the stronger interest of the Indian government certainly lay in the politics of cultural heritage and the antiquities trade. No definite figures are possible for the scale of this clandestine market, but it is undoubtedly huge. The art-historical reputation and purchase price of the Sivapuram Nataraja had transformed it into a prime trophy of cultural heritage. The government's hope was that a successful repatriation of the celebrated bronze icon might have trickle-down effects on the large illegal trade in Indian antiquities.

Settlement and Return

To make a long legal story short, Simon and the government of India agreed to an out-of-court settlement in 1976. The Sivapuram Nataraja would return to India but only after Simon had retained it on loan for ten years. In addition, India relinquished any claims against other objects in the Norton Simon collection. This protected the Somaskanda, which was every bit as much a smuggled antiquity as its old Sivapuram companion. The press largely portrayed this settlement as a humiliating defeat for Simon, but others have pointed out that the deal maker made out very well for himself. He retained the Nataraja as a showpiece for a decade, and he inoculated the rest of this South Asian collection against all future claims by the government of India. And he got his $900,000 back by suing Ben Heller. The power of Shiva's curse evidently did not extend over Simon, though it did over Heller.

In 1974, Norton Simon had begun to look for a permanent home for his large and expanding art collection. By this time he had acquired over a hundred South and Southeast Asian art objects, as well as significant holdings of European art. During the 1970s, Simon successfully took over the financially strapped Pasadena Museum of Modern Art and gradually transformed it into the Norton Simon Museum. The Sivapuram Somaskanda settled into its new residence there as part of the permanent collection.

In 1986, it was time for the Sivapuram Nataraja to return to India. The return of such highly valued and successfully pursued objects of cultural heritage may be treated as occasion for public ceremonial and celebration. In the case of the Pathur Nataraja, repatriated in 1991, the chief minister of Tamil Nadu, Jayalalitha, and other high officials received the returning bronze in Chennai with all due devotional attention. The event was covered in the Indian newspapers, accompanied by photographs of Jayalalitha standing next to the decorated Nataraja (Davis 1997: 256–7). Such ceremony confirms the ability of select objects to serve as embodiments not only of gods but also of shared community values and historical continuity. This would not be the case with the Sivapuram Nataraja, however.

During its ten-year leave of absence, the celebrated icon had been nearly forgotten in India. As M. S. Nagaraja Rao, the director general of the Archaeological Survey of India, recollected, officials in India suddenly remembered the agreement about ten days before its expiration. They hurriedly dispatched Nagaraja Rao to fly to Los Angeles to retrieve the image. As the Nataraja was being crated for transport, Nagaraja Rao recalls, the museum curator was in tears. Nagaraja Rao flew with the icon back to Chennai, where there was a brief reception at the airport, attended by the police officers who had pursued the case. From there, the Nataraja bronze was taken to a local Vaishnava temple, the Parthasarathy Koyil, for some ritual attention. In Nagaraja Rao's view, the Sivapuram Nataraja should have gone back to its original home for reinstallation, as was agreed in the settlement. But instead, the icon seemed to drop out of sight.

Incarceration and Museumification

One might hope that the celebrated Sivapuram Nataraja, successfully recovered as a masterwork of ancient Indian sculptural art, might return to a suitable life in India. The government of India had never proposed installing the bronze in an Indian museum, such as the Rajaraja Chola Art Gallery in Thanjavur, first established by Palaniappan in 1951, or in the Chennai Government Museum, which had sought to acquire it in the same year. The premise of the government's case had been that the Nataraja bronze, as a potentially living embodiment of Shiva, ought to return to its proper ritual home, the local Hindu temple in Sivapuram. This would be both theoretically and ritually possible through the rite of *jirnoddhara*, a common reconsecration procedure. However, there was no attempt, as far as I have been able to discover, to return the bronze to worship.

The problem for the Nataraja was that the temple at Sivapuram, like many other small village temples in South India containing bronze sculptures that are immensely valuable on the international art market, could not adequately protect its treasures. Recognizing this danger, the Tamil Nadu government in the 1980s constructed an Icon Centre at Tiruvarur to house those valuable, vulnerable images in a safe place (Davis 1997: 257–8). According to some reports, the Nataraja—too valuable for its

own safety in Sivapuram—went there. According to the online report of the Tamil Nadu police department's Economic Offenses Wing, the Sivapuram Nataraja is currently in the safe vault of the Kapalishvara temple in Chennai.[10] In neither case is the famous Nataraja accessible to viewers, nor does it receive the ritual attentions proper to it as a religious icon. It has been incarcerated, deprived of both cult value and exhibition value in the eyes of the world.

The Somaskanda image from Sivapuram currently enjoys a happier situation. It is on display at the Norton Simon Museum in Pasadena and is celebrated on the museum website as one of the highlights of the collection (Figure 41 website). Unquestionably, the bronze enjoys its status there for its exhibition value, as a work of sculptural art rather than a cult icon. Though the Norton Simon Museum is a firmly secular institution, the collector himself envisioned a semireligious role for his museum. "I am not essentially a religious person, but my feeling about a museum is that it can serve as a substitute for a house of worship," Simon wrote in 1974.[11] "It is a place to respect man's creativity and to sense a continuity with the past." Accordingly, the Asian galleries in the museum, designed by Frank Gehry, are intended to "suggest to the viewer the ambience one finds at religious sites" and to create "a temple-like atmosphere of serenity and tranquility" (Knoke 2000). When I have visited the Somaskanda there, the ambience has indeed been peaceful and contemplative.

This mode of aesthetic display allows the Somaskanda to interact readily with museum goers, but it reduces the identity of the image. There is no attempt to suggest the colorful ornamentation in which the Somaskanda would originally have appeared, and no effort is made to evoke the dramatic tumult of the temple processions for which the icon was made. And there is no mention made—neither on the museum walls, nor on the museum website, nor in the sumptuous two-volume catalog of the museum's Asian collection—of the complex travels and tangled events that have brought the Somaskanda from a village in southern India to urban California (Pal 2003: 222–4). Visitors to the Asian galleries are asked to regard the Sivapuram Somaskanda as an exquisite work of sculptural art from India's past.

In the end, what do these images want from us? As we have seen, the lives of Indian images may take abrupt turns, which lead them in unexpected directions to unforeseen places. Their identities and roles may well change over time.

When I began to study the biographies of Indian art objects, I assumed that such images should be returned to their original settings to serve the religious purposes for which they had been created. But, I learned, this is not always possible. Changing conditions may preclude this kind of recovery. Present-day Sivapuram may not be equipped to receive its tenth-century Nataraja and protect it properly. Even if one sides with the Indian government in its case against Norton Simon, one must admit that the outcome of its success—with the Nataraja incarcerated in a Tamil Nadu storeroom—is not a happy one. Yet its biography also reminds us that the life of an image may always take still another turn in the future.

Meanwhile, one can visit its old processional partner, the Somaskanda from Sivapuram, in California at the museum devoted to the collecting energy of Norton

Simon. There the bronze sculpture may help museum goers, in Simon's words, to respect human creativity and to sense continuity with the human past. But I believe it should also pose a challenge both for curators and for viewers. Since the humans who created the bronze sculpture in the tenth century were assuredly not intending their creation for museum exhibition, why did they make it? What was its original role in the religious life of Sivapuram? And how did it get from there to here? To answer these questions requires an act of imaginative reconstruction. But it is a worthwhile one, for these images want their stories to be told.

2 Under the Gaze of Kali: Exhibitionism in the Kalighat Painting Exhibition at the Cleveland Museum of Art

DEEPAK SARMA

Introduction

In this chapter, I propose to examine the use of an enlarged portion of a Kalighat painting of the goddess Kali in the recent exhibition *Indian Kalighat Paintings* at the Cleveland Museum of Art (June–September 2011).[1] The image, an especially dramatic one of the goddess Kali sticking her tongue out, was used prominently on the title wall, on an outdoor billboard, and in other publicity (brochures, websites, and the like) and was intended to allure and provoke piqued patrons. Using such an image raises issues concerning the representation of religions and religious objects in museums, the "Western" constructions of Hinduism and the so-called "dark goddess," the perpetuation of colonial stereotypes, and the noble, but notorious, need to attract potential patrons.

To this end I first contextualize the goddess Kali in the colonial and postcolonial imagination. Then, I address the challenges of using and exhibiting religious objects in museums. Third, I briefly describe and contextualize the Kalighat paintings themselves. Having done so, I offer several instances in which patrons' behavior and interaction with the image on the title wall could (or would) be regarded as offensive, if not sacrilegious, by some members of the imagined global Hindu community. Fourth, I address the complex challenge, and the common but controversial and paradoxical choice, of the use of exhibitionistic and stereotype-producing/confirming objects on exhibition title walls and elsewhere to attract and to educate. Fifth, I problematize the issues in light of my own complicity as the expert consultant and guest curator of the exhibit.

Kali and Colonialism

The goddess Kali has been an easy target for Christian missionaries and British colonizers and has been in the gaze of yoga-embracing North Americans and apologetic academics, and directors of Hollywood movies.[2] Her fierce iconographic presentation and sexual and erotic imagery made her, and continue to make her, the archetype of the kind of perversion and prurience that was falsely believed to

pervade the Indian subcontinent. Such visual representations, when combined with agenda-laden and embellished colonial ethnographies of Kali worship that fixate on references to blood sacrifices, make Kali and her devotees ideal examples of the exotic. As Hugh Urban and others have argued, these stereotypes, images, and purported accounts were used to justify colonization and racial and ethnic inequalities and to satisfy imperialist voyeurism and exoticism (2003).

These stereotypes, however, were (and are) not entirely etic. There is an equally important history within South Asia itself, in which Kali and her association with *tantra* and other purportedly antinomian proclivities was not and is not portrayed in a positive light (Humes, 2003). As Cynthia Ann Humes has documented, there is a long history among Hindus, Jains, and Buddhists of sectarian polemics, stereotypes, and caricatures of Kali and her devotees (2003). These stereotypes and anxieties parallel and feed their counterparts in the "West" and have helped to give rise to contemporary Kali consumption.

While colonization may have ended, the emic and etic archetype has been perpetuated in the postcolonial imagination. The goddess Kali persists in Hollywood blockbuster movies such as the 1973 *The Golden Voyage of Sinbad* and the even more well-known 1984 George Lucas film *Indiana Jones and the Temple of Doom*. Though the latter did provoke some protests from Hindu communities in America and in India, the non-Hindu American public embraced it and it achieved tremendous financial success (Tharoor 2007). The film was faulted for portraying undesirable imperialist and oppressive themes and reinvigorating the Hollywood fascination with sinister Oriental "cults." *Indiana Jones and the Temple of Doom*, moreover, like its British predecessors, painted a picture and plot highlighting the so-called white man's burden (i.e., where imperialist nations had an obligation and responsibility to care for nonwhite colonized peoples), along with the customary white savior narrative (where white heroes saved nonwhite people from exploitation by other nonwhite people).

In both the colonial and the postcolonial imagination, Urban explains, the goddess Kali "represents the allure of the forbidden Other, which threatens to seduce and corrupt the colonizers themselves" (Urban 2003: 170). A Kali object is thus never innocently on display, neither in the Hindu or non-Hindu context nor in the Indian or non-Indian context. Rather, its display is intended to provoke, to challenge, to intensify *bhakti* (devotion), and to teach. It is in this context that the Cleveland Museum of Art strategically utilized an enlarged portion of a Kalighat watercolor painting of the goddess Kali—namely, a close-up of her face with her tongue lolling between her teeth, suggesting savagery, sexuality, and the sanguine—to call attention to the Kalighat exhibit and to seduce and tantalize unsuspecting and willing patrons.[3]

Not only did this dramatic image appear on the title wall of the exhibit, but it also appeared in a highly visible elevated outdoor sign on a commuter feeder to downtown Cleveland[4] (Figures 42 and 43 website). This publicity and media attention paid off: the Kalighat exhibit was well attended and received a very good review in the *Plain Dealer*, confirming its attraction to museum patrons (Litt 2011).

But what exactly were these images intended to provoke in the imagination of the museum attendee or in that of the sleepy and impatient commuter waiting for the light to change? Was the image of Kali and her tongue merely a confirmation of the stereotypes that may have already been held by the majority of viewers of the title wall and the outdoor advertisement, whose knowledge of Hinduism was likely negligible? Were they visiting the Cleveland Museum of Art in the same way that nineteenth-century Londoners flocked to see Sarah Baartman, otherwise known as Hottentot Venus? Or in the same way that native artisans were on display in 1886 at the Colonial and Indian Exhibition in South Kensington in London? (Mathur 2007).

Also, does the religious status of goddess Kali preclude her use as an advertisement? And, if the stereotypes were reminiscent of colonial constructions, what were the pedagogical and ethical implications of the exhibit itself?

Museums and Sacred Objects

One of the primary objectives of modern museums is education, both of connoisseurs and of the larger public. In this connection, it has become central to museums to provide patrons with sufficient data and resources to contextualize particular objects, exhibits, and so on. Such information is included in labels, member magazines, brochures, curator-led gallery talks, and the like. With religious objects in particular, there is a tremendous challenge to contextualize the pieces yet continue to show them in a secular setting. There is a dangerous temptation to walk a fine line between the secular and the so-called sacred, as exemplified in the consecrated Tibetan altar at the Newark Museum of Art, a public and state-supported museum. There is an equally dangerous temptation to enjoy the aesthetic quality of an object taken entirely out of its original context in ways that were never intended by their creators or commissioners, such as displaying "naked" Hindu sculptures which are very rarely displayed without added garments.

While it is possible to argue that the images can be displayed since they have been decommissioned (i.e., deemed no longer "sacred") by someone (or some group who claims to have the authority to do so, it is not always possible to prove this. As Richard Davis has argued in his *Lives of Indian Images*, sometimes images were stolen from temples and sold on the open market as decommissioned and as legally obtained (1997). Also, while the object may be decommissioned by a governing body in the past, that may not matter for religious patrons who do not accept their authority.

Should museums consult with invested communities and people, such as local Hindu or Indian organizations? If museums do, then they risk stipulations or requests that only a limited set of objects or kinds of objects can be displayed so long as they support the theological position or vision of a particular group. If there were voices from the local Hindu community, for example, who did not consider *tantra* to be archetypally Hindu, then would they be able to dictate that any *tantra*-related object not be put on display; or that it be displayed under a different, non-Hindu taxonomy; or that it be displayed with labels that indicate its being ostracized by a vocal and

proactive Hindu community—a community that promulgates its own version of an imagined Hindu tradition?

The educational endeavor and component can be relatively harmless and unremarkable when the objects are secular in nature. Contextualizing one of Claude Monet's *Water Lilies* may involve references to Monet's eyesight and to his house in Giverny, France. While one of his paintings in the *Water Lilies* series may inspire religious language, experience, and fervor in viewers, it is not likely that Monet conceived of it in this way.[5] As Crispin Paine has shown, there are far greater complexities and challenges when religious objects are displayed in museums (2013).

There are easily recognizable issues concerning the handling and preservation of religious objects, such as the materials and instruments used, and the gender and background of the conservationist or preservationist, for example. In North America, these issues as they pertain to Native American objects have been partially addressed in the Native American Graves and Repatriation Act (NAGPRA). There are now rules in place concerning the handling, preservation, and storage of objects that are deemed or held to be religious by Native American communities.

These issues are significant (and are in need of being addressed more comprehensively and uniformly when it pertains to Hindu, Jain, Buddhist, and Sikh objects) and are enhanced when one considers their colonial history and the history of their display. Would it be acceptable, for example, to display Hindu images that were intentionally used by British colonizers to denigrate Hinduism? Or to display ones that were caricatures produced and sold primarily for their satirizing qualities? Would it be acceptable, for example, to display historical Confederate Flags and other reminders of slavery in the United States?[6] Museums risk jeopardizing the entirety of the exhibition, as evidenced in 1969 in *Harlem on My Mind: The Cultural Capital of Black America, 1900-1968*, hosted by the Metropolitan Museum of Art, when it is believed to be more sensational than educational (Cooks 2007).

More recently, in 2013, the Jewish Museum Berlin hosted an exhibit entitled *The Whole Truth,* which included an exhibit of a Jewish volunteer who was enclosed in a glass box and available to answer any and all questions about Jewish stereotypes. While the exhibition was certainly provocative by dint of this portion of the exhibit alone, its installation in the capital city of Germany, given the history and horror of the Holocaust, was questioned as dangerously irresponsible. What if these exhibits were attended by neo-Nazis and others whose enthusiasm and interest may have more sinister underpinnings?

In this connection, is it acceptable to display objects that are deemed offensive or inappropriate by Hindus, or by any other vested community? Or to display objects that confirm, rather than confront, unfortunate stereotypes? What responsibilities do museums hold? Again, as already asked, should museums consult with invested communities and people?

When a religious, or formerly religious (or purportedly decommissioned), or currently deemed semireligious object is on display in a museum, there are many questions and controversies that must be addressed, answered, or otherwise ignored.

It is with these methodological, cultural, and postcolonial challenges in mind that I accepted the invitation to guest-curate the *Indian Kalighat Paintings* exhibit at the Cleveland Museum of Art.

Indian Kalighat Paintings: The Exhibit

Display of the Kalighat paintings and its signature object, namely the image of the goddess Kali at the Cleveland Museum of Art, are especially ironic given their history as a subaltern voice against the decadence of globalization. What then, gave rise to these stylized and hastily executed watercolors?

Picture nineteenth-century Calcutta, a dynamic and vibrant cosmopolitan city; the political capital of British India and the financial hub for trade between India, East Asia, and Europe; a center for religious pilgrimage; and a focal point of new movements and ideas—political, artistic, and cultural. Within this context one finds colonized subjects who are enticed by the new and dominant imperialist paradigm, as well as marginalized subalterns, whose livelihoods and worldviews are threatened by this new model of British imperial colonization/globalization.

To facilitate the spread of this nonnative cultural "species," the British sought to educate and indoctrinate willing colonial subjects who could then function as clerks in British East India Company offices in Calcutta, many merely imitating their idealized British superiors. These peons, known as English *Babus* (Native Indian Clerks), were upwardly mobile Bengalis, the so-called *bhadraloks* (lit. "well-mannered persons"), and they were made wealthy by the East India Company, in comparison with, and in contrast to, the majority of exploited lower-class, lower-caste Bengali subaltern service workers, who did not benefit from British cultural imperialism. These *Babus* unashamedly embraced British and European sensibilities, mores, depravity, and vices, happily surrendering to globalization, to an invasive species that could erase indigenous Indian norms. Notorious for their smoking and drinking and for keeping courtesans and dancing girls who manipulated and controlled them, the *Babus* had become ideal conspicuous consumers of the Colonial world. Ironically, their British keepers did not respect the *Babus* and certainly did not consider them to be equals.

Impoverished Kalighat artisans, who were drawn to Calcutta from rural Bengal, were concurrently observers, critics, victims, and reluctant beneficiaries of the decadence made possible by British colonial masters. Kalighat painters sold their watercolor *patuas* (paintings) as souvenirs in bazaars in the immediate vicinity of the Kalighat Temple (a temple dedicated to the goddess Kali) in South Calcutta, an activity that began in the 1830s and had come to a close by 1880. A critical response to globalization, Kalighat motifs thus included religious themes, Western material influence, and lampooning and satirical commentary regarding the changing social order and urbanity. This satirical caricature of a Bengali English *Babu* dapper dandy, whose fashion sense combines British and Indian styles with dissonant results, is an archetypal Kalighat painting.[7] Imitating his British superiors, he sits cross-legged on

a Victorian chair, holding a hookah, sporting a Prince Albert hairstyle, and wearing buckled shoes. His posture models photo studio portraits fashionable among the British, further substantiating and exhibiting the simulation. In this way, Kalighat painters ridiculed these vain *Babus* as foppish *nouveau riche* and offered a subaltern voice against the decadence of globalization.

Sold for a paltry amount, from one paisa (1/64th of a rupee) to one *anna* (1/16th of a rupee), these watercolors were simultaneously souvenirs for nineteenth-century tourists, both Indian and British/European, and inexpensive images of deities to be used for worship in personal shrines of lower- and middle-class Hindu pilgrims. A popular image was one of the goddess Kali, which was a replica of the image worshipped inside the Kalighat temple and was the signature object for the Cleveland exhibition[8] (Figure 3). The image of Kali, where Kali is depicted with her tongue out, with blood dripping from her mouth, and holding a sword and a demon's severed head in two hands, especially fits into the colonial imagination and into Victorian popular culture, and it would have been a paradigmatic souvenir-cum-artifact to be shown to intrigued and horrified friends at home in Britain who could feel smug and justified in their colonization of India. A portion of this image, namely the eyes and the protruding tongue, was enlarged for the exhibition's title wall, for the outdoor billboard, and for other publicity.

Kalighat images of gods and goddesses thus satisfied the Orientalist imaginations and preconceptions of foreign visitors who could, with their encyclopedic collections of images, show their proximity to the exotic and satiate the religious pilgrims who were enamored by images of their Europeanized deities and who were disdainful of *parvenu* lifestyles. In the process, the innovative Kalighat painters, transforming folk art into a popular genre, could offer scathing portrayals of the changes that they observed in nineteenth-century colonial Bengal.

By the end of the nineteenth century, their style had changed drastically, and mass production, combined with industrialization, meant that hand-drawn images were replaced by block prints, lithographs, and oleographs. The Kalighat moment was as brief and transient as the paintings themselves, whose cheaply made, low-quality papers and fugitive colors made them ephemeral and evanescent. The end result was this brilliant and marginalized artistic movement that depicted a fleeting moment in Bengali, Indian, and colonial history and may have been an important impetus for insurrection and eventually Indian independence.

The Kalighat images, then, were intended as caricatures and stereotypes and as souvenirs for both Indians and the colonial British. It is ironic that these images were used once again, though in the context of an exhibition of the Cleveland Museum of Art, an institution of global citizenship and aesthetics and globalization *par excellence*. And, moreover, in the words of the art critic of the *Plain Dealer:* "The Kalighat paintings represent a delicious case of aesthetic slumming by the normally upper-crusty museum, which prides itself on collecting elite artworks made by elite artists for elite patrons" (Litt 2011). How ironic that they would appear in an exhibit at the CMA!

Observations of the Absurd

From my observations as guest curator, it was clear that patrons who randomly happened upon the title wall were intrigued and were likely to visit the exhibition galleries. I imagined that the conspicuous outdoor sign had a similar effect (though I often wondered if they interpreted the tongue-lolling Kali to be taunting them on their morning commute). The title wall certainly served the purpose of drawing wanted and unwanted attention to the exhibit.

As both an insider and an outsider, it was sometimes difficult to observe patrons. In this connection, I observed from afar countless attendees position themselves in front of the title wall, under the lolling tongue of goddess Kali, for a photo of themselves doing an unsavory and unsophisticated activity (not unlike tourists taking "trick pictures" of them holding up the Tower of Pisa). They imagined themselves being licked by the enlarged tongue, picking her nose, and the like, and they often documented their absurd antics with their cell-phone cameras. Though amusing and funny at first glance, the behavior could also be easily perceived as offensive, mocking, and, for some, sacrilegious.

The irony of this, moreover, was that that the Kalighat painters were themselves documenting the absurd and the excess of globalization. The real question was, who was lampooning whom? The patrons or the patronized? Were the patrons lampooning the Kalighat images and the gods and goddesses depicted? Or were the Kalighat painters prognosticating the continued absurdity and excess of globalization as evidenced by the voyeuristic and mocking museum patrons?

Ideally, potential patrons would read the labels of the Kalighat paintings, jettison their Lucas film–induced stereotypes, and become educated promoters of Kalighat paintings. Ideally, the dramatic and enlarged image of goddess Kali would have a positive pedagogical impact.

But what if it did not? What if the labels that I wrote were not as attractive as the objects and were consequently ignored? Again, what responsibility does the museum have?

Pedagogical Pragmatism?

These pedagogical issues parallel those facing teachers anywhere and are especially prominent in academic settings. What if one were teaching a class on Hinduism and one's students were all training to become Christian missionaries and had their hearts set on traveling to India to convert those they believe to be "Hindu heathens?" Are there topics that teachers should avoid when teaching classes in South Asian religions? Should one dive into *Ripley's Believe it or Not*-type topics that would fuel their missionary zeal, such as *sati* (bride burning) or worship of a fearsome goddess like Kali? Or, should one take a defensive posture and act as an apologist for Hinduism and avoid such topics? While these scenarios may be a little extreme, teachers (and curators) face unavoidable dilemmas when teaching students who have never had

any exposure to Hinduism or South Asian religions. Is it ethically and pedagogically sound to *introduce* a culture with such sensationalist images and ideas?

Alternatively, should topics change if the majority of the students in one's class self-identify as Hindu? Should some discussions be avoided? Should one limit or even shun the use of controversial and potentially offending critical theories, say Freudian psychoanalysis, or themes in examining and interpreting Hindu beliefs, myth, and rituals?

In both cases, a hypothetical teacher finds herself in an unavoidable methodological quagmire. How much should teachers cater to their audiences (clientele?), namely the students? By itself, this issue is not unusual and is one that faces every teacher to some extent. The same scenarios and challenges are faced by museums, which, in part, are sites for educators and for education.

Thinking as a pragmatic teacher, one can reason that alluring topics or objects help to attract a potential student. Once the student has entered the proverbial classroom, the teacher has the opportunity to change stereotypes and to educate. The initial teachings or topics are provisional. Teachers optimistically believe that the provisional teaching will be corrected soon after the student decides to take the class. Could the tongue-lolling image of Kali be perceived in this way? Or is it merely a kind of tawdry sensationalism?

Curatorial Complicity and Complexity

As guest curator, I was complicit in the generation and maintenance of stereotypes about Hinduism, especially those depicting and utilizing the goddess Kali. It was certainly by choice that I was curating; I was, after all, invited to guest-curate. But from another perspective, it was hard (if not narcissistically self-reflective) to place myself in the unfortunate lineage of English-educated *Babus* depicted and derided in the Kalighat images themselves. To add to the irony, I was again selling, or in this case, exhibiting, souvenirs to be shown to intrigued and potentially horrified friends and patrons, and those whose stereotypes (exotic, "Oriental" India, and so on) might be confirmed. My liminal insider/outsider status paradoxically mirrors the historical scenario.

Would patrons wander inside the galleries and read the label attached adjacent to the complete, rather than partial, image of Kali:

The Goddess Kali, 1800s
Black ink, watercolor, and tin paint on paper
India, Calcutta
Black-skinned, four-armed, her tongue out and blood dripping from her mouth, Kali has a third eye, representative of enlightened or divine knowledge, on her forehead. Simultaneously benevolent and dangerous, she holds a sword and a demon's severed head in two hands while the other two hands are in gestures of protection and blessing. This image would have been sold as a pilgrim souve-nir to both locals and the colonial British around the Kalighat temple and is a

replica of the image worshipped inside. The image of Kali especially fit into the colonial imagination and into Victorian popular culture and would have been an iconic souvenir/artifact to be shown to intrigued and horrified friends at home in England.

Or would they read just the first few graphic and gruesome sentences, enough to confirm what they had already suspected?

Though one had to be optimistic, it was especially difficult not to feel ambivalent about the potential pedagogical outcomes.

Conclusion

In this chapter, I have addressed a number of methodological complexities that I faced as the guest curator of *Indian Kalighat Paintings* at the Cleveland Museum of Art. The issues were highlighted with the use of what I thought to be an especially controversial enlarged Kalighat image of a tongue-lolling goddess Kali. As a marketing device, the use of the image was strategic and effective. As a pedagogical device, it risked confirming stereotypes as much as it allowed for the possibility of attracting potential patrons. As guest curator, I was complicit in these strategies, unwanted consequences, and potential rewards made possible by the exhibit.

Like the Kalighat movement and moment itself, my work, under the gaze and guise of Kali and as guest curator, was ephemeral and evanescent, and, perhaps, another in a series of subaltern voices against the decadence of globalization.

3 Reconsecrating the Icons: The New Phenomenon of Yoga in Museums

BRUCE M. SULLIVAN

YOGA: The Art of Transformation was exhibited at the Sackler Gallery in Washington, DC, from October 19, 2013 to January 26, 2014, and included some 133 objects related to yoga. The Sackler, the Smithsonian Institution's Asian art gallery, also hosted yoga classes during the exhibition as part of its public program "Art in Context: Practicing Yoga in the Galleries." For each such session, a museum docent and a yoga instructor led a tour of the exhibition and then conducted a yoga class in an exhibition gallery (Figure 4). Participant Michele Stark, a yoga practitioner for five years, said that practicing while surrounded by art was a "deeper, more meaningful experience" than a typical yoga studio class.[1] When the same exhibition opened in the Asian Art Museum of San Francisco, the diversity of modern yoga was celebrated in the museum with multiple yoga classes, including *vinyasa* flow yoga but also "kids yoga," "Laughter Yoga," and "AcroYoga," in addition to music and dance.[2] A small regional museum in Ohio, the Valley Art Center in Chagrin Falls, advertised "Yoga in the Gallery" as a "slow flow yoga class" on March 1, 2014, with the added attraction that "yoga will be followed by wine and cheese."[3] Museums hosting public events in which yoga is featured is a recent development, worthy of our attention both for what this tells us about museums and about yoga as practiced in Europe and North America today.

Museums of all kinds have an interest in attracting visitors, and they sponsor a variety of programs in an effort to bring into the museum people who might never have been there before, or only rarely. The diversity of public programs sponsored by museums is dazzling, and in addition to lectures about the art, many museums offer programs for families and children—after-hours events featuring readings, music, food, and drink. Surely among the most surprising programs to be hosted by many museums are the plethora of classes in which yoga, meditation (usually Buddhist), and the Chinese meditative exercise *tai-chi* are taught. These Asian practices are offered to the public in museums of all kinds, not exclusively in those with collections of Asian objects. In this chapter, I will describe the forms of yoga offered in museums and present a preliminary analysis of the reasons for its popularity, based on interviews with museum staff, yoga instructors, and yoga class participants.

The rubric under which many museums offer yoga (as well as meditation and *tai-chi*) is as a community wellness program. Numerous examples of museums hosting such classes can be cited, and many will be discussed in this chapter. Most that I have found offering yoga are in the United States, which seems to be the place one most often encounters this phenomenon, though Canada and Britain also offer examples. Museums offering such public programs are very diverse, and while museums with Asian collections often have such programs, there are few such museums. In North America and Britain, museums hosting such programs are usually collections composed principally of Western art; some have no Asian collection at all. As an indication of the diverse array of museums that regularly host yoga sessions, I list below some of the many that I have noticed with such programs:

The Asian Art Museum of San Francisco
The Baltimore Museum of Art
The Cincinnati Art Museum
The Cotton Museum at the Memphis Cotton Exchange (Tennessee)
The Crow Collection of Asian Art (Dallas)
The Dalí Museum (St. Petersburg, Florida)
The El Paso Museum of History (Texas)
The James Monroe Museum and Memorial Library (Fredericksburg, Virginia)
The Louisiana State Museum, The Cabildo (New Orleans)
The Museum of Fine Arts (Boston)
The Peggy Notebaert Nature Museum (Chicago)
Philadelphia Museum of Art
The San Diego Museum of Art
The SEAD (Science, Engineering, Art & Design) Gallery (Bryan, Texas)
The Tampa Museum of Art (Florida).

This short list is by no means comprehensive but only indicative of the range of types of museums sponsoring yoga programs, from large urban museums to small regional and specialized museums. I focus attention in this chapter on yoga classes hosted by museums because these appear to be much more numerous than classes in meditation or *tai-chi*.

Museum Yoga Classes Similar to Yoga Studio Classes

A museum with a public program in yoga typically hires a yoga teacher who has an active practice in a yoga studio. Practitioners of modern yoga are developing new varieties of the ancient practice at a stunning pace. "From 2001 to 2011, more than 2,000 trademark applications containing the word 'yoga' were filed, including ones for Metal Yoga, Broga and Hillbilly Yoga" (French 2014: 21). The diversity of modern yoga is reflected in museums offering yoga classes. Two major streams of tradition, or yoga lineages, are regularly featured in museum yoga classes, as they are in yoga

studios throughout the Western world. The founders of both these traditions were students of Tirumalai Krishnamacharya (1888–1989), and the organizations and lineages they established are global in scope. As David White states, "No person on the planet has had a greater impact on contemporary yoga practice than Tirumalai Krishnamacharya," whose "legacy in some way extends to nearly every one of the tens of millions of contemporary practitioners who take to their yoga mats on a daily basis" (White 2014: 197 and 223; see also Singleton and Fraser 2014). Often described as "postural yoga," the two main yoga lineages are modern forms of the ancient hatha yoga tradition (White 2012: 21). One of Krishnamacharya's pupils, K. Pattabhi Jois, popularized a form of yoga practice called vinyasa or ashtanga vinyasa, a style emphasizing the flow of movement from one yoga posture (*asana*) to another, with attention paid to coordinating the breath with the movement (Byrne 2014; Smith 2008). Indeed, many yoga instructors use the term "flow" or "slow flow" as English equivalents to the Sanskrit term "vinyasa". Stephen Phillips (2009: 19–27) provides a first-person account of a fairly typical yoga class of the "hatha flow" variety that includes discussion of the use of music and devotional aspects of the practice. In the following museums, vinyasa is specifically mentioned as the style of yoga taught:

The Mobile Museum of Art (Alabama): Vinyasa Yoga: "'The practice of yoga increases strength, flexibility, and balance, while quieting the mind and re-connecting with the light that shines within us and connects us to all living beings,' yoga instructor Tracey Narayani Glover says."[4]

The Philadelphia Museum of Art: Classes have been held in the museum for a decade, and in recent years these have been taught by Dhyana Yoga studio; its main teachers describe their instruction as vinyasa ashtanga yoga.[5]

The Indianapolis Museum of Art: "Yoga in the Galleries. Combine breath, flow and art in an all levels vinyasa series." While that series of classes is no longer offered, yoga for kids is a regular feature of the monthly family day activities.[6]

The Wichita Art Museum (Kansas): "WAM welcomes back yoga with a new twist. The second Saturday, May through August, 8:30 am – 9:45 am, this special vinyasa yoga class will be held outdoors."[7]

The DeCordova Sculpture Park and Museum (Lincoln, Massachusetts): "Activate your body and mind as teachers from Stil Studio lead vinyasa yoga surrounded by sculpture and nature."[8]

The second main lineage of Krishnamacharya's yoga tradition was begun by B. K. S. Iyengar, his son-in-law (Smith and White 2014). Iyengar yoga emphasizes alignment and the use of props to achieve proper posture. Some museums explicitly state that the style of yoga taught in their galleries is Iyengar yoga:

The Horniman Museum (London): "Learn authentic Iyengar yoga and be inspired by some of the Horniman's collection."[9]

The Umlauf Sculpture Garden & Museum (Austin, Texas): Twice weekly, yoga classes are taught by Brigitte Edery, who is described as follows: "After moving

to Austin in 1989, she discovered the healing benefits of Iyengar Yoga, a system of Hatha known for its precision and structural alignment."[10]

The Cotton Museum at the Memphis Cotton Exchange: "Iyengar Yoga emphasizes posture, balance, and breath control to unite mind, body and spirit. Leah's one-on-one guidance helps students develop strength, mobility and stability a while improving their overall sense of well being (sic)."[11]

The Rubin Museum (New York): Many yoga classes are offered, including this example: "Iyengar yoga teacher Matthew Sanford is paraplegic who uses yoga practice to address the short and long-term effects of traumatic loss and disability. He is a pioneer in adapting yoga for people living with disabilities but teaches students of every type."[12]

The Cleveland Museum of Art is the third and final location for the exhibition *YOGA: The Art of Transformation*. As such, it is sponsoring many yoga classes during the period of this exhibition (from June 22 to September 7, 2014), including both vinyasa and Iyengar traditions of yoga practice.[13]

Museums host yoga classes not only on these two traditions of practice but also on others as well, and often the yoga taught in the museum is not identified as being derived from any particular tradition. The Crow Collection of Asian Art in Dallas, as part of its wellness program, offers *tai-chi* and Buddhist meditation in its galleries every week (recently *qigong* also), as well as multiple yoga classes taught by various teachers (Figure 5 and Figures 44 and 45 on website), with no particular tradition of yoga practice being specified.[14]

Museum Yoga Classes using Music, Dance, or Acrobatics

A recently developed trend is to blend music and dance with yoga, and this can be found in yoga studios and wherever yoga is taught, despite the fact that such a combination is not traditional in yoga practice. The combination of music with yoga is embodied in the figure of MC Yogi (Nicholas Giacomini). He performed as both yoga instructor and musician at the opening festivities for the yoga exhibition (Figure 6 and Figure 46 on website) at the Asian Art Museum of San Francisco.[15] He is quoted as having said that museum visitors could "experience the exhibit and then come and dance and celebrate and feel how the tradition is alive, not just confined to framed pictures on the wall."[16] MC Yogi has recorded his music, which comprises mostly hip-hop or rap-style songs that include praise of Hindu deities (with titles such as *Rock on Hanuman* and *Ganesh is Fresh*). According to the *Wall Street Journal*, MC Yogi has sold over 100,000 albums.[17] He has been interviewed on National Public Radio's program *To the Best of our Knowledge* in an episode called "sacred hip hop,"[18] and he is a regular participant in large festivals featuring yoga and music, such as Wanderlust.

In addition, MC Yogi was invited to perform in the Smithsonian Institution's Sackler Gallery as part of the "Young and Visionary: Contemporary Voices" initiative. Three

years before the opening of the yoga exhibition, he and his wife Amanda Giacomini, also a yoga practitioner, performed his original songs of Hindu devotional music on September 25, 2010, in the museum.[19] The museum's website describes the program as follows: "Delve into the wonders and challenges of the contemporary world with artists and other creative minds engaged in shaping the future through Contemporary Voices." MC Yogi's image is the one used to illustrate the program as a whole.

The combination of yoga, music, dance, and acrobatic techniques is often advertised as a "yoga rave." One organization called YogaRave.org has sponsored yoga raves all over the planet, beginning in Buenos Aires, Argentina, in 2007 with the formation of the musical group So What Project!, led by Nicolás Pucci and Rodrigo Bustos. As stated on their website,

> Yoga Rave is a party like none other in the world, a new concept in fun where the body responds only to the stimulation of music, yoga & meditation. The initiative sprang forth from the Art of Living Foundation, the largest volunteer-run NGO in the world. Just like the rest of the Foundation's initiatives, the motive is non-profit. The money raised goes to bring yoga, meditation, and stress reduction to university campuses and young professionals in need through the YESplus workshop.[20]

The same site describes the music of the Yoga Rave as an

> awesome blend of ancient sanskrit (sic) mantras/chants mixed with modern beats (e.g. rock, techno, hip-hop, etc). Mantras are just sound vibrations that have a specific event on the body/nervous system and the energy and connection generated in the room during the concert/dance party after yoga and meditation is phenomenal.

The Indian guru Sri Sri Ravi Shankar established the Art of Living Foundation in 1981, and it remains linked with Yoga Rave.[21]

Some museums have hosted yoga raves as public programs. For example, the Art of Living's yoga rave in Philadelphia in 2012 was held at Gallerie Isada, an art gallery and performance space. Another venue was the Bellevue Arts Museum, just outside Seattle, which provided the following description of the event:

> Yoga Rave is a party like no other—thousand-year-old mantras performed live, spun to electronic sounds with yoga and breaks of deep meditation. Fill yourself with energy and get intoxicated with the sounds and silence of the Self with no alcohol or drugs.[22]

The theme of enjoyment without intoxicants is presented consistently by the Art of Living Foundation and YogaRave.org:

> At the party one can enjoy both music & silence. It all begins with some Yoga to warm up the body & continues with an easy guided meditation that leaves attend-ees in the ideal state to hear So What Project!'s opening chords & slowly begin connecting with the music. At the end of the night there is another meditation.

The party, which lasts 4 hours, is accompanied by a bar offering exotic & energizing drinks that are completely alcohol-free plus gourmet vegetarian food.[23]

"Stress reduction" and "fun" are also frequently cited as goals of the yoga rave parties.[24]

Toronto's Royal Ontario Museum has also regularly hosted yoga raves, though not in association with the Art of Living Foundation. As stated on the museum website, the intention was to bring into the museum some visitors who might otherwise not attend:

> "Friday Night Live @ROM is an opportunity for Toronto's young adults to experience the Museum in a way that speaks to them," says Janet Carding, Director and CEO, Royal Ontario Museum. … Every Friday night, party goers can experience a moveable feast of food and drink throughout the ROM's galleries. Pop-up bars around the Museum will feature weekly local and international artisanal wines, beers and cocktails … mellow out with late-night yoga in the ROM's Rec Room. Performance by DJ Lokei Featuring Jay Sea.[25]

Clearly, this is a very different concept of the place of yoga in the museum's programming than the Art of Living Foundation envisions, though the target audience in both cases seems to be young adults, including university students. The final Friday night event of the season, on November 30, 2012, included "The second ever Yoga Rave featuring Linda Malone of IAM Yoga and Amber Joliat from Misfit Studio" along with jazz, DJ-remixed music, and other attractions.[26] The following year's events included a yoga rave in celebration of "Middle Eastern culture" and as an added attraction for a special exhibition:

> Be the first to see the ROM's blockbuster exhibition, Mesopotamia presented by RSA Insurance before it opens to the public. This night celebrates Middle Eastern culture with a yoga rave with Linda Malone from Iam Yoga, live performance by west coast composer/DJ Adham Shaikh and JUNO-nominee Jaffa Road.[27]

This tradition of yoga raves in the Royal Ontario Museum continued in 2014. No doubt, yoga raves occur in festival and club settings more often than in museums, but it is striking that some museums would sponsor such events.

The Rubin Museum of Art, which houses an impressive collection of Tibetan religious objects, also hosts musical events regularly. One recent example emphasizes the combination of art, music, and yoga in what seems an explicitly religious context, a concert by Yogamaya and the Hanumen:

> Our evening will begin with a guided tour of art in the Rubin's galleries specially selected by Stacey, Bryn, and their collaborators. After uncovering some of the deeper meanings and archetypical truths within the artworks, we will journey into the theater where you will be bathed in beautiful, sacred music offered by The Hanumen. Our exploration continues with a heart-opening yoga class co-taught by Bryn and Stacey, and accompanied by live mantra music. A short group kirtan will conclude this soul-stirring evening of beauty.[28]

The website's description of the two yoga instructors Stacey and Bryn cites both Iyengar and vinyasa traditions of practice in their background, and their yoga studio classes are said to be often accompanied by music.

Museum Yoga Classes as Unique Events

Sponsorship of large-scale yoga sessions in museums by the global yoga clothing corporation Lolë, headquartered in Canada, indicates a commercial interest in the combination of yoga with music and art. The 2014 tour includes museums in Barcelona (the Museu Nacional d'Art de Catalunya), Toronto (the Royal Ontario Museum), Montreal (the Musée des beaux-arts de Montréal and Vieux-Port de Montréal), Edmonton (the Art Gallery of Alberta), and New York (the Museum of Modern Art). The 2013 tour included Paris (the Grand Palais). The events include well-known teachers of yoga offering instruction to hundreds of practitioners on matching yoga mats in vast spaces, to the accompaniment of classical music. These yoga classes in museums are also presented as wellness events: "the Lolë White Tour™, an event dedicated to promoting peace and well-being around the world."[29] Donations by participants "support wellness programs in their city," such as a year of free yoga classes. Such sponsored commercial events do not lead to ongoing yoga practice in museums, though many free yoga classes are said to be offered in those cities.

A surprising twist in modern forms of yoga can be seen in gatherings advertised as "vinyasa and vino" events. Such events bring people together for perhaps an hour of yoga practice followed by a social hour featuring the consumption of wine. It may be hosted by a winery, a club, or a yoga studio. The following describes such a gathering in Florida:

> Thursday—May 10th 2012: The 3rd annual Vinyasa & Vino: A Yoga and Wine Event benefitting Girls, Inc. at the chic, sophisticated Hyatt Regency Sarasota … Alicia Stevens teaches smart vinyasa flow yoga in sarasota, florida (sic) and beyond. … 6-7pm—Yoga
> Practice a fun, playful yoga session with Alicia Stevens accentuated with live guitar by Randall Buskirk. 7-9pm—Wine
> Mingle and savor the delicious raw, local and organic menu paired with perfect wines prepared by Chef Leo. Also, enjoy shopping opportunites (sic) with local vendors, including ems b. jewelry.[30]

The New Bedford Art Museum held its "Vinyasa, Violin, and Vino" event on May 31, 2012.[31] The Journey Art Gallery of Canton, Ohio, described its gathering as follows:

> Vinyasa & Vino Yoga is back!!!! Join us for Friday evening yoga Mar. 21th (sic) at 7:00pm with Topaz. After class, we invite you to take your happy, mellow self into the gallery and join us for wine, appetizers—soak in the beauty and maybe even do a bit of shopping![32]

The Dallas Museum of Art, like many others, stays open late one night a month for special programming. A typical evening includes music, film, yoga in the galleries, yoga for kids, etc.[33] And as the Royal Ontario Museum and many other museums' after-hours or evening programs advertise, yoga is often offered as part of an enjoyable set of attractions including music, dance, food, and drink, in addition to the museum's art collection.

Another example of unique events featuring yoga and meditation in museums is the meditation "flash-mob." This social movement, known as MedMob, began in Austin, Texas, in January 2011, with sixty meditators on the floor of the Texas State Capitol building as a political protest. Now there are groups in some 400 locations.[34] London's MedMob group has organized events on the steps of the city's National Gallery for winter solstice 2011 and in the Great Hall of the British Museum on January 20, 2012. MedMob as an active organization seems to have peaked in 2012 and appears to be less active at present. As public spaces, museums have been used by groups in many cities for such gatherings, if not indoors, on the steps or grounds of the museums. Again, however, such apparently spontaneous gatherings do not lead to ongoing yoga or meditation practices in museums.

Museum Yoga Classes for Youth: Yogiños

Yoga for children is a widespread movement that has also found its way into museum offerings. Children's museums in many locations offer yoga classes for family groups, including museums in the cities of Phoenix, Sacramento, Missoula, New York, and the National Children's Museum outside Washington, DC.[35] Of course, museums of all kinds host yoga events designed for children and families. An example of such a program is the Norton Simon Museum's Art + Yoga Family Festival, which is described as follows:

> Join certified yoga instructor Greville Henwood on a tour exploring Indian and Southeast Asian art. After the tour, practice oms, asanas, mudras and yoga movements inspired by the gestures and poses of Hindu and Buddhist gods and goddesses. Leave the workshop feeling relaxed, rejuvenated and enlightened. The course is free and limited to 20 participants ages 6–12. Participants must be accompanied by one adult only.[36]

The association between the art exhibited and the postures adopted in yoga practice is rarely as explicitly articulated as it is in this program.

An innovative and distinctive approach can be seen in a rapidly growing organization called Yogiños: Yoga for Youth. Founded in Texas in 2008, this organization describes itself as follows:

> An OHMazing® interdisciplinary curriculum in English, Spanish, and Sanskrit. We weave together the 8 Limbs of yoga with original art, music, games, stories, and other sensory-integrated activities to promote flexibility, strength, balance,

collaboration, civic and social responsibility, mindfulness, nutrition, and wellness both on and off the yoga mat.[37]

Founder and executive director Beth Reese has a PhD in museum education and has taught art history, art museum education, and museum studies at the university level. She is also a mother of three and a longtime yoga practitioner. Concerning the term created for Yogiños, Reese says: "Looking at yoga holistically is one of the founding principles of Yogiños. We call it 'OHMazing': making good choices for yourself, others, and the environment both on and off the mat and in every aspect of your life" (Wachob 2011). Reese goes on to note the importance of their collaboration with the museum in Dallas: "The partnership that Yogiños: Yoga for Youth® has with the Crow Collection of Asian Art has become an extraordinary opportunity to weave the philosophies of yoga and Yogiños into the museum's on- and off-site educational programs."[38]

Yogiños has made two DVDs that demonstrate their approach to yoga for youth. The first DVD created by Yogiños, *The Story of Ganesha*, "used original works of art from the Crow Collection of Asian Art" and was filmed in the Art Museum of South Texas in Corpus Christi. The second DVD, *Vishnu's OHMazing Journeys*,

> was filmed in the Crow Collection of Asian Art in Dallas and developed and funded in partnership with them. In this DVD, we use original works of art to tell some of the stories of Vishnu, specifically stories about the choices he made to help the earth. The DVD also emphasizes that each of us are the artists and creators of our own journeys. (Wachob 2011)

Stories told on the disc include myths of three forms (*avatara*) of Vishnu (Kurma, Varaha, and Krishna). The myths are told in association with artworks representing these forms, and yoga postures are related to them as well. Both discs feature music by MC Yogi; the second DVD includes his song entitled *Give Love.* The Crow Collection celebrated the release of the DVD with a night of activities, including a concert by MC Yogi at the museum.

> Rock your chakras with MC Yogi. A full time yoga teacher and performing artist MC Yogi combines his knowledge of yoga with his love for hip hop music creating an exciting new sound that brings the wisdom of yoga to a whole new generation of modern mystics, truth seekers, and urban yogis.[39]

While yoga for children is reasonably widespread, Yogiños is unique in having a clear articulation of the rationale for and significance of its combination of yoga with art and thus the important role of the museum in its yoga practice. For example, of the five training modules developed by Yogiños, Module 3 is "The Yoga of Art, Music and Dance," a workshop that includes these components:

- Discuss characteristics of how the intersections of yoga, art, and music are meaningful for our bodies, hearts, and minds;
- Use music and art as catalysts for designing and implementing yoga classes;

- Make art and music in relation to a theme-based class;
- Presentations and discussion of current research and programs associated with yoga, art, and music;
- The Yoga of Art, Music and Dance eManual.[40]

As Meredith Paterson, director of yoga training for Yogiños, expressed their approach:

We wanted the kids to move around and do yoga poses as they observed the works of art. First they would start with *pranayama* breathing exercises to help settle their minds and reduce their anxiety as they enter the museum space; this helps them separate the museum space from the bus or car they rode into the parking lot on. Then they would view the art and shape their bodies into poses that reflect what they were seeing, as a way to kinesthetically experience the art, even though they can't touch it. … We found that doing this helped them to experience the art in a whole different way; it helped them pay attention to the materials the art was made of, helped them see the art in three dimensions once they had moved their bodies into those shapes. With a sculpture, they would look at it from all directions and they were able to assimilate more information as they moved through the museum. It also seemed that it was more fun![41]

For Yogiños, then, the museum setting is not simply a nice atmosphere in which to practice yoga but is integral to the practice. In addition to yoga in museums, Yogiños conducts yoga sessions for youth in educational settings and trains teachers to use yoga in classrooms.[42] Yogiños staff and teachers still bring artworks into the classroom when teaching their distinctive approach to yoga. While this organization began in Texas and remains very active there, it has opened new locations across the United States from Nevada in the west to Maryland in the east, and a new center in Belgium. I attribute its success in part to the fact that both Beth Reese and Meredith Paterson have experience in education as well as yoga (one in art history and museum education, the other in pedagogical theory and practice). Yogiños: Yoga for Youth is a dynamic organization with a distinctive approach to yoga and the benefits of teaching yoga in museum settings.

Conclusions: Interpretations of "yoga" in Museums

Why is yoga a popular and widespread public program in museums, especially in North America? Part of the answer to this question is that museum staff members who are responsible for public programs see yoga as a discipline that complements or reinforces the appreciation of objects in museums. As stated by Allison Wyckoff, Manager of Public Programs at the Asian Art Museum of San Francisco,

So much of what we do in interpretation and looking at museum objects requires the same sort of mindfulness as yogic philosophies that are supported by practice. Breath, posture, and grounding, a presence and focus—that's how we

prepare ourselves for looking at art and asking others to look at art. I think museums and yoga go hand in hand. I see museum-going as a mindful practice. In a way, the entire museum is a contemplative space, or can be.[43]

In a somewhat similar vein, Becky Manuel, coordinator of community programs at the Art Institute of Chicago, told me that

people are attracted to do yoga in part because the site is the museum. We are conscious of yoga as a religious or spiritual practice, but for us what is important is that it is an experience for families to have together: an authentic experience of yoga in the context of art. Both Yoga and art have a spiritual component—inner serenity comes through both. And it is fun for us in the museum and our visitors to think of art in a new way.[44]

Museums often emphasize the art's presence as an appealing feature for their yoga programs. The Baltimore Museum of Art advertises its summer "Yoga in the Sculpture Garden" event as follows: "Practice yoga amidst masterworks and experience a meditative way to deepen your interaction with modern and contemporary sculpture. Each class focuses on a specific work by significant artists."[45] The Cincinnati Art Museum's director of marketing and communications, Regina Russo, promotes the connection in its "Yoga with the Masters" program:

"The art museum is a place of reflection, a place to find solace and to go inside as you look at the beauty around you," she says. "What better place to pair these two art forms: going inside to see the beauty within and coming into the space to see the beauty around you?"[46]

The idea that yoga practice in a museum setting enables one more fully to appreciate an art work or an object of religious significance is concisely framed by Karin Oen of the Crow Collection: "Parking your yoga mat in front of a particular sculpture for the duration of a session provides an opportunity for a deeper connection with that work of art."[47]

Noteworthy with regard to art appreciation through yoga practice is the fact that yoga is traditionally understood to entail withdrawal of the senses (*pratyahara*), changing the focal point of the practitioner from external objects to a purely internal awareness. The foundational ancient text *Yoga Sutra*, attributed to Patanjali, requires this discipline as the fifth of the eight limbs (*ashtanga*) of yoga practice (Jha 1934: 2.54–5). The same discipline is described in the equally ancient and even more revered text *Bhagavad Gita* (6.24–7), and in other works on yoga. Thus, one could argue that there is a contradiction between the contemplation of works of art, with its outward focus, and the practice of yoga, with its inward focus. For example, as an aid to developing concentration and inwardly focused awareness, yoga practitioners use a *mandala* or meditation diagram, having committed the object to memory so that it can be brought to mind without the need to physically look at an external object. As the introductory verses of the *Yoga Sutra* state (Jha 1934: 1.2–4), the ultimate objective of the yoga practitioner is to cease being entangled in sensory objects

and thoughts and instead to realize one's true identity as observer of the world, but an observer neither identified with nor responding to external sensory objects. The connection between art and yoga might thus be best understood as meaningful in the same way as the contemplation of a mandala is for the practitioner—namely, as aiding in building concentration and focus that the dedicated yoga practitioner aspires ultimately to transcend.

The Yogiños organization may have articulated the best rationale for relating yoga and the arts. "Current brain, academic, and cardiovascular research provide evidence that practices related specifically to yoga and its breathing techniques offer a wide array of health benefits and mood improvement, as well as improved mental clarity and academic abilities" (note 30). The Crow Collection of Asian Art and Yogiños have cooperated to make that site a "wellness museum" with yoga central to its programming.[48]

One of the most frequently cited reasons for museums to sponsor yoga classes on their grounds is community health and wellness. Certainly there is a long history of yoga being understood as conducive to wellness. One of the earliest passages on yoga, *Shvetashvatara Upanishad* 2.10–15 (Olivelle 1998: 419), states that "Lightness, health, the absence of greed, a bright complexion, a pleasant voice, a sweet smell, and very little feces and urine—that, they say, is the first working of yogic practice." While these benefits are said to come early in the practice, one "obtaining a body tempered by the fire of yoga, will no longer experience sickness, old age, or suffering." Though mostly dedicated to psychological well-being, *Yoga Sutra* also refers to attaining through practice various powers, including that of bodily perfection (beauty, grace, and strength), and even transcending limitations of matter (Jha 1934: 3.44–46). The seventeenth-century work *Hatha Yoga Pradipika* (Swatmarama 1987: 2.47), a foundational text for modern postural yoga, clearly states that breath control leads to overcoming old age so that one may look like a sixteen-year-old! These ancient texts are, of course, not well known or widely read by modern practitioners. The idea that yoga has healing properties is so deeply engrained in modern postural yoga in part because the most widely read and cited work on yoga in recent decades, Iyengar's *Light on Yoga* (1966), devotes an appendix entitled "Curative Asanas for Various Diseases" to detailing specific postures to treat some eighty-eight diseases and medical conditions. Indeed, a recent study of contemporary yoga practice (de Michelis 2004: 252) describes the typical postural yoga class as a "healing ritual of secular religion." That museum officials would regard yoga as contributing to wellness within their communities is thus entirely understandable and conforms to the widely held view among yoga practitioners.

Despite what advocates have long said, one might well question whether yoga's effects are entirely beneficial. *The Science of Yoga: The Risks and the Rewards* (Broad 2012) documents the effects (both positive and negative) of practice as determined by scientific measures, including the numerous injuries suffered by practitioners. As Broad indicates, many studies call into question the safety of particular postures,

especially headstands and shoulder stands. Officials at museums hosting yoga classes may want to discuss their contingency plans for injuries on site.

The most surprising reason I have heard for practicing yoga in a museum came from students of a yoga teacher (the teacher wished to remain anonymous since her students had not given permission to be quoted). This yoga teacher, who has frequently taught in museum galleries, says that two of her students expressed enthusiasm about taking yoga classes in the same room with objects such as Buddha images and statues of Hindu gods. These yoga practitioners said that they regarded their practice as "reconsecrating the icons."[49] Some of the religious objects in museum galleries were undoubtedly deconsecrated by established ritual procedures; others surely were not. Museums rarely if ever inform the public concerning this aspect of objects being exhibited, however. That yoga practitioners would voice a religious motivation for engaging in their practice is not surprising, but for them to adopt the view that the religious status of a statue would be affected by the performance of yoga in its presence is a fascinating new religious perspective. Hindu (or Buddhist or Sikh) traditions do not have any such ritual performance.

The varieties of yoga encountered in diverse settings such as yoga studios, raves, wineries, and museums (to name a few) raise questions about what is meant by the term "yoga." Andrea Jain (2014: 459) reasonably argues as follows:

> Symbols, practices, and ideas vary across yoga studios and ashrams within the United States alone, thus illustrating that the quest for the essence of yoga is an impossible task. In the history of religions, there are no original ideas or practices, and there are no unchanging essences. … In short, the problem with any definition of yoga remains: who is to say which, if any, yoga practitioners have it all wrong?

Nonetheless, the question remains what we mean when we use the term "yoga." As Velcharu Narayana Rao (2004: 219, 238) observed regarding the narratives regarded as variations on the story of Rama and Sita, "How many changes in the narrative does a Sita character comfortably accept and at what point does a change trigger another character that is no longer Sita? … The limits, I suggest, are best understood by exploring the underlying cultural grammar of these narrative traditions." Similarly, at what point does "yoga" as named by a practitioner cease to be yoga as understood by the "cultural grammar" of Indic civilization? Is a yoga rave still yoga while acro-yoga crosses the boundary into some other category? And, as Jain observes, "Who is to say"?

This first attempt to describe the diversity of yoga classes offered in museums is limited in its scope and can only be provisional in its conclusions. While museum versions of yoga classes reflect the practices found in yoga studios, the presence of works of art is clearly an attraction to practitioners. For museums, the appeal is to bring into the museum visitors who might otherwise not enter. Providing an opportunity for an enjoyable experience combining a relaxing (or invigorating) yoga session with art appreciation (and perhaps a glass of wine, meal, concert, or other

attraction) may aid the museum to increase attendance. Giving children a positive museum experience may produce lifelong museum visitors. If yoga classes increase community wellness and build goodwill, the museum benefits. If yoga provides its practitioners an increased ability to focus and perceive, in the galleries they may have an aesthetic experience, perhaps even a religious experience, such as only a museum could offer.

4 Sikh Museuming

ANNE MURPHY

In April 2014, the *Vancouver Sun* reported that a Canadian real-estate billionaire, Bob Singh Dhillon, had purchased a sword that he said belonged to Maharaja Ranjit Singh, whom the newspaper called "the first warrior king of the Sikh empire" (Shore 2014). Dhillon noted that he had decided to buy the sword because Ranjit Singh "holds a big place in the psyche of Sikhs" and because "per capita there are more Sikhs in Canada than in India, so it makes perfect sense that we should bring it here and be custodians of our own history." He suggested that "museums and cultural groups … pitch him their ideas" until he could realize plans for a "Canadian museum of Sikh culture" (Shore 2014). Such a museum does in fact exist online and, since the fall of 2014, in the form of physical gallery in greater Toronto: "The Sikh Heritage Museum of Canada" (shmc.ca) is, according to its homepage, a "Canadian organization celebrating the unique culture, history and legacy of Sikh Canadians." It features online and physical exhibitions about Sikhs in the First World War, Sikh toy soldiers, Sikhs in Canada, and the history of the Komagata Maru incident, a pivotal event in early Indo-Canadian history when a ship carrying over 350 migrants from British India was turned away from Canada in 1914. Led by a currently volunteer executive director, Pardeep Nagra—who is well known in Canada for his landmark challenge to boxing regulations that barred participation with a beard—the institution aims to research and educate about the history of the Sikh community of Canada ("Bearded" 2000; Nagra 2014).

Such interest in collecting objects related to Sikh history and attending to their display reflects both a broad contemporary reality and a longer transnational history in changing terms. Current Sikh engagement with the museum form is, indeed, persistent and diverse. Recent years in particular have witnessed a number of diverse museological engagements with Sikh material culture and art in North America. In some of these, objects are considered "art"—recent major exhibitions at major institutions include *I see no Stranger: Early Sikh Art and Devotion* at the Rubin Museum of Art in New York City in 2006–7, a display of Sikh objects at the San Francisco Asian Art Museum, and an exhibition at the Smithsonian Institution in Washington, DC, which opened in the July of 2004. Such exhibitions have celebrated Sikh culture in broad historical terms. In a different mode, the Wing Luke Asian Museum in Seattle, Washington, produced the exhibition entitled *The Sikh Community: Over 100 Years in the Pacific Northwest* in 2006, focusing on the local

history and material culture of the Sikh community in the region, within a broader presentation on Sikh culture and history; other related exhibitions have focused on Punjabi culture more broadly, such as the *Bhangra.me* exhibition at the Museum of Vancouver in 2011–12.[1]

Such museological projects are by no means a North American phenomenon. The Maharaja Duleep Singh Centenary Trust in England, a registered charity since 1993, has been active in commemorating the lives and activities of Sikhs in Britain as, according to the organization's director Harbinder Singh Rana, "loyal subjects of the crown" (Rana 2002; see also Axel 2001 and "Anglo Sikh. …" 2002). In addition to collecting objects and preserving sites related to Maharaja Duleep Singh, the last ruler of the independent Punjab before annexation by the British East India Company, the organization has constructed an online "Anglo Sikh Heritage Trail" (http://asht.info/), in association with the United Kingdom Punjab Heritage Association, to highlight the history of the Sikhs in Britain through sites in the United Kingdom. In response to the centenary of the beginning of the First World War, the UK Punjab Heritage Association (UKPHA) initiated its contribution to the commemoration with an exhibition in London, followed by a series of additional events.[2]

The first officially recognized (since 2001) Sikh Museum in England is located in Leicester and was founded in association with a *gurdwara* or Sikh place of worship (see Figure 7 and Figure 47 website); this has been followed by the National Sikh Heritage Centre and Holocaust Museum, in association with Sri Guru Singh Sabha Gurdwara, in Derby.[3] When the Guru Nanak Sikh Museum of Leicester was registered as a public museum with the British Museum Service, the museum had to develop a comprehensive acquisitions and conservation policy and an educational program for the general public. It was founded on the second floor of the Guru Nanak Gurdwara and was a part of the gurdwara before being officially designated a registered, public museum. It contains weapons, texts, reproductions of paintings found in similar museums in India, and three-dimensional reproductions of major Sikh shrines in India—such as the Golden Temple and five Takhats. It also, distinctively for this genre of museum, contains contemporary artwork from Sikh artists not working in the historical painting genre. The Leicester museum is also distinguished for another reason: It was, in the summer of 2002, also the site of the Queen's second visit to a gurdwara, during her jubilee tour of the United Kingdom. Her first such visit was to the Golden Temple in Amritsar. As the Queen noted in her address at the National Space Centre on August 1, 2002, "Here in Leicester, you have a reputation for successful cultural integration, producing a distinctive city. All-faith communities are part of what it is to be British in 2002" (Ridley 2002; "Special Coverage" 2002). The museum was thus here mobilized within a larger strategy to locate Sikh history— as commemorated in the museum—and the Sikh presence in the United Kingdom as a part of a larger national narrative of diversity of faiths. Resham Singh Sandhu, chairman of the Leicester Council of Faiths, argued that the Queen's visit was "further proof of the city's great multi-cultural heritage," and said that he thinks "the future of multi-faith Leicester has become stronger as a result of this visit. … By visiting the

Sikh temple and listening to us, it has shown her commitment to how happy she is to be part of a multi-faith family" (Ridley 2002: 1).

Such exhibitions are, however, no less prominent in India itself. Thus we can add to this list a prominent exhibition on the Sikh tradition held in Delhi, entitled *Piety and Splendour*. This exhibition was originally planned around the prior project at the Victoria and Albert Museum in London, but no objects featured in it came from the United Kingdom (Goswamy 2000; "Portrayal …" 2000). Most dramatically, we must also include among such endeavors the striking new Khalsa Heritage Complex built in Anandpur, Punjab (Launois (Sat Kaur) 2003; Mathur 2007: 169), which details the history of the Sikh community from the time of Guru Nanak to the foundation of the Khalsa and demise of the tenth Guru, Guru Gobind Singh, in 1708.[4] The Heritage Centre opens with a gallery paying homage to Punjab's diverse and eclectic culture, by the prominent designer/artist Orijit Sen recognizing the place of Sikh tradition within it, and features artfully designed exhibition spaces that detail Sikh history, with a sensitive and moving abstract installation to denote the martyrdom of Guru Arjan, the fifth Guru. Such museums are also found in association with Gurdwaras: In addition to the well-known museum at the Golden Temple or *darbar sahib* in Amritsar are similar museums associated with other major historical gurdwaras in Delhi, such as Sis Ganj in old Delhi and Bangla Sahib in New Delhi.

Such efforts represent a particularly Sikh museological presence, drawing on multiple regimes of meaning and representation on the part of the different actors involved and situated within the cultural and public space reserved for the museum. They allow us to see how different kinds of publics are organized in relation to the representation of being Sikh, and how the museum form is adapted by and for different publics to articulate the place of the Sikhs in the world. I concentrate here on formal institutional forms of museological production, but it must be noted that these are accompanied by both online and physical representations of the Sikh past in more politically contested forms, in particular in relation to the violence of the Indian Army assault on the Golden Temple in 1984 and the targeted attacks of Sikhs that occurred in the wake of the assassination of then Prime Minister Indira Gandhi later that year (Axel 2005; Chopra 2010, 2011). Given that such representations have received significant scholarly attention, however, I concentrate here on underexamined forms of museological and Sikh representational engagement in order to broaden our view from an exclusive focus on 1984-related visual and memorial discourse and to consider this form of representation as a larger phenomenon.

The Museum Form

We see in the diverse efforts described above three modes of Sikh engagement with the museum form: first, the mobilization of mainstream museums to highlight a broad "civilizational" narrative about Sikhism; secondly, more locally driven historical narratives, such as exhibitions that focus on the history of the community in diaspora rather than focusing on Sikh history writ large or the history of the tradition in

South Asia; and thirdly, the development of what we can call the "Gurdwara Museum," where the museum is explicitly attached to a religious institution and emerges as an aspect of the engagement of that institution with its publics, both Sikh and not. Memories of 1984-related violence and Indian state oppression find a place most commonly in the latter form but also, as noted, have an independent and particularly important virtual life. All are part of the "inter-ocular field" identified by Appadurai and Breckenridge: a rich array of representations that comprise as a whole the visual field, and which are "structured so that each site or setting for the disciplining of the public gaze is to some degree affected by viewers' experiences at other sites" (Appadurai and Breckenridge 1999: 418). They also have to be understood alongside other parallel institutions and activities in "leisure, recreation and self-education" (Appadurai and Breckenridge 1999: 411). In this way we can see museums as "a part of a generalized, mass-media-provoked preoccupation with heritage and with a richly visual approach to spectacles" (Appadurai and Breckenridge 1999: 411).

The museum is in many ways a quintessentially colonial institution, born in India of the British colonial drive to categorize, rationalize, and display the Indian past and present for the "greater" good of control; as Bernard Cohn (alongside others) has argued, "the major interpretive strategy by which India was to become known to Europeans in the seventeenth and eighteenth centuries was through a construction of a history for India," and objects were "discovered, collected, and classified" (and later displayed) as a primary means to serve this agenda (Cohn 1996: 77–8; see also Prakash 1999: 21–2 and Singh 2003: 187). The museum thus acted along with the census and the map to shape, according to Benedict Anderson, "the way in which the colonial state imagined its dominion—the nature of the human beings it ruled, the geography of its domain, and the legitimacy of its ancestry," serving the very political purpose of justifying British rule ([1983] 1991: 164; see also Guha-Thakurta 2004: 43). In the context of the metropole, Tony Bennett has argued that the growth of the museum in Europe exemplified a "new 'governmental' relation to culture in which works of high culture were treated as instruments that could be enlisted in new ways for new tasks of social management" (1995: 6); the social engineering aspects of the museum form were thus fundamental to its constitution there as well, as "a response to the problem of order, but... seeking to transform that problem into one of culture—a question of winning hearts and minds as well as the disciplining and training of bodies" (1999: 335).

The first museums in India were of colonial construction, such as the famed Ajaibghar or "Wonder-house" in Lahore, immortalized in Rudyard Kipling's *Kim* (and at one time curated by Kipling's father) (Bhatti 2012; Qureshi 1997; Prakash 1999: 37ff.). The Lahore Museum was modeled after London's "India Museum" and was first begun upon the order of the Financial Commissioner of Punjab to serve utilitarian ends, "with a view to the development of the resources of the country" (quoted in Qureshi 1997). It was later merged with the contents of the Punjab Exhibition of 1864, which itself was part of a larger phenomenon of public fairs or exhibitions which, according to Breckenridge, worked to situate "metropole and colony within

a single analytic field" that was global, while simultaneously reinscribing difference and the primacy of the nation-state (Breckenridge 1989: 197). They demonstrate the colonial construction of the world as exhibition, as described by Timothy Mitchell: the world ordered into representation and represented, organized, and consumed by the modern metropole subject (Mitchell 1991 [1981]). Culture and history were thus rationalized and disciplined for this observing metropole audience and, later, to organize and discipline a colonial populace.

Guha-Thakurta has drawn attention to the "issue of failure or incompleteness," reconceptualized as one of "hybridity and difference," that marks the role of the museum in India, where the "unbridged gap between its actual and intended public" gave rise to a range of "unintended meanings" in the late nineteenth and early twentieth centuries (2004: 45; see also Prakash 1999). Such meanings related fundamentally to the question of audience: Who was to consume the museum in its colonial context? Guha-Thakurta argues that the functioning of the museum "remained wracked by a set of construed binaries where knowledge stood pitted against wonder, where the scientific gaze battled to find a place amid a sea of curious eyes, and where the project of education saw itself subverted by the demands of mere amusement and recreation" (2004: 79). The popular nature of the museum was a problem: audiences seemed to ignore the educational aspects of the museum and gain something altogether unintended (and far too enjoyable) for the intended purpose of the museum (2004: 80). Viewing was a fundamental part of colonial practice but somehow was rendered problematic in an uncontained and undisciplined form (Guha-Thakurta 2004: 81).

Such undisciplined viewing has been given a different set of disciplinary contexts in the postcolonial state, where the museum has been mobilized to serve a different set of state and other elite interests. Anderson argues that "political museumizing" was inherited by postindependent states, at least in Southeast Asia, and certainly this can be seen in the representation of the Sikh past in the National Museum in Delhi in 2000, where this past is made a part of a larger national narrative within a larger museum context meant to show, as Kavita Singh put it in a recent article, "that India was eternal and … that India was great." (2003: 177). A different set of nationalizing interests, as will be explored, might also describe other forms of Sikh museological representation. The museum in these contexts is reimagined for new publics and new politics; we also see diverse audiences inscribing new meanings within the museum form. Along the lines that Guha-Thakurta has argued, Shaila Bhatti has described how visitors to the postcolonial Lahore Museum, too, view the exhibits outside the parameters originally intended for the museum, "interpreting and creating meanings that address a set of requirements different from the museum's authorised knowledge and visual pedagogy" (Bhatti 2012: 151).

The colonial museum constructed "man" as both subject and object of knowledge—in radically different ways, of course, depending upon one's race and nationality (as well as gender), with a tension between the theoretical universality of representation and its much more limited realities. Today, this contradiction between

the universal and the particular continues to haunt the museum form in the West as well in South Asia, as many museums in Europe and the United States endeavor to reach a diverse public that remains largely underrepresented or unrepresented both within their staff and, in relative terms, collections. At the same time, individuals and groups vie for representation within these institutions (Karp, Kreamer, and Lavine 1992). Simultaneously, many of the colonial contradictions that haunt the museum in South Asia persist in relation to diverse viewerships within the region and outside of it. Community museological representations take their place in relation to these forms of "museumizing," political and otherwise, representing a part of a larger phenomenon of the "post-museum" form, identified by Eilean Cooper-Greenhill (2000), which, in the words of museum theorists Corinne Kratz and Ivan Karp, creates museums as "temples of civilization, sites for the creation of citizens, forums for debate, settings for cultural interchange and negotiation of values, engines of economic renewal and revenue generation, imposed colonialist enterprises, havens of elitist distinction and discrimination and places of empowerment and recognition." Thus, the museum acts not only as an institution of public culture but also as a social technology: a means by which a set of social processes and transformations are engaged and through which publics are created and voiced, creating "global theaters of real consequence," with reference to principles of multiculturalism and pluralism (Kratz and Karp 2006: 1, 4).

"Gurdwara museology" exists as a separate entity, outside of (and historically prior to, in terms of Sikh participation) mainstream national or private secular museum activity, but reflecting parallel engagements with pluralism and community building. Such museums are associated with the Sikh congregational site or gurdwara directly. Modern historical paintings that narrate Sikh history—with an emphasis on the Gurus and martyrs, from the distant and recent past—are the staple of the gurdwara museum, while overwhelmingly objects of the court (with the occasional religious object) narrate the Sikh past in traditional Western-style museum contexts. The content of the gurdwara exhibitions, therefore, is less the objects themselves as objects than the persons and histories highlighted within the objects and paintings—the narration of history itself that is on display. This direct association between gurdwaras and museums is found in India, but, as has also been noted, the first recognized Sikh museum in the United Kingdom was founded in association with a gurdwara. Along similar lines, we find the Gur Sikh Temple of Abbotsford, British Columbia, which itself has been preserved and declared a national historic site in Canada, as the oldest surviving gurdwara in the country, having been finished in 1911. It also features a small museum space that holds exhibitions on local Sikh history.

The museums associated with gurdwaras, in general, have as their primary content historical paintings, many of which are reproduced as popular posters (McLeod 1991). Such narrative illustrations are typical of many cultural and religious traditions in South Asia, but the central location and formal organization of such images in a museological religious setting is fairly unique in its frequency, at least, to the Sikh context (although the museum form overall is proliferating in general in religious contexts, and not just in India; see Robson 2010). The Central Sikh Museum

at the Golden Temple is the most prominent example of Sikh museology and is famous in particular for its explicit images of those killed in the 1984 attack on the site by the Indian Army (Chopra 2011). The museum has organized images of the Gurus and martyrs of the Sikh tradition into a linear narrative, followed chronologically moving forward through the space of the museum to a climax with images of those who died in Operation Bluestar and the Sikh militancy movement of the 1980s and 1990s. Earlier martyrs are portrayed in Western-style realistic narrative oil paintings that idealize both martyr and martyrdom: images of the scholar and Sikh leader Bhai Mani Singh being dismembered and of the ninth Guru, Tegh Bahadur, bravely facing a gruesome death. In contrast, photographs of those who died in the separatist movement narrate more recent history. Such an organization of the past around such images is common among museums of this type in India and takes a three-dimensional form at a gurdwara in Mediana, not far from Ludhiana, where historical paintings of Gurus and precolonial martyrs take larger-than-life and vivid three-dimensional form at a major historical gurdwara on Guru Gobind Singh Marg, dedicated to the tenth Guru (Guru Gobind Singh Marg n.d.: 52).

Not only martyrs are portrayed in these types of gurdwara museums, however. The recently built museum associated with Sis Ganj, a major historical gurdwara in Delhi, for example, features other elements that constitute the Sikh gurdwara museological narrative. Prominent among the approximately 200 paintings on display are portraits of individuals, particularly the Sikh Gurus, but also other famous Sikhs and others: Baba Budha Ji and Sain Mian Mir, for example. Portraits of acts of service by model Sikhs are prominent, as are group acts of service, such as the de-silting of the Golden Temple pool. Also common are portraits of great heroes, including important Indian nationalist heroes from the early twentieth century and more recently: Sikhs in the Indian Army are portrayed in the 1971 war, for example. A sign near the entrance describes and delineated the purpose and function of such images in 2002:

> The Sikh religious principles and practice permit the painting of portraits of the Gurus and depicting the events concerning Sikh history in paintings. But the garlanding of the portraits of the Gurus, offering worship of touching the feet of the Guru as shown in the paintings is not allowed. Every Sikh should avoid doing so. To indulge in such practices is to go against the basic tenets of Sikhism.

The form and content of historical paintings is generally consistent in gurdwara museums from one to the next, and images are constantly being produced that adhere to the stylistic norms of the genre. Amolak Singh, for example, was the "Creative Artist" and curator of the Sis Ganj Museum in 2002 (Singh 2002). He estimated at that time that he had created a quarter of the paintings in the museum, the remainder having been donated by the Punjab Sindh Bank, which sponsored their production for its annual calendar. Gifts are also commonly given to the museum, but objects qualifying as actual "relics," or historical objects related to the Gurus' lives, are kept within the Sis Ganj Gurdwara itself, rather than in the museum. This is not always the

case; objects that might be called relics are housed at the Central Sikh Museum in Amritsar. Several relic objects were on display at that museum in 2006, such as a kartar of Guru Hargobind, the sword carrier of Guru Gobind Singh; and the comb, chakkars, and kartar of Baba Deep Singh.

The gurdwara museum thus represents a type, but instances of the type are not univocal, even within themselves; Indian nationalist heroes are shown in the same museum as heroes of the Sikh movement for an independent state, separate from India. Lou Fenech has observed this multivalency as well, in his discussion of the representation of Udham Singh: "Most scholars who observe Sikh religious-nationalism," he notes, "tend to reify this phenomenon in the same way that Sikh identity is reified, and thus ascribe to it a severe rigidity which is simply not borne out by much of the evidence at our disposal. The memorialization of Udham Singh ... provides a working example of this point" (2002: 84). What museum sites do focus on, as a group, are important figures and events that feature in narrations of the Sikh past, complete with the contestation and contradictions inherent in that narrative. This museum type is thus different in content and orientation from the "Western" or Western-style museum, but we cannot accept that designation as anything but convenient: "Western" museology guides the National Museum in Delhi, and gurdwara museology is found in "the West" as well.

Thus, at the same time that the museum constitutes a colonial form of knowledge, contemporary uses of the museum form exceed colonial foundations as a particularly modern and postcolonial form of representation, one that is being configured today in relation to a broader commemorative imperative within a larger field, both in specific, communitarian terms and in global ones. Sikh museology demonstrates this; Sikhs have been very active in self-representation not only in so-called "mainstream" museums, but also in the construction of both heritage centers and local museums, and the "gurdwara museum." Such Sikh cultural work is in keeping with broader transformations; the museum form is used today for a wide range of memorial and representative practices that go beyond its imperial underpinnings. Sikh postcolonial uses of the museum form represent an appropriation of this "public" aspect of the museum, in which a diverse public seeks a voice in, and, in some cases, control of, a powerful and elite tool of representation of the past, empowered by notions of "multiculturalism" and "pluralism" in the modern nation-state (Simpson 1996: ch. 4–6). These narrations take place within larger multicultural narratives that are quite distinctive in different locations, given differing notions of ethnicity, identity, and representation. In North America, the museological context is mobilized for the representation of culture and ethnicity for both the majority community, which seeks to "include" minority cultures through representation in elite cultural institutions, and these deemed minority communities themselves, which seek access to—and, importantly, control of—these representational strategies.

The practice of display of the past and, through it, the production of a public for that display do not, however, exist only in the West and in relation to Western museological practice. Such practices formed a central logic in multiple modes in

precolonial South Asia in ways that do impinge on the relatively recent museum form and mirror preexisting practices that parallel aspects of it. This can be seen, for example, in the ways in which South Asian rulers and court members collected and displayed art objects, and in the ceremonial exchange and display of gifts and honors as a means of expressing authority, which was at the center of the performance of both political sovereignty and religious community formation (known as *khil'at*) in medieval and early modern South Asia (Murphy 2012). The categories of objects on display in these contexts do not map directly to the "cultural/anthropological" versus "religious" versus "art" categories that govern objects and their display in today's museum, but they do have an inner logic of their own that governs both the practices associated with display and the kinds of publics—and what they mean—that they produce.

Colonial and Postcolonial Contexts

We can see the complex ways in which prior practices meld with and also transform Western museological modes of display in the cultures of collecting and display that adhere today to Sikh historical objects related to the gurus and other important personages. We can call such objects "relics," suggesting their commonalities with the material traditions of other religions (Murphy 2012: ch. 2). These objects and their cultures of collection and display are deeply tied to the precolonial South Asian display practices I have alluded to and are simultaneously now deeply intertwined in modern national and transnational processes. In Sikh religious terms, such objects are revered for their relationship with the ten Sikh Gurus and other honored persons in the tradition and can be found in a number of forms; weapons are the most prominent form they take, but they also include texts, clothing, and other types of material culture. These objects have been used by the gurus and other important persons, or gifted by them, and function to represent aspects of the Sikh past. Yet, even when their core historical referents are consistent, these objects function differently in different settings, and the viewing/revering publics organized around them also change (Murphy 2012). They can in rare cases be kept in museums associated with gurdwaras, such as in the Central Sikh Museum in Amritsar, which holds several. More commonly they are kept within gurdwaras themselves (see Figure 7) or in private homes. They have indeed been excluded from the Khalsa Heritage Centre in India; their presence would have, in the words of Director George Jacob, turned the museum into a "shrine" (2011). Pardeep Nagra of the Sikh Historical Museum of Canada agreed that the inclusion of such objects in his institution would be problematic in religious terms (2014).

We can see changing power and cultural relations within a transnational cultural economy in the ways that objects such as these operate in the public realm. One example of the complex precolonial and postcolonial lives of such objects is a set of weapons belonging to the tenth Guru, which was in the imperial collection of the independent state founded by Maharaja Ranjit Singh centered at Lahore (Murphy

2009). In 1849, when the East India Company annexed the Lahore state and the imperial treasury came into British hands, then governor general Dalhousie advised the board of directors of the East India Company that "it would not be politic … to permit any Sikh institution to obtain possession … of these sacred and warlike symbols of a warlike faith." The objects thereafter became part of his private collection and remained in the United Kingdom until they were sought by the Indian High Commission for return to India in 1966. This coincided with the movement for the establishment of a Punjabi-language state in India. After their repatriation, the guru's objects were brought on a full tour of Punjab and then installed in the central sanctum of the Takhat Keshgarh Sahib, located in Anandpur Punjab, where they are revered (see Figure 8). The objects thus inscribed the boundaries of the new Punjabi state with their journey around it. Parallel to this was the establishment of the Guru Gobind Singh Marg or road in Punjab in this same period, demonstrating how the story of the objects is fundamentally linked to that of place (Guru Gobind Singh Marg n.d.). The Marg weaves its way from central Punjab, the Majha region, to the Malwa region, tracing the route of the tenth and final living Sikh Guru, Guru Gobind Singh, from Anandpur Sahib

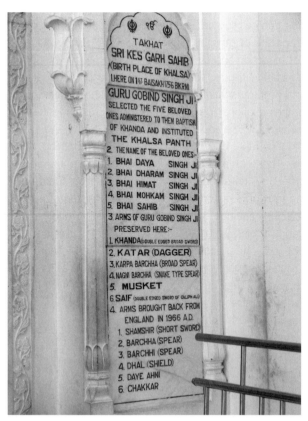

Figure 8 This plaque outside Takhat Kesgarh Sahib in Anandpur describes the objects that were repatriated from the United Kingdom.

to Talwandi Sabo. The road was initiated in the late 1960s under the chief ministership of Zail Singh, a part of an effort (according to historian J. S. Grewal) on the chief minister's part to "demonstrate that he was a better Sikh that the best of the Akalis," despite his commitment to land reform that challenged the hegemony of powerful Jat landowners (1990: 213). The places the guru visited during this journey were marked and major historical gurdwaras built to commemorate where the Guru stayed; five-petaled pillars were placed along the route, with five plates featuring inscriptions from the guru in Punjabi, Hindi, Urdu, and English; and, on the fifth, a description of the place being memorialized (Guru Gobind Singh Marg n.d.: 91 ff.). All this was done for a road that, in the words of historian J. S. Grewal, combined "a large measure of fiction with convenience and utility" (1990: 213). Newspaper coverage of events focused on the assertion of then-current debates regarding a nascent separatist movement and concern over "national integration"; On April 13, 1973, the *Tribune* noted: "Replying to a question by reporters about the Akali Dal stand on the formation of a Sikh homeland, Mr. Tur and Mr. Badal remarked that 'all of us are Indians first'."

The historical gurdwara is indeed linked to the historical object in relation to the category of the *itihasik*, the historical. Both are revered as memorial technologies, allowing for the recuperation of the experience and memory of the guru and the integration of that memory into a history of the community. That history, in the end, is a form of collecting practice, and it is one that both encompasses and exceeds the historical imaginary of Western historiography and museological practice (Murphy 2012). These relics are objects related to the Guru—central to the definition of a Sikh relic—but the valences associated with them were also national and regional, in sometimes competing, sometimes complementary dimensions. They bear a complex relationship with the landscape of the Sikh past. Narratives of loss and recovery are common to such objects and play into complex political relationships. And they continue to do so. More recently, one of the items prized by the maharaja, the kalgi or turban ornament of the tenth Guru, which has been sought multiple times in the past, is said to have been found and returned to India, although the claim is controversial (Murphy 2010).

Punjabi Locations

The museum mimics, but is distinct from, earlier representational practices in the form of the collection of objects; museums continue in complex intersection today. The Bhais of Bagrian hold a special position in Sikh religious and political circles; they are responsible for the execution of all Sikh religious offices for the state of Patiala (Singh and Singh 2012). They hold this honor as guardians of the *langar* or communal meal housed at Bagrian, which was mandated by the Guru and maintained by the family for centuries (see Figure 48 website). The house of Patiala and other former princely states of eastern Punjab are called the "Phulkiaan" states, named for their descent from a common patriarch named Phul. The family was converted to Sikhism at the intercession of Bhai Rup Chand (a follower of the

Sixth Guru, Guru Hargobind), who influenced the sons of Phul; both the Bagrian house and the family in Bhai Rupa (to which we will return) are descended from Bhai Rup Chand (Dhavan 2011; Griffin 1865, 1970 [1873]; Murphy 2012; Singh 1993: 288 ff.). Narratives of the ancestral founders of these states, the sons of Phul, are organized around the devotion of the family to the Guru and his explicit granting of the resulting right of sovereignty to them. The settlement of land and the transition of formerly pastoral people to agriculture accompanied the conversion to Sikhism, so the strong association of authority and control of land and devotion to the Guru is not surprising; it reflects the broader pattern by which land was settled across the north in the sixteenth and following centuries, as described by Thomas Metcalfe (1979), and the general process whereby Jats entered the Sikh community (Habib 1976). The rule of the Phul family was thus guaranteed and legitimized through a relationship with the guru; A *hukamnama*, or order, of the guru to the family that attests to this relationship is kept in the main gurdwara of the royal family of Patiala, and objects belonging to the Guru that were gifted to the family are periodically displayed (Singh 1999: 121–4). Although such elements are clearly directly related to the building of sovereignty, the establishment and substantiation of relationships with the Guru through object and place do not necessarily translate to the foundation of a state but to different types of influence and power. We can see this with the Bagrian collection; the family maintains the *langar* that they were mandated to hold, and the maintenance of this tradition works alongside the collection of objects the family holds, which substantiate their role and their relationship with the Guru (see Figure 49 website).

The family of Buta Singh in Bhai Rupa in the Bhatinda area also holds a collection that attests to their lineage to Rup Chand. The family of Bhai Boota Singh, the current head, tends the objects gifted to them, displays them to devotees, and manages the annual *mela* (festival) that is held every year at the site to commemorate the founding of the village on the fifteenth of the month of Vaisakhi. The most prominent of the Bhai Rupa objects is a chariot (*rath*) kept in a house in the center of the village (see Figure 50 website). Devotees who visit ask for gifts of grace, especially for offspring, before the rath. As is common in Malwa, many leave neem leaves in thanks when their wish is granted, in keeping with the general use of neem for auspicious occasions as well as for purity. Remaining objects are kept locked in the family house (see Figure 9). Pilgrims come for *darshan* (viewing) of the family's handwritten manuscript and other objects as well as of the rath.

In addition to housing objects related to the Gurus, the village of Bhai Rupa itself encompasses and displays Sikh historical memory. The old *mitthi* (clay) house of Bhai Rup Chand and associated with the sixth Guru is located within the village, a short distance from the location of the rath, along a lane behind the rath house. This is the house where *langar* was made for the sixth Guru and where he stayed for six months. It is not generally kept open, as the building housing the rath is, but is opened only for occasional viewing. The wooden stake associated with the founding of the village by Bhai Rup Chand and Guru Hargobind is preserved in the side wall of the house

however, and does remain viewable through doors from both the outside and inside; as such, it is an object for public consumption. Although the family indicated that there is no special day reserved for devotion to the rath and other objects, the annual mela for the village in the middle of the month of Vaisakh focuses on the rath and the family primarily, and other objects are also displayed for viewing. The mela commemorates the day the sixth Guru participated in the founding of the village.

These objects are celebrated not only locally, within the village of Bhai Rupa, but also more broadly. The objects have taken part, for example, in the temporary museum set up at Keshgarh Sahib, the Takhat at Anandpur, which commemorates the founding of the Khalsa, at the time of the 300th anniversary of the Khalsa in 1999–2000; some of the objects were included in the 2004 remembrance of the 300th anniversary of the martyrdom of the sons of Guru Gobind Singh at Fatehgarh Sahib Gurdwara. They also visited the cities of Vancouver and Surrey, BC, several times, in 2008, 2010, and 2014; and they were also on display in the Gurdwara Sahib Dasmesh Darbar in Surrey in 2008 and 2010, as will be discussed below.

North American Travels

Relic objects are thus found in a range of contexts—royal, regional, and familial—and have been museologized in multiple ways. They also, as we have seen, travel. As Carol Breckenridge has noted, it is now a commonplace that objects undergo a metamorphosis when they are collected; such changes are inherent to the changing nature of the object as a social formation (1989: 196). The Bhai Rupa objects were sent to California in 2000 for the 300th anniversary of the Khalsa, and they have subsequently traveled to Vancouver several times in the last decade (see Figures 51 and 52 website). These objects, or at least some of them, are therefore tied to transnational Sikh experience and history, in addition to being tied to the narration of the Sikh past in Punjab. In this context, they must be situated within the production of a very different public, not one focused as much on national versus regional concerns but one concerned first and foremost with cultural and religious articulation within a multicultural diasporic context. In this way, relics that travel demonstrate the way "things-in-motion" reflect their changing social and political context (Appadurai 1986: 6).

Fresno, a major city in the southern central valley of California with a long-standing Punjabi community, has witnessed two major "exhibitions" of relics (Leonard 1992; Murphy 2005). These exhibitions are distinct from the kinds of courtly objects displayed at the San Francisco Asian Art Museum and other elite institutions as emblematic of Sikh culture; here, exhibition takes place within an explicitly religious setting, with relic objects with historical importance directly tied to the Gurus. The Nanaksar Gurdwara, which was founded in 1984, hosted the objects. In the late 1990s, the gurdwara played host to the first such object, the Gangasagar, owned by the family of Rai Aziz Ullah Khan of Pakistan but resident in England; the vessel is said to hold liquid even though its metal body has been pierced, while sand passes

through it. Dr. S. S. Chahal, who initiated the visit, found out about the Gangasagar by watching a BBC program about it; he then contacted the family and over time arranged for its visit to Fresno. The pitcher was given to an ancestor of the current owner, Rai Kalaan, by the tenth Guru when the Guru was said to have taken refuge in the family home in 1704. The story is typical; as has been discussed, gifts between the Gurus and devotees established and maintained connections (Murphy 2012). The objects from Bhai Rupa, which were brought to Fresno in 2000, received a similar welcome.

Why are such relic objects important in diaspora? According to Dr. Chahal, a local doctor, anything that belonged to the Guru is precious. Whenever he visits Punjab, the doctor visits the historical places related to the Gurus. These objects, therefore, represent the opportunity to bring that Punjab-based history to the United States. This is what the doctor emphasized again and again: the importance of history and its representation through these relics. As Dr. Chahal put it, "Civilization is changing, in my opinion in the wrong direction." These objects and the opportunity to see and touch something belonging to the Guru may be, in his view, a means to fight that negative change. When asked about the display of Sikh historical and art objects at the San Francisco Asian Art Museum, Chahal noted that he had not been involved but knew of the work.

Diverse museological initiatives work in tandem: They produce a Sikh past for consumption by multiple audiences, focusing on the history of the religious tradition and its leaders through divergent but comingled practices of collection, valuation, and display. Relics are found in the gurdwara but not in the San Francisco Asian Art Museum, and a largely Sikh audience is intended in the prior venue; a more general audience is intended in the latter. The representation of the Sikh past is constructed in both. There is controversy associated with relics that travel; the Shiromani Gurdwara Prabhandak Committee (SGPC), which governs Sikh gurdwaras in Punjab and is both religiously and politically powerful, planned to reprimand and demand penance from Gursewak Singh Sodhi of Dhilwana Kalan village, in the Moga district of the Indian Punjab, for sending relics consisting of the clothes and turban of Guru Gobind Singh to Canada from a shrine there without its permission in 2003. The SGPC claimed that this had "really hurt" the sentiments of India's Sikh community: "These holy articles were secretly sent from India and exhibited in Canada to collect huge offerings of money and gold," SGPC official Jagjit Singh Brar told reporters. ("Indian Sikhs …" 2003). Control and the making of a public: these are the key issues in all displays, all museologies, all relic traditions.

Museuming and the Making of Sikh (and other) Publics

As Benedict Anderson has noted, "Museums, and the museumizing imagination, are both profoundly political" ([1983] 1991: 178). Relics and other objects that represent the Sikh past today involve national, transnational, counternational, and postcolonial forms of public making. The current transnational and diaspora interest in the relic

resonates with broader museological interests as well as with Sikh religious and communitarian/political interests. They reflect long-standing collecting and display traditions in Sikh and South Asian contexts and also respond specifically to the political demands of our time. Connections between Punjab and Sikh diaspora communities are maintained in multiple ways—through travel networks, transnational marriage patterns, political and social organizations, social service or philanthropic activities, and a vibrant exchange of religious personnel: *sants* (religious leaders or holy men of various types), *granthi* (textual specialists), *katha vachak* (specialist interpreters of the sacred text), and *ragi* or *ragi jatha* (musicians). Objects and other representational projects function alongside these other cultural formations and "flows," as Appadurai famously put it (1996), part of a larger "interocular" and cultural field of exchange.

Objects function to express authority, relationships, cultural heritage, and even different forms of sovereignty (and these are multivalent, today and in the past). The Sikh community has produced itself through the representation of the past, and different media of representation—in this case, the object and site—have acted to constitute the community in multiple and changing terms. Fundamental changes were introduced in the colonial period, which I have detailed elsewhere, drawing on long-standing commitments (Murphy 2012). In that period, a logic of representation shared between object and site in relation to the past partially broke down, and the two came to embody very different relationships to the writing of Sikh history. Objects came to lose some of their prominence as the drive for the articulation of Sikh territory prevailed, and the logic of the religious site vis-à-vis the state and the community articulated in the precolonial period changed. Objects thus came to be marginalized among representations of the Sikh past, and the Sikh historical landscape in territorialized terms is the material form that has dominated in the representation of the Sikh historical since the beginning of the twentieth century.

Yet, as we can see with the collections at Bagrian and at other sites like Bhai Rupa, material objects and sites do both continue today to contribute to the constitution of the Sikh community as technologies of memory and authority, referring to a kind of collecting practice through which the history of the community was written. The object and the gurdwara, in their continuing significance, can be seen to embody two alternative perspectives toward the past and present: a deterritorialized one and a territorialized one (Murphy 2012). These representational practices suggest compelling possibilities and intersections in the constitution of the Sikh community in transnational and national modes, partially through a "museumizing" imagination that reflects a colonial genealogy but cannot be limited to it. This hybrid and postcolonial museological imagination creatively engages with the museum as a form of colonial knowledge and provides for alternative forms of material representations. The operation of objects in a deterritorialized diasporic mode in the postcolonial period functions outside of the language of territory, and in a museological imaginary that exceeds a colonial genealogy and rewrites history as a collection, to be experienced by the viewer.

The museological form is today not what it used to be, and its colonial antecedents should not mask its diverse and resistant forms. In today's museum imaginary, Sikhs act as collectors, museum patrons, and museum creators and proprietors, actors creating what Saloni Mathur has called the "new nexus of entanglements between history, religion and heritage," and producing what she has described, with reference to the Khalsa Heritage Centre in Punjab, as the kind of "myriad emergent formations and cultural representations that we are likely to encounter in the future" (2007: 169). Culture, religion, and race have become powerful categories of articulation of Sikh interests in diaspora, alongside and sometimes exceeding the national and its limitations, as located in Punjab. But the latter do not disappear. Relics are sacred in a way most museum objects by definition no longer are, but like a museum object, they are on display, before a public, representing the past—and, of course, the present. A relic, therefore, is not just what it is, as an object, but what it does, and who it does this for. The same in the end is true of the museum.

Part 2 Exhibiting Buddhist Religious Objects in Museums

5 Planning the Robert H. N. Ho Family Foundation Gallery of Buddhist Sculpture, 2009–2014

JOHN CLARKE

This paper seeks to analyze, from a curatorial standpoint, the intellectual processes involved in the planning and development of a new gallery of Buddhist sculpture within the Victoria and Albert Museum (V&A). A particular focus will be the tensions, issues, and challenges arising from the location of a gallery dedicated to Buddhist art within an avowedly secular British national institution. This gallery is also highly unusual in having two distinct iterations. It first opened on April 29, 2009, but due to a major building project (the construction of a new museum-wide temporary exhibition gallery), it was subject to a planned closure in late 2013. The necessity for a new entrance associated with the new exhibition space meant that the projected reinstalled gallery was due to lose one room (Room 19) and would not be returned in its entirety to its former site (Rooms 17–20). Another room (Gallery 47f), close to the Japanese, Chinese, and Korean galleries but removed from the other rooms (17, 18, 20), was found to compensate for this loss (Figure 53 on website). As lead curator, I felt this situation both necessitated and offered a unique opportunity to rethink the intellectual and aesthetic structure of the entire gallery scheme. The several stages of the project therefore also chart the evolution of curatorial thought in relation to Buddhist art and its display over something like seven years. If one includes an earlier scheme, which was in the end not followed, three distinct gallery concepts were involved.

It was in 2007 that a run of four rooms (Rooms 17–20) became available on the western side of the ground floor surrounding the Madejski Garden. The movement out of these rooms of Renaissance art in preparation for a new Medieval and Renaissance Gallery, which formed part of the major redevelopment of the museum known as Futureplan, was the driver behind this. The space was offered to the Asian department, which made the decision to make Buddhism the overarching theme. The reason for this choice was that, due to its very widespread nature, the religion provided an opportunity to show some of the Asian department's finest sculptures, including several pieces then in storage, spanning virtually every country from India eastward to Japan. The new gallery was made possible by a generous grant of £1.5 million from the Robert H. N. Ho Family Foundation, a philanthropic organization devoted to promoting an understanding of Asian culture and Buddhism. This was the organization's first major museum project in the United Kingdom. Working with me on

the project as the curator for the Chinese material was Beth McKillop, then Keeper of the Asian Collections and now Deputy Director of the V&A.

I took over the project in late 2008 on the departure of John Guy (now Keeper of the Indian and Southeast Asian Collections at the Metropolitan Museum, New York). The original plan developed by him involved four regional geographical groupings of India, Sri Lanka and the Himalayas (Rooms 20 and 19), Southeast Asia (room 18), and East Asia (Room 17). These groupings were to be combined with the theme of the Buddha's four essential qualities, namely, compassion (Rooms 20 and 19), wisdom and protection (Room 18), and radiance (Room 17). One highlighted object in each section would carry this secondary theme.

One of the primary factors shaping both the initial plan outlined above and my subsequent schemes was the nature of the museum and its mission. The V&A was originally founded as the Museum of Manufactures in the aftermath of the Great Exhibition of 1851 as part of a government-led drive to improve the design quality of British manufacturing. It became the South Kensington Museum in 1857 and finally the Victoria and Albert Museum in 1899.[1] The remit of the museum from these times onward has been to inspire and inform designers and artists through its collections. The aesthetic qualities of objects and the stories they can tell about craftsmanship and craft techniques continue to be uppermost in the minds of the V&A's curators. It is these factors, for example, that continue to form the principal criteria for acquiring objects. The core of the museum's original holdings was made up of objects purchased to be used by the School of Design set up in 1837, together with pieces purchased from the Great Exhibition. To these were added the important early collection owned by the East India Company, which came to the then South Kensington Museum in 1879. The V&A's remit stands in contrast to its sister institution the British Museum, where the historical importance of an object is regarded as of more overall importance than its aesthetic qualities. Though the approaches are not mutually exclusive and the V&A's art and design perspective has certainly been tempered by the fact that more attention has recently been placed on the cultural significance of objects, the general distinction nevertheless remains true today. Naturally, therefore, this perspective formed an important aspect of the background to my thinking for the Ho Gallery scheme of 2009–13.

I felt that any narrative in a museum of art and design should seek to show the variety of artistic styles and evolving aesthetics as Buddhism moved from its Indian home eastward across Asia from the third century BCE onward. Geographical groupings were therefore important in giving visitors the "feel" of Buddhist art in each Asian area. At the same time it seemed self-evident that no one could understand Buddhist objects without the addition of a substantial element of religious interpretation. Clearly, objects had to be placed somehow in their religious as well as social and political contexts. It is in relation to this aspect that a museum such as the V&A or the British Museum has to act with circumspection and consciously, since, as they are secular and nonpolitical public spaces, care is taken to display objects without

promoting any particular religion or political cause. The reasons for this position are fairly self-evident: Public money is involved in funding such institutions, and this necessitates a neutral standpoint and one that is as objective as possible. Such a stance is mostly barely noticeable to the public but involves, for instance, using the third person when speaking about Buddhist doctrines in interpretive panels or labels; thus, these would read "Buddhists believe that one's actions determine future rebirths" rather than using syntax suggesting direct ownership of a truth, for example: "One's actions determine one's future rebirths." The latter statement would also imply that an objective truth was being conveyed on a level with the way a scientific truth is referred to in the modern world. Beyond simple interpretive devices such as this, however, there are many aspects of what might be termed "religious neutrality" that affect how displays are constructed and how a gallery space is used, and these will be addressed further into this discussion. As will also be seen, just where the dividing line between acceptable and unacceptable interpretation lies in respect to religions is not always obvious and clear cut.

Following the display approach of the adjacent English and European sculpture galleries (Galleries 21 and 21A), the Buddhist sculpture spaces used abundant natural light to show mainly large sculptural works in a spacious and airy environment. Building work and the removal of a mid-twentieth-century floor covering revealed the beauty of the original Victorian fabric, including a black and white mosaic floor. This was therefore a gallery of Buddhist sculpture and not of Buddhist art per se. Because of their light-sensitive nature, manuscripts and paintings could not be displayed. Despite the bias toward larger sculpture, shown in natural light and where possible displayed in the round and outside cases, some compromises had to be made in respect of the types of object shown. In particular, this applied to some of the museum's finest pieces of Burmese sculpture, including a shrine formerly in the royal palace in Mandalay, which were composed of wood and lacquer. Although these key objects were vulnerable to the effects of daylight, they were included despite the fact that the conditions were not ideal. However, two layers of ultraviolet film were added to the windows, and a blind system allowed for the exclusion of the most damaging direct sunlight.

Among the factors influencing the conceptual planning process were the results of an independently conducted audience focus group study carried out in early 2008 (Moussouri 2008). Four groups were formed with representatives of the three target audiences: two with Buddhist faith groups representing different Buddhist traditions and organizations, one with independent adults, and one with professionals in the creative industries.[2] In total, twenty-five people participated in the study. Participants were given an outline of the new proposed gallery and its main themes and were then asked to comment both on these and on what they would ideally like to see in a new Buddhist gallery. Not unexpectedly, of these it was Buddhists who had the most expectations and the strongest opinions. Buddhist groups believed that the story of the Buddha himself was of primary importance, with some even suggesting it should form the overarching theme for the entire gallery. The two other most mentioned

themes were Buddhism as practiced in different Asian cultures and the three Buddhist schools existing today (Moussouri 2008: 15).[3]

The restorative and affective nature of Buddhist sculpture was remarked on by many informants, and the Buddhists called for a contemplative space to be created within the gallery. They also felt that other valid approaches, which could well be combined, were the "experiential journey approach," possibly using the Buddha's life as the vehicle for this, and the thematic and aesthetic approaches (Moussouri 2008: 11–15). Though all the groups believed a geographical grouping of styles should not be the dominant narrative, all equally thought that two of the most interesting themes would be how Buddhism is practiced in different cultures and the different Buddhist schools. It appears that this apparent contradiction was the product of a partial explanation by the focus facilitators of the new scheme. Participants were told that the gallery was to be organized geographically (Moussouri 2008: 11), but it was not explained that a second strand, based on religious affiliation, would also be present. All participants believed that a strong unifying concept was essential as was the use of fewer, but aesthetically higher quality objects. Non-Buddhists said that in order for viewers to understand the works, the gallery should provide information on the historical and social context and on the role of sculpture and artists (Moussouri 2008: 26).

Everyone in the groups thought that more multisensory contextual material should be provided: sound, in the form of chanting or music; photography; and even smells such as incense, all of which would create an immersive atmosphere conducive to appreciating the objects. Several pointed to temples they had visited in Asia and some exhibitions in Western museums, including the Sacred Traditions Gallery in the Chester Beatty Gallery, Dublin, as examples of experiences that had "transported" them, enabling them to better understand Buddhist art works in context (Moussouri 2008: 16–17). The Buddhists also hoped that the new gallery could be used to build a sense of community and help explain their faith.

In making sense of the many suggestions arising from this consultancy exercise, it appeared important to remember that while Buddhists clearly constituted key stakeholders, in numerical terms they made up a very small percentage of the total audience. Though they provided many useful insights into how visitor engagement might be developed, it was clearly necessary to remember that these were strongly related to a pure faith perspective. They looked at Buddhist art as in reality what it is: an aid to worship and meditation, a means of creating merit, and an expression of doctrine. Buddhists could, of course, be forgiven for not having an understanding of the museum's position on faith matters. They would not immediately realize, for example, that the V&A is a museum of art and design first and foremost and maintains a position of "religious neutrality," an attempted objectivity that eschews any religious partiality or ownership.

There are signs, however, within the museum profession that the separation between the secular and religious is no longer quite as rigidly interpreted as it once was. An argument may be emerging that says that, as the responsibility of museums

is to provide cultural context for their objects, that would necessarily also include religion. In the last decade or so, a number of American institutions have used the staging of Buddhist rituals within their galleries to that end. An example is the Gardner Centre of Asian Art and Ideas at the Seattle Museum, which asked Shingon priests and Tibetan monks to reconsecrate several older works from their particular traditions. Accompanying programming, videos, and an interactive element meant that temporary rituals were integrated into long-term displays, and old objects were reunited with their living, present-day traditions. A more relaxed attitude toward the juxtaposition of the religious and secular was evident, with the separation between them no longer being so rigidly interpreted. Rituals have also recently been integrated into exhibitions on several occasions at the Rubin Museum in New York and at the Freer/Sackler Gallery in Washington.[4]

While the preceding examples were specific and related to particular exhibitions or objects, the demands for a "living" shrine room where prayers might be said seems to go beyond them in scope. There was even one suggestion that each of the rooms in the V&A Buddhist gallery should have its own shrine room from each respective tradition, where people might sit and meditate or pray (Moussouri 2008: 15). In a nonsecular institution, perhaps a Buddhist community museum, there would be much to be said for such an approach, which brings living Buddhism into each museum space. Several museums do indeed have shrines, notably the Tibetan shrines at the Newark Museum in New Jersey and the Sackler in Washington, DC. But these are "non-living" in the sense that activities such as meditation do not take place in them. Instead, they provide a purely visual context, rather than a fully ritual one. Thus, providing a shrine or meditation room where religious activities could take place in the V&A's new Buddhist gallery would prove problematic. Similar suggestions have in the past been rejected by the museum's senior management. A museum is not in the same category as, for example, an airport, where one usually finds a multifaith chapel.

Understandably, the Buddhist groups wanted displays to teach doctrines, for example, the core teachings of the Buddha or the use of Dharma and Samgha as a possible framework for object arrangements. Buddhists, in fact, wished to use the art of the faith to teach doctrines rather than have doctrines illuminate the meaning of what, for the museum, were primarily seen as art objects. It was also unclear how the gallery could be used to develop a sense of community without holding religious events in it or in association with it. Once the new gallery was in existence, there were surprisingly few actual requests to use it for meditation sessions. There were practical reasons why such sittings were not given permission; for example, the likelihood of restricting visitor flow through fairly small spaces that were already much used as conduits between parts of the museum. If groups had been allowed to use the gallery spaces out of hours, security and the need to employ attendant staff become a further issue. Beyond all this is the more basic issue that the museum is not a temple or consecrated space—a venue for religious activity—but a secular space with a remit to inspire,

educate, and entertain through its collections of art and design. There is of course no reason why individuals or even groups cannot use such a space for their own private meditation or devotion, provided it has no external manifestations that might impinge on others' use of the gallery.

The museum naturally welcomed the participation or attendance of Buddhists at ongoing gallery talks in the new spaces when open and at the free two-day symposium on Buddhist sculpture that was held in 2011 in the museum's lecture theater. It was evident that many did indeed attend these events. Though as a museum professional I considered Buddhist art as art and did not take a devotional standpoint, I nevertheless felt that the museum should accord respect to these pieces of sacred art. This was reflected in the gallery design; for example, all pieces were raised up on plinths in almost every case to waist level or above. This honors the traditional Buddhist desire to place sacred objects on as high a level as possible relative to oneself so as not to look down on them.

Returning to the suggestions made by the focus groups, it was clear that these were in many respects examples of "blue skies" thinking, unhindered by any perception of possible or actual limiting factors. Almost no scheme is in reality free from such parameters. The fact that the new gallery would be located along a major route to the café and formed an important artery within the museum meant that it could not form a true meditative space. Even if there had been a will to provide a shrine room, there was simply no space to do this or to provide a space for a stupa around which devotees could perform the rite of circumambulation (Skt. *pradakshina*), another suggestion that came out of the focus group study. The findings of the study were published (internally) in August 2008, by which time text hierarchies, positions, and content had already been largely fixed. Though there was therefore very limited potential for modifying the overall approach, it was felt that the adopted plans had already anticipated a number of the key suggestions.

On the question of contextual information, it is an internal design rule that there should be no photographs placed on gallery walls, and sound too is usually considered too intrusive in a permanent gallery situation. Contextual film, music, and speech are therefore delivered via audiovisual points linked to telephone receivers or via the museum's website. This situation is likely to change as more reliance gradually comes to be placed on Wi-fi handheld appliances, which allow the use of a full range of multimedia material. Another aspect of interpretation that is not fully understood by the typical visitor is that fairly strict guidelines issued by the Learning and Interpretation Department on word limits operate in relation to labels and introductory panels. In practice, the limits of sixty words for an average label and around 180 for an introductory panel mean that very careful choices have to be made about what is selected from all the possible interesting information relating to any given object.

All of the preceding therefore formed the background against and within which the gallery planning process took place.

Information Gathered from the Focus Groups

The 2009–13 scheme evolved independently of the earlier layouts but came to incorporate geographical groupings that were broadly similar to the first scheme, though they separated the Himalayan (Tibetan and Nepalese objects) from the earlier Indian and Sri Lankan ones. The themes of Buddha—compassion, wisdom, radiance, and protection—were dropped in favor of what, it was hoped, would be a clearer introduction to the three main Buddhist schools; that is , Theravada, Mahayana, and Vajrayana. This latter interpretive strand was to run alongside other information relating to geography and history.

Thus, two main interconnected interpretive themes ran throughout the rooms: the doctrines of the main Buddhist schools, and the historical background to the artistic styles for each region. The explanations of these approaches were presented on two separate introductory panels in each room, as combining them would have produced a far too lengthy text (Figure 10). As time and place were felt to be essential elements in understanding the images and their art styles, this historical and geographical panel was headlined and placed just inside each room to the left of each entrance. Each of these panels included a simple line-drawn map in white against a black background, matching the Corian® plinths of the object bases. The religious and doctrinal explanations were placed on the back wall of each room in the form of a white transfer text panel applied directly to the wall. Thus in Room 19, devoted to late Mahayana Buddhism in India and the transfer of the doctrines to the Himalayas, the two panels were "Buddhism's decline in India and expansion abroad" and "The Compassionate ideal: Mahayana the 'Great Way'" (Figure 54 on website). This room was the most text heavy of the four in having an extra doctrinal panel dealing with Tantric or Vajrayana Buddhism. The dual narrative was expanded by the presence of three short (three-minute) films shown in Room 19 and an interactive presentation in Room 18. All three films in Room 19 related to the Mahayana/Vajrayana world of India and Tibet and showed sculpture in relation to temple architecture, its original context in many instances. One gave glimpses of the rock-cut cave temple complexes of Ajanta, and another the late tenth/eleventh-century temple at Tabo in the Western Himalayas, renowned as housing an intact three-dimensional mandala of Mahavairocana. The third film showed contemporary religious practice in Ladakh (Jammu and Kashmir State, India). The interactive presentation introduced the language of Buddhist images; that is, the meaning of the most important gestures and postures (*mudras* and *asanas*) and the meaning of the symbolic attributes held by Buddhist deities and bodhisattvas.

As each room represented a region, movement through the spaces represented the journey of the faith from its Indian origins via land and sea routes to Southeast Asia, Central Asia and Tibet, and East Asia. The path through the gallery from Rooms 20 (India) to 17 (East Asia), it was hoped, would feel like a miniature journey through Asian art and Buddhist history. It started in Room 20, which was the notional entrance as it lay nearer to both the grand or main entrance and the Exhibition Road

(side) entrance to the museum. This first room was dedicated to Indian Buddhism from the first century CE to just after the end of the first millennium. The theme here was the life of the Buddha and the early sculptural styles of India, especially those of Mathura (northern India) and Gandhara (northwest India and Pakistan), both disputed locations for the first known Buddha images in anthropomorphic form. A classic-seated Mathuran sandstone Buddha of the third century and a Gandharan-seated Buddha of the third or fourth century represented these schools. A rare bronze standing Buddha Shakyamuni belonging to the Gupta tradition and dating to the late sixth century flanked the entrance to the next room together with a Gupta-inspired stucco head of the Buddha from Hadda in Afghanistan. The Gupta style, with its restrained and harmonious elegance, is often seen as the culmination and summation of earlier Indian styles, and these pieces thus formed a natural "bridge" to the pieces from the Pala Dynasty (the ninth to the twelfth centuries) in the next room. As mentioned above, this room (Room 19) displayed objects from the last phase of Buddhism in India (from the eleventh to the thirteenth centuries) and from Nepal and Tibet. This room contained several very beautiful cast-metal gilded images of bodhisattvas (Figure 11). Due to the lack of large-scale images of Tantric deities, it was necessary to introduce a case housing smaller Tibetan Tantric images here in order to be able to represent the Vajrayana tradition. Room 18 was devoted to mostly Theravada Buddhist works from Southeast Asia, with a predominance of Burmese objects, including the impressive shrine from the Mandalay Palace of circa 1850–70 (Figure 12). Finally, East Asia in Room 17 combined Chinese with two Japanese objects. Highlights here included a preaching Buddha and a large wall-mounted head of the Buddha from the cave temple complex of Xiangtangshan in southern Hebei Province dating to the sixth century CE.

As has already been discussed, contextual photographs, whether large or small, are not placed in galleries and such material is delivered via audiovisual points or the museum's website. It was, however, possible to include other types of contextual material in the form of oil paintings and plaster casts. Rooms 20 and 19 both contained a nineteenth-century oil painting copying the sixth-century CE murals in the Ajanta caves in Maharashtra State. These were two of 165 copies made between 1872 and 1885 by Major John Griffiths (1837–1918), head teacher of painting at the Bombay School of Art, and his most talented Indian pupils (Figure 10). They are important in their own right as they record details since lost in the original works. In room 19, an equivalent was provided by two life-sized tinted plaster copies of reliefs from the terraces of the temple at Borobudur in Java, the originals dating to the period 760–830 CE and the copies made by the Troppen Museum (Tropical Museum) in Amsterdam in 1900.[5]

As Lead Curator, I felt that the gallery had to display the finest examples of Buddhist sculpture available in our collections. Finest in this context meant the finest aesthetically. For this reason, several damaged works were excluded from the final selection. I considered that the beauty of objects and their careful juxtaposition was a key element in creating an aesthetic impact. The aim was that through this beauty

and a harmonious placement, visitors would experience an aesthetic emotion that might make a deep impact, inspiring them to find out more about the objects and Buddhism itself. With space very limited, each object also had to "justify itself" for inclusion. This meant that each object was significant as an example of a type of sculpture or a stylistic school. Aesthetic and historical juxtapositions were crucial, and every piece was placed carefully in a "conversation" with its neighbors. Thus in Room 19, an eleventh-century stone Indian representation of Tara and another of the goddess Purneshvari were placed close to a Nepalese gem-set gilded metal image of White Tara of the sixteenth century.

After the opening on April 29, 2009, the gallery was positively reviewed in a number of British mainstream newspapers, in the *Asian Art Newspaper*, and in relevant online pages. Visitor comments were also consistently positive. The gallery was closed in November 2013.

The 2014–17 Scheme

Planning for the second Ho Gallery of Buddhist Art began in early 2014, with the first part of the new scheme, consisting of Gallery 47f, due to open in early August 2015. The question that might be asked here is whether any new understandings had begun to alter the way I thought Buddhist sculpture should be displayed during the years between the development of the first gallery and this new phase. As mentioned, the findings of the focus groups arrived effectively too late to be integrated into the first plan, though many had, in any case, already been anticipated. Nevertheless, several key unacted-on points remained in my mind. In particular, I began to feel that the religious doctrines of Buddhism and its schools should become the main overall framework for understanding Buddhist works, and that this could form a link to the living faith. I felt this approach might lead to a better public engagement with the art, while artistic styles and historical information could be linked to it. The new scheme would therefore allow for a rebalancing between the religious and doctrinal elements and the art-historical and stylistic aspects. The Ho Foundation also played a part in both reinforcing this idea and in introducing new perspectives that would affect the planning process.

The Foundation convened a two-day weekend workshop in Washington, DC, on October 5 and 6, 2013, bringing together museum professionals, curators, conservators, designers, and Buddhist practitioners in order to enable an extended, informal discussion on the issues, challenges, and opportunities emerging from presenting Buddhist art in the twenty-first century. The workshop was deliberately designed to be cross disciplinary and to encourage professionals to think outside their usual academic frameworks, and one of the central discussion themes was how museum curators and educators might help Buddhist objects come alive in museums. Though the discussions were far too wide ranging and extensive for any attempt at even a brief survey of them to be made here, a number of points I considered to be key emerged.

There was a consensus that the emotional power of Buddhist art was of paramount importance in engaging viewers, and that crowded displays and didactic panels often got in the way of this. How could displays be rethought to overcome these limitations? Echoing the V&A's own focus group exercise, participants at the Ho weekend workshop talked about how sacred spaces provide a much stronger environment for experiencing Buddhist art. Can museum professionals therefore learn from such settings, for example, in the use of dramatic lighting, an isolation of a focal piece, and in creating an immersive temple-like environment?

An interesting example of the recreation of an immersive religious environment in a museum was provided by a presentation on the Alice Kandell Tibetan shrine, acquired in 2011 by the Freer/Sackler Gallery. This powerful ensemble of 224 separate ritual objects and scroll paintings re-creates the complete shrine of a Tibetan nobleman in about 1900. Arranged in a traditional small shrine-room setting with low-volume chanting played as a background, it contains very little interpretation. Both the press reviews and visitor surveys were positive about the shrine's transportive power and its ability to engage an audience. As already mentioned, it also became clear that a number of museums were becoming more open toward Buddhist teachings and rituals in a museum setting. The transportive environment with its power to move is also related in aesthetic terms to the category of the power of the masterwork. One participant touched on research conducted at the Freer/Sackler that suggested museum visitors responded most positively to three main factors; First, visitors were engaged by big ideas, and secondly responded to personal stories linked to objects, which gave them a human dimension. Thirdly, people were moved and inspired by objects that were masterworks of the highest quality.[7]

These stimulating discussions served to reinforce my desire to create a completely fresh narrative and new object juxtapositions that would place religious meanings at the center of displays, while at the same time allowing those meanings to be related to art and style. Though it would not be possible to create a contextual immersive religious environment, there was a determination to arrange powerful aesthetic combinations and to use light and space to create drama and underscore importance and meaning. As ever, the physical spaces themselves, and additionally the separation of two of the rooms from the rest, created an extra challenge to those aims. All these factors therefore entered into the renewed planning process. As has been mentioned, one new space was to be provided adjacent to the Tsui Gallery of Chinese art, the Toshiba Gallery of Japanese art, and the Samsung Gallery of Korean art. This would be separated both by these galleries and the European sculpture galleries from the run of other rooms—20, 18, and 17 (Figure 53 on website)—and would thus be at some distance from them. With a new entrance created from the Madejski Garden to the newly created Lafitte Courtyard in what had been Room 19, Room 20 was effectively now separated from Rooms 18 and 17, though by only a fairly small distance. It appeared evident to me that any new scheme therefore had to assume that each room stood alone thematically, though equally they all had also to form a coherent intellectual whole.

A further complication centered on the fact that the rooms adjacent to the new entrance between courtyards was planned to be brightly lit and blind free. This meant that the light-sensitive wood and lacquer objects that had before been displayed in Room 18 (with blinds partially drawn) could no longer be housed there. The new Gallery 47f space was lit by diffused daylight at lower levels and was thus much more appropriate for these works. This meant that works from Southeast Asia, mostly from Burma, would need to be placed there.

At an earlier planning stage, I had thought in terms of retaining a broadly geographical grouping while creating new primary interpretation panels featuring mainly the religious doctrines relating to the objects in each room. However after long thought, it occurred to me that both clarity of concept and visual clarity would be enhanced by abandoning rigid geographical groupings and instead placing similar types of images together. Such groupings would also closely relate to Buddhist schools, making interpretation clearer from a visitor's viewpoint.

Therefore, 47f, instead of containing East Asian and Southeast Asian objects, would become a gallery devoted to the Buddha image itself and would additionally contain Indian objects. In this new grouping, it would be possible to tell several important and interrelated stories. Along the south wall would be arranged key examples of the Indian Buddha in its two primary forms, seated in meditation (Skt. *dhyanasana*) and standing offering protection (Skt. *abhaya mudra*), dating from the second century up until the eleventh century CE. This wall grouping could therefore show the evolution of the images in India during these centuries. These two icons were diffused at the same time as doctrines throughout Southeast and East Asia during the first millennium. The rest of the room would show this diffusion and chart the styles of those two regions through its Buddha images. Geographical groupings were to be retained to a certain extent, with roughly one half of the room featuring East Asian works and the other Southeast Asian. This would continue to allow an overall sense of regional style to be experienced by visitors. As the room is less brightly lit, it would now be possible to hang two Thai temple banners in existing wall vitrines. One shows the Buddha flanked by his two disciples the other the Buddha descending from the Heaven of Indra after preaching to his mother there. Some interesting new juxtapositions could now also be made. In particular, a seated Buddha from Mirphur Khas in Pakistan from the sixth century could be placed next to a seated Buddha of the same date from Xiangtangshan in Hebei Province. The two images share several stylistic elements, with the figure, face, and halo of both being closely comparable. They thus dramatically show the influence of Indian styles on Chinese Buddhist imagery in the northern Qi period as Buddhist teachings were carried by merchants and monks via the central Asian trade routes.

It was decided that the fluidity of the layout, together with the fact that visitors could possibly enter from any of four entrances, made the use of several interpretation panels problematic. Key information on groupings and themes trusted to such panels might easily be missed by visitors. Recent studies of visitor's behavior support this, suggesting that visitors to free galleries tend to go from one object to another

somewhat at random and do not read every panel. One study carried out by the British Museum in 2009, for example (Edwards, Francis and Slack 2011), found a significant difference in the behavior of visitors to temporary paying exhibitions and to permanent galleries. Around 70 percent of visitors to charging exhibitions reported that they wished to follow the themes and read the text panels as they went. Only 16 percent reported that they browsed the exhibition, stopping at whichever object caught their eye. By contrast, observation carried out in seven of the free permanent British Museum galleries revealed that visitors took a more object-centered approach, browsing freely, spending an average of only three minutes in each gallery, and stopping at three to seven pieces. Seventy percent of visitors browsed and introductory panels were largely ignored (Edwards, Francis and Slack 2011: 154–6). This research, brought to my attention by colleagues in the Learning and Interpretation Department, swayed my opinion in favor of placing thematic information on individual object labels and abolishing a hierarchy of introductory panels, each introducing an easily missed "big idea." One single introductory panel would be retained for each room.

A brief overview of the new layout starts as before at Room 20, now separated from Rooms 17 and 18 (Figure 53 on website). The space would experience a heavy footfall of people entering from three main museum entrances, including the new one from the freshly created Lafitte Courtyard. The main theme here, therefore, had to be clear and simple and to stand alone. The life of the historical Buddha Shakyamuni as revealed in icons and reliefs appeared to be ideal. Closely linked to that is the theme of pilgrimage to the places of his life, a central Buddhist religious activity from the earliest times to today. The new plan also involved moving into this space associated objects, such as a first-century CE pillar from the first stone railing around the Bodhi tree at Bodhgaya and Buddhist relics displayed in Gallery 47b (in 2014). Across the new entrance (former Room 19) from this area is Room 18. Here I would place together bodhisattvas, goddesses, and guardians relating to Mahayana doctrines from all Asian areas. Though the geographical element would be weaker here, there would still be a group of Indian and Nepalese objects together near the entrance from Room 19, thereby forming a stylistic link to the Indian objects in Room 20. This new arrangement, however, would strongly represent the widespread nature of Mahayana doctrines and the bodhisattva ideal at its heart with pieces from India, Nepal, Japan, Java, and China. The adjacent Room 17 would contain Tantric images and the wrathful guardians of Vajrayana Buddhism, mainly from Tibet and Nepal. However, there would also be a Japanese guardian Fudo Myo O included to jolt people's normal association of Tantra solely with Tibet and/or India. An Indian stone Mahakala or guardian of the doctrines would underline Tantra's Indian origins. A new juxtaposition here would be the placing together of a large gilded copper Bhairava head with gaping mouth from Nepal with the similarly featured Indian stone depiction of Mahakala. The angry faces of both with similar fangs, hair composed of flames, and adornment of snakes again graphically shows the interrelationship of Buddhism and Hinduism in Nepal and the borrowing by Buddhism of features of the young form of Shiva (Bhairava) for its Mahakala image. It seemed important to have displays

reflect in some way this type of cross-religious discourse and help break up the popular idea of a pure Buddhism as something completely separate from Hinduism.[8]

In these rooms too, the decision was made early on to place more thematic information on labels rather than on interpretive panels as in the old layouts. The future of interpretation and its ability to convey the multiple and many layered stories relating to Buddhist art appeared also to lie much more with Wi-fi and handheld devices than with static panels or even labels. Prototype tours created for the new V&A Europe 1600–1800 Primary Galleries showed how thematic tours or trails could be created even without developing a specific Ho Gallery application. These could lead a visitor through and between separated rooms focusing on one or more themes. By this means the more in-depth contextual interpretation really needed to explain Buddhist art could be delivered effectively. It is here that contextual music, chanting, and film clips showing how art is created and how images are worshipped could be made available. Other themes that can only be briefly touched on in labels and panels include the artists and their patrons and the nature of the icon itself, including its relationship to any indwelling numinous power.

Although this aspect was seen as a vital development for the near- and medium-term future, it also seemed important to continue to have other contextual information available in the rooms themselves. The interactive element produced for the first Ho Gallery, which explains the language of Buddhist sculpture in terms of postures, gestures, and symbols displayed by the images, would be made available in several of the rooms. It would also be necessary to create new short films that would show the relationship of sculpture and painting to temple architectures and give a glimpse of living Buddhism, as with the first gallery.

This then, at the time of writing (August 2014), is the conceptual plan for the new Ho Family Foundation Gallery of Buddhist Art (expanded from a purely sculptural display by the presence of two paintings). It is hoped that this chapter helps to reveal the complex nature of gallery planning in a major museum and the issues and challenges raised by the presence of sacred art in an evolving secular space. As Buddhism is one of the fastest growing religions in the West, a curator must plan for increasing expectations from its followers, which need to be balanced against the needs of a majority audience that remains largely ignorant of its tenets.

6 Entering the Virtual Mandala: Transformative Environments in Hybrid Spaces

JEFF DURHAM

The Asian Art Museum of San Francisco conserves a wide variety of art associated with the imagery of mandalas, which are geometric maps of Buddhist visionary worlds. Formally, mandalas usually consist of a series of nested squares and circles; these elements provide a "pavilion" (*manda*) that houses a particular "essence" (*la*) of enlightened awareness (*bodhi*) (Leidy and Thurman 1997: 17). Functionally, mandalas simultaneously reflect and guide meditative experience, such that the physical creation and meditative visualization of artwork becomes an integral part of the contemplative tradition.

Mandalas are especially prominent in cultures influenced by the system of ritual, philosophy, and meditation known as the Vajrayana, the Lightning or Diamond Vehicle of Buddhism. Artists from India and Tibet to China, Japan, and Southeast Asia all created Vajrayana mandalas, from two-dimensional paintings and three-dimensional sculptures to large-scale architectural constructions. Whatever its precise artistic expression, however, the geometric form of the mandala performs a critical, cosmological function: it defines the center of the cosmos and its four symbolic directions. As with many similar cosmological schemata across traditions, each region is color-coded and associated with specific sets of related divinities. Mandala geometry might therefore be described as transformative in the sense that its symbolism transforms any area into a mandala and in so doing marks that location as the center of the cosmos.

The exhibition *Enter the Mandala* at the Asian Art Museum of San Francisco has been designed to allow museum visitors to explore the visionary worlds of Vajrayana mandalas in depth and in context. To make such an exploration possible, we have installed within our gallery space traditional artworks that were originally created to comprise a mandala. When these artworks are installed according to traditional directional schemata, our gallery takes on the form of a virtual mandala that visitors can physically enter. The result is an immersive exhibition in the museum environment of a corpus of art that was also intended to be immersive in its original environment—an exercise in cross-contextual communication that might just give visitors a glimpse into the worlds of experience that mandalas project and reflect (Figure 13).

Figure 1 Decorated Somaskanda (Sundareshvara), Avani Mula Festival, Minakshi-Sundareshvara Temple, Madurai, India.

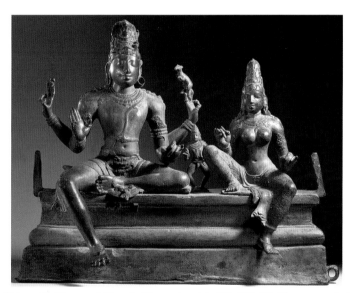

Figure 2 Shiva with Uma and Skanda (Somaskanda), 950–975 CE, Sivapuram, India. Norton Simon Museum.

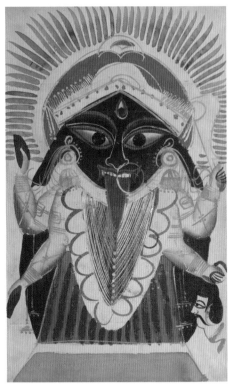

Figure 3 The signature object for the CMA exhibition, a replica of the image worshipped inside the Kalighat temple. *The Goddess Kali*, 1800s. India, Calcutta, Kalighat painting, nineteenth century. Black ink, watercolor, and tin paint on paper; 45.9 × 28.0 cm.

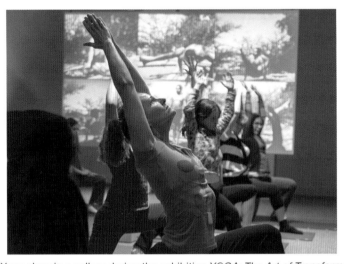

Figure 4 Yoga class in a gallery during the exhibition *YOGA: The Art of Transformation*, with a 1938 film featuring Krishnamacharya and Iyengar in the background. Sackler Gallery.

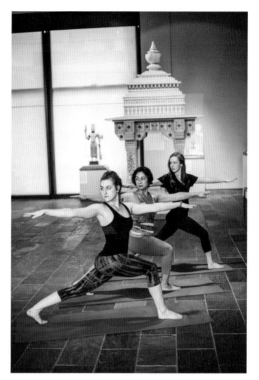

Figure 5 Yoga in the South and Southeast Asia Gallery, with a seventh-century Vishnu statue in the background. Crow Collection of Asian Art.

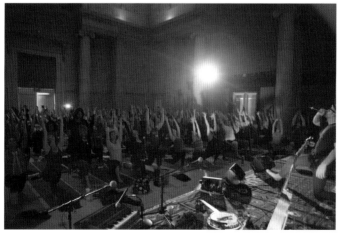

Figure 6 MC Yogi performing at *YOGA: The Art of Transformation* opening party, 2014, Asian Art Museum, San Francisco.

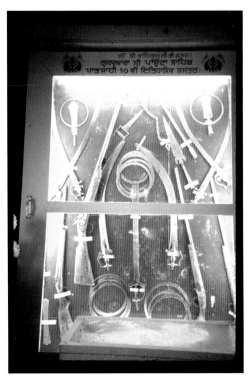

Figure 7 Historical weapons at Paonta Sahib Gurdwara.

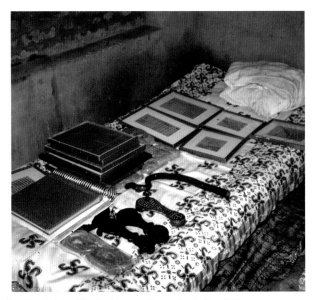

Figure 9 The family of Buta Singh displays the objects for visitors.

Figure 10 Room 20, "India," showing black introductory panel to whole gallery (left nearest) and introduction to life of the Buddha (black panel left furthest). To right of central opening, religious theme panel in white letters printed directly on the wall. Victoria & Albert Museum.

Figure 11 General view of Room 19 (India and Himalayas) showing Tibetan Buddha and Nepalese Tara figures. Victoria & Albert Museum.

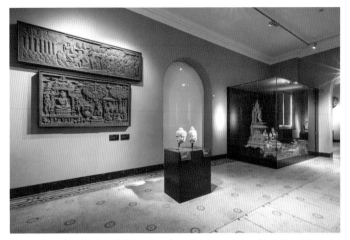

Figure 12 Room 18, "Southeast Asia," showing plaster casts of reliefs at Borobudur and Buddha's shrine from the Mandalay Palace. Victoria & Albert Museum.

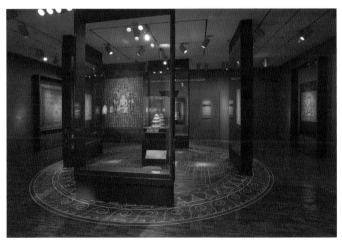

Figure 13 *Enter the Mandala* exhibition gallery. Asian Art Museum, San Francisco.

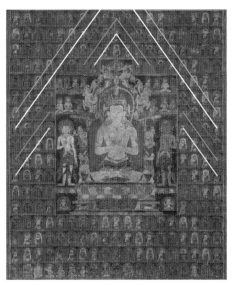

Figure 14 The cosmic Buddha Vairochana, approx. 1300; Tibet; Colors on cotton. The multicolored lines constitute a "pointed shrine" (*kutagara*) made from the colors attributed to the Five Buddhas. Screen shot from Asian Art Museum interactive display. Asian Art Museum, San Francisco.

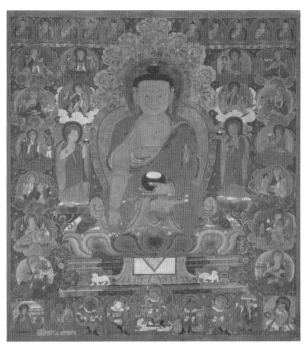

Figure 15 *Shakyamuni Touches the Earth. The Buddha Shakyamuni with Sixteen Buddhist Arhats*, 1600–1700; Tibet. Colors on cotton. Asian Art Museum, San Francisco.

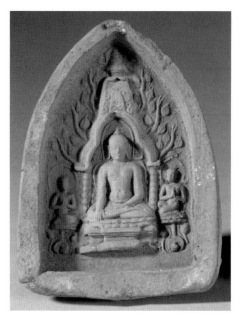

Figure 16 Burmese Mahabodhi Plaque. Votive tablet with seated Buddha flanked by kneeling worshippers, approx. 1100; Myanmar. Terra-cotta. Asian Art Museum, San Francisco.

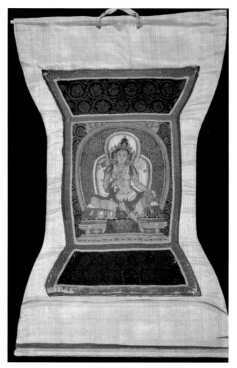

Figure 18 The Buddhist deity Green Tara, 1200–1300; Tangut empire, China. Slit-silk tapestry (*kesi*). Asian Art Museum, San Francisco.

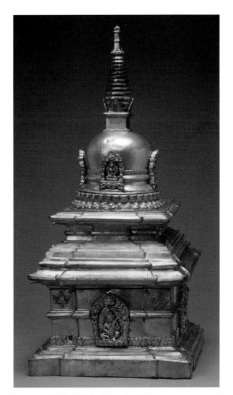

Figure 19 Svayambhu Stupa, 1700–1800; Nepal. Gilded copper. Asian Art Museum, San Francisco.

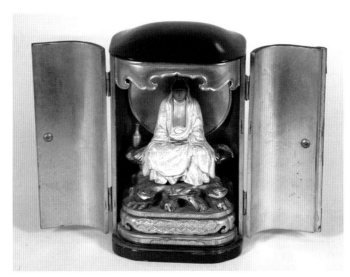

Figure 22 Portable shrine with Bodhisattva Avalokiteshvara in Water-Moon manifestation (Japanese: Byakue Kannon). Japan, Edo period (1615–1868), nineteenth century. H. 7½ in. (19.1 cm). The Metropolitan Museum of Art.

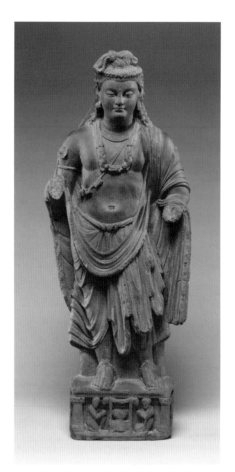

Figure 23 Bodhisattva, probably Maitreya. Pakistan (ancient region of Gandhara), ca. third century. H. 23¼ in. (59.1 cm). Schist. The Metropolitan Museum of Art.

Figure 24 View of Gallery 208 showing dry lacquer sculpture of Buddha Amitabha. The Metropolitan Museum of Art.

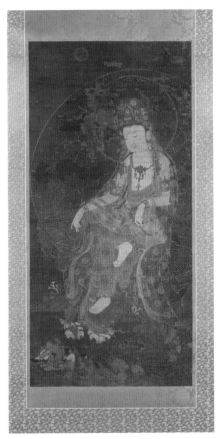

Figure 25 *Bodhisattva Avalokiteshvara in the Water-Moon manifestation*. Korea, Goryeo dynasty (918–1392), first half of the fourteenth century. Ink and color on silk. 45 1/16 × 21 7/8 in. (114.5 × 55.6 cm). The Metropolitan Museum of Art.

Figure 28 View of gallery 206. The Metropolitan Museum of Art.

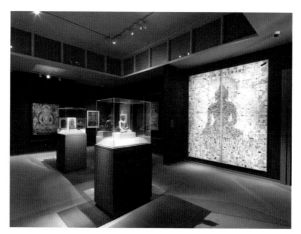

Figure 29 View of gallery 251 with *Dissected Buddha by Gonkar Gyatso*. The Metropolitan Museum of Art.

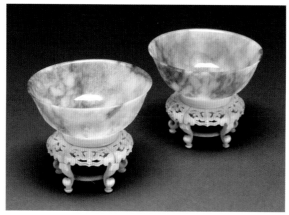

Figure 30 Pair of bowls with Buddha and Tibetan script, China, Qing dynasty (1644–1911), nineteenth to early twentieth century. Jadeite. Crow Collection of Asian Art.

Figure 31 3-D *Mapping Cultures, Tibet* exhibition mapped landscape. Crow Collection of Asian Art.

Figure 33 Artist unknown, Japan. *Kesa*, mantle for a Buddhist priest, nineteenth century; slit tapestry weave (kesa), [k'o-ssu] type. 80 × 45 in. (203.2 × 114.3 cm). Phoenix Art Museum.

Figure 34 Artist unknown, Sri Lanka. Buddha's footprint (Buddhapada), eighteenth century; opaque watercolor on cloth. Framed: 89 x 45 x ⅞ in. (226.1 x 114.3 x 2.2 cm); 81¼ × 38½ in. (206.4 × 97.8 cm). Phoenix Art Museum.

Figure 35 Artist unknown, China. Large square panel with crossed vajras, eight auspicious emblems, lotus blossoms, and other Buddhist symbols. Ming Dynasty silk lampas; red silk ground of dyed yarns in $^2/_1$ twill weave, interwoven in tabby weave with gold-colored silk yarns. 36¼ × 36¹¹⁄₁₆ inches (92 × 93.1 cm); framed 43 × 43 inches (109.2 × 109.2 cm). Phoenix Art Museum.

Figure 36 St. Mungo Museum of Religious Life and Art, Buddha and bodhisattva statues and stained-glass windows.

Figure 37 St. Mungo Museum of Religious Life and Art, Shiva Nataraja beside stained-glass window.

Figure 38 St. Mungo Museum of Religious Life and Art, Zen rock garden with Catholic cathedral in background and a clootie tree in foreground.

Figure 39 Durga from Bengal, probably about 1840 (British Museum).

The present chapter presents *Enter the Mandala* as a case study focused on potential areas of convergence and conversation between traditional art and the modern museum environment. Each section explores a specific aspect of this exhibition, especially as it relates to a potentially contentious issue in the museological presentation of sacred objects. It examines differences in perspective between traditional devotees and Western scholars and examines the use of "atmospherics" in museum exhibitions. It explores how the different capacities of original and copy operate in the realm of Vajrayana imagery and examines how fragmentary and holistically conceived objects appearing in the exhibition relate to one another. It addresses the issue of authenticity vis-à-vis reconstructed contexts in the museum environment. Finally, it addresses the issue of how explicitly consecrated objects might be allowed to "speak" within spaces like a museum, which are by definition secular.

Differences in Perspective: Can the *Enter the Mandala* Space Bridge Them?

Visually, mandalas are minutely detailed and saturated with philosophical meaning; as a result, they are a feast for the eyes and the mind—whether one is a museum visitor, a traditional devotee, or a Western scholar. However, differences between such perspectives have to date conditioned museum presentations of mandala-oriented artworks. Many early scholars of Tibetan art, for example, allegedly treated Himalayan painting traditions with what one analyst has called "formal egocentricity," such that scholars consider themselves and their interests "superior to the objects." Under these conditions, the artworks are to be "treated as objects for aesthetic enjoyment, controlled by a dominant subjectivity, placed on a wall under specified lighting … they are not to be treated as living channels and windows on reality, with due sacredness, *mysterium tremendum*, holiness." The result is a "museum or mausoleum setting" (Thurman 1998: 29) that fundamentally misrepresents the nature of the exhibited artworks in an effort to appeal to occidental audiences' presumed aesthetic sensibilities.

Such an arguably voyeuristic perspective on sacred artwork contrasts markedly with that of many Buddhist practitioners from Vajrayana-oriented schools of Esoteric Buddhism. For such persons, mandalas are not just images to view but visionary worlds to enter. To work with a mandala, traditional meditators first re-create its imagery in their mind's eye, and then imaginatively enter its world.[1] Under these conditions, entry into the mandala is entry into a visionary, sacred space engineered to catalyze a fundamental change in perspective and, with it, transformations in awareness and personality.

Given that the mandala comprises holistic or holy space, the question for modern museum professionals is this: Is it possible to give visitors a glimpse of these visionary

worlds while remaining as contextually authentic as possible in our presentation; that is, without turning the museum into Thurman's mausoleum? In other words, might it be possible to leverage the museum's resources to fuse the emic and etic, the insider and outsider points of view, such that the imagery becomes relevant across cultural chasms and thus "transparent to the transcendent"? (Campbell 2004: xxv)

The Asian Art Museum's exhibition *Enter the Mandala* affirms the viability of such an approach. To create the exhibition, we began by identifying three paintings from what was originally a set of five stunning *thangkas* created around the year 1300.[2] Each of these three paintings depicts one of a group of five so-called "cosmic Buddhas," each of whom is color-coded according to the symbolic direction over which he is thought to preside (Figure 14, and Figures 55, 56, and 57 on website). A full set of five cosmic Buddhas would include the blue Buddha Akshobhya (the "Unshakeable") of the east, the yellow Buddha Ratnasambhava (the "Jewel Born") of the south, the red Buddha Amitabha ("Infinite Light") of the west, the green Buddha Amoghasiddhi ("Unfailing Success") of the north, and the white Buddha of the center, whose name, Vairochana, means simply "the Radiant."[3]

In addition to articulating the fundamental structure of the Vajrayana visionary cosmos, each of the Five Buddhas presides over a specific type of psychological constitution known as a "family" (*kula*). Each family is dominated by one of five psychological poisons (*klesha*); moving clockwise from east to center, they are aversion, pride, attraction, jealousy, and ignorance. When properly activated through ritual and visualization, however, each of the Five Buddhas transmutes the poison over which he presides into a corresponding insight (*jnana*).[4]

As noted above, the Asian Art Museum conserves only three paintings from the original set of five. To construct the mandala Gallery, we therefore started by aligning these three extant *thangkas* along our gallery's axis in accordance with the symbolic spatial direction each depicted Buddha represents. Our intention was to allow the artworks to perform their intended function (Huntington and Bangdel 2003: 95): the articulation of the center of the universe along with its four surrounding symbolic directions, a form that manifests this unique place where the holistic vision of enlightenment is theoretically available. The paintings thus need not be arrayed in the foursquare, nested form of a mandala for the function of the mandala to operate; indeed, sets of Five-Buddha images "are frequently placed above a door or a crossbeam in front of the main shrine" in linear fashion, and such arrangements are deemed to "have the same effect" as the more familiar nested geometries of the mandala configuration.[5]

From the Vajrayana perspective, the imagery of the Five Buddhas transforms any given space it occupies into a virtual mandala, such that the centering function operates wherever the mandala form replicates.[6] From the museum exhibition perspective, one key goal of the display was to capitalize on this constitutive capacity of the mandala form to put visitors "into" a virtual mandala environment. Thus, instead of simply looking at a picture of a mandala, visitors can enter one, breaking the

fourth wall as it were. In this way, visitors can explore dimensions of Buddhist art and philosophy in a manner that is simultaneously immersive and transformative.

The "Atmospherics" of the Mandala: Twilight Spaces and Liminal Zones

In the physical space of the museum, *Enter the Mandala* can be approached from two directions, the brightly lit Korean or Japanese galleries. Whichever direction the visitor takes into the *Enter the Mandala* room, the customary lighting for display of the museum's permanent collection gives way to what is obviously a very different kind of environment. That is, the mandala's gallery has been darkened, while individual objects are carefully illuminated with targeted lighting arrays. This strategy was an intentional move designed to create a particular kind of "twilight" atmosphere. This is important because the texts from which many of the artworks in *Enter the Mandala* are drawn make extensive use of something called "twilight language" (*samdha-bhasha*) (Snellgrove 1987: 158). From a philosophical perspective, the Buddhist twilight language is unique in that its symbolism simultaneously references phenomena as apparently different as darkness and light, and so like twilight itself it stands at the nexus between apparent pairs of opposites. For example, a reference to the ritual bell (*ghanta*) can be interpreted as a reference to the philosophical concept of emptiness (*shunyata*), and also to the female sexual organs. In the same way, a reference to the thunderbolt (*vajra*) will often symbolize the complementary concept of stratagem (*upaya*), and also the male sexual organ.[7] For this reason, twilight language is ideally suited for communicating ideas that would almost certainly be disturbing to mainstream society (such as ritualized sexuality), and through that language to deliver messages comprehensible only to other persons trained in its symbolic intricacies and multivalent web of references.

In an important critical article, such modern exhibition and design techniques as precisely calibrated lighting strategies have been castigated as "atmospherics" (Branham 1995). And the point is not without merit; atmospherics deployed in the museum setting do indeed have an ambiguous history. It is well known, for example, that museum historiography involved an emphasis on entertainment (Paine 2013: 17); a setting like *Enter the Mandala* not only suggests but indeed employs techniques that might in a less interdisciplinary age be seen as theatrical rather than scholarly.

Other critics are even more vociferous than Branham. Greenblatt, for example, castigates "theatrical tableaux, ubiquitous in museums today," and inveighs against associated exhibition strategies that utilize "a pool of light that has the surreal effect of seeming to emerge from within the object." Greenblatt goes on to speculate that such operations constitute "an attempt to provoke or heighten the experience of wonder, as if modern museum designers feared that wonder was increasingly difficult to arouse" (Greenblatt 1991: 49). Are such criticisms on point when applied to a concrete exhibition like *Enter the Mandala*?

To be sure, *Enter the Mandala* does in fact utilize "pools of light" as an important display component of the exhibition, but their purpose is not to create any ginned-up sense of awe. Instead, the purpose is twofold: first, to illumine the works effectively so that otherwise elusive detail can be ascertained; and second, to establish common ground for dialogue between the museum context and that of the artworks we conserve. Thus, just as the Buddhist twilight language that informs the art in the gallery fuses apparently disparate levels of literal and symbolic meaning, physical twilight within the gallery space fuses the apparently disparate phenomena of light and darkness. In other words, the historical function of the objects themselves—rooted in traditional texts and guided by traditional interpretations—informs the specific display methodologies employed in *Enter the Mandala*.

Originals and Copies: The Eastern Region

Once the visitor has entered the twilight space of the mandala gallery, a journey through its visionary environs can begin.[8] When exploring mandalas from the tradition represented in the exhibition (retrospectively called *yoga tantra*),[9] the journey begins in the symbolic eastern quadrant, which is color-coded blue. Subsequently, the movement is clockwise through the four quadrants of space— yellow south, red west, and green north. Finally, one arrives at the center of the mandala and—under the right conditions—encounters an unseen seer dwelling in his hidden place.

In the museum environment, *Enter the Mandala*'s visitor path also begins in the blue, symbolically eastern region of the gallery. In this eastern region, we exhibit two different paintings of the Buddha. To the left is a large sixteenth-century painting of the historical Buddha Shakyamuni performing the act that is perhaps the defining moment of his career: he touches the earth to witness his merits, and in the process defeats time, death, and illusion (*Mara*). At that point, he sees the fundamental structure of the cosmos and with this vision achieves enlightenment (*nirvana*). In Buddhist philosophy and iconography, this earth-touching event would become the archetype according to whose form the act might be represented in microcosmic ectype and then transported, thus enabling even devotees distant in space and time from ancient Buddhist India to tap into the spiritual potency that the moment of enlightenment encapsulates (Figure 15).

To the right of the Shakyamuni painting, visitors encounter an image of yet another Buddha touching the earth. While his hand gesture is the same, much else is vastly different. Perhaps most obviously, this Buddha is dark blue, marking him as Akshobhya, the Buddha of the eastern direction. Like all the cosmic Buddhas who occupy the symbolic directions of the mandala, Akshobhya's role is by definition transformative. In Vajrayana meditative thought, Akshobhya transmutes the poison (*klesha*) of anger (*dvesha*) into a corresponding wisdom called the "mirror-like"

(*adarsha-jnana*). Akshobhya is typically shown with a five-lobed crown, a form of ornamentation that the historical Buddha Shakyamuni would not have worn.

Finally, note that the image of Akshobhya is a copy; although the original resides at the Honolulu Museum of Art, the Asian was able to secure a high-resolution reproduction of the painting.[10] Interestingly, while distinctions between original and copy are crucial to valuation within the contemporary art market, in this tradition it is often the *replication* of effective forms that gives an artwork its power, not the *uniqueness* of the forms in question. For under certain conditions specified in traditional texts from the sutra and tantra corpuses, copying enhances rather than dilutes the power of a given image[11]—an important difference between the Vajrayana context and that of the global art market.

Wholes and Parts: The Southern Region

Moving clockwise through the symbolic sectors of the gallery, a fourteenth-century painting of the cosmic Buddha Ratnasambhava presides over the yellow, southern region of the mandala. Like Akshobhya, he has a psychological function, transmuting the poison of pride (*abhimana*) into the wisdom of equality (*samata-jnana*). And also like the Akshobhya reproduction in the eastern sector of the mandala, Ratnasambhava does something the historical Buddha Shakyamuni never did: he wears a five-lobed royal crown, which marks him as a member of the group of Five Buddhas who occupy the symbolic directions of the Buddhist meditative cosmos.

In traditional accounts, the historical Buddha Shakyamuni's earth-touching event took place underneath the Bodhi tree at Bodh Gaya in India. Centuries later, a temple known as the Mahabodhi was constructed at the site.[12] In Buddhist thought, the replication of this form—which comprises a central axis surrounded by the four symbolic directions—replicates the potency of the Enlightenment event it depicts. Thus, by creating a virtual Mahabodhi temple, it becomes possible to transport its potency across temporal, cultural, and geographic space.[13]

To show how artistic replication of an archetypal event transmits religious potencies, we have selected votive art objects from Southeast Asia in particular to occupy the symbolically southern region of the gallery. A clay seal from Burma, for example, shows the Buddha touching the earth beneath the Mahabodhi temple (Figure 16). This plaque would have functioned as a microcosmic Mahabodhi capable of preserving its capacities intact over vast reaches of space and time. Similarly, a pyrophyllite shrine probably made in India but transported to Southeast Asia (Figure 58 on website) takes another approach, concentrating all the eight great events of the Buddha's life around an earth-touching Buddha (Huntington and Huntington 1990: 217–20). Again, the potency of the whole is contained in its microcosmic replica, making the art object in question ideal for transporting the potency of the Enlightenment event across temporal and cultural space. The "act of displacement" that is involved in the

display of "virtually all older artifacts" (Greenblatt 1991: 44) is certainly in place, but to castigate "the museum" (as if there were such an abstract entity) with so broad a brush is to ignore the fact that many of the objects—especially pilgrimage art such as we see in this portion of the exhibition—were designed to be so displaced and would not function otherwise.

Often, however, Esoteric Buddhist art objects in the museum constitute no self-contained microcosms, but rather have come to us as dispersed components of what was formerly a more complete set of objects originally created to work together. These objects exhibit not a *formally centripetal* pattern tending to concentrate a tableau of sacred imagery (like the pyrophyllite shrine referenced above), but rather a *historically centrifugal* pattern where initially complete sets have been dispersed (like the fourteenth-century Buddha paintings that structure the gallery space). Under the latter, centrifugal conditions, curators and conservators must piece together clues to reconstruct traditional context and identity as far as possible.

Sometimes the clues are unequivocal; the Asian's three fourteenth-century Buddha paintings represent perhaps the most salient example of a centrifugally dispersed group that we could partially reconstitute. At other times, we encounter incomplete sets of images whose identity can only be inferred from limited diagnostic clues. For example, the hand gestures of the different bronze figures in the southern sector of *Enter the Mandala* allow us to identify them as forms of Vairochana, the Buddha who, as unseen seer, occupies the center of the mandala.

Other objects in this region of the gallery present different and arguably greater difficulties. One dark stone sculpture from the Pala Dynasty (from the eighth to the twelfth centuries) in the southern sector has not only been removed from his architectural, external context, but his hands and face—his internal context, if you will—have also been lost (Figure 17). Nonetheless, sufficient clues remain, for his crown and the position of his arms allow us to infer that he too is Vairochana, the Buddha of the center. In the case of this object, there is no attempt to hide "signs of alteration, tampering, and even deliberate damage" that "many museums simply try to efface" (Greenblatt 1991: 44). Instead, the fragmentary nature of this object provides a springboard for further research as regards both identification and contextualization.[14]

From the perspective of critical theory, the symbolically southern portion of the exhibition does in fact combine objects from disparate culture spheres. It might therefore be open to Malraux's charge that museum practice "not only isolates the work of art from its context but makes it foregather with rival or even hostile works" (Malraux quoted in Branham 1995: 35, 36). Yet are the works in this section hostile or complementary? We would argue the latter point of view, for in the "foregathering" that these objects seem to exhibit, patterns that might otherwise remain hidden can be revealed. Under these conditions, the artworks presented do not compete with one another, but rather work cooperatively to restore silenced voices, reveal forgotten contexts, and perhaps even contribute to original research.

Figure 17 Vairochana Sculpture. Crowned Buddha in niche, a fragment of a votive stupa; approx. 1000–1100, Pala period; Bihar state, India. Stone. Asian Art Museum, San Francisco.

Proxies and Pure Lands: The Western Region

Moving to the symbolically western region of the mandala, visitors encounter a large thirteenth-century Japanese rendition of the Western Pure Land of Sukhavati, the "Joyous Place" (Figure 59 on website). Presiding over its precincts is the Buddha Amitabha, whose name means "infinite light." Called a *Taima mandara*, this painting features a glowing gold palette, deep detailing, and a strong geometric gravity pulling viewers hypnotically toward its center.[15] Why might such visual strategies be employed? Some hypotheses are textually based, for the books that describe Amitabha say that the moment a person hears that Buddha's name, they are safe from hell and will eventually be reborn in Amitabha's Pure Land (Gomez 1996: 71–5).

On the basis of this analysis, the *Taima mandara* becomes a visual transformation of a textual idea—Amitabha pulls you into his world the moment you encounter him. It is perhaps for this reason that artistic images like this *Taima mandara* have a special capacity, since according to the Japanese savant Kukai, a single glance at them is

sufficient for transforming a human being into a Buddha (Bogel 2009: 3). Under these conditions, paintings like the *Taima mandara* might better be understood as a kind of spiritual technology than as any sort of didactic illustration.

The Buddha at the center of our Japanese painting, however, wears no crown and exhibits none of the red color that mandala schemata would associate with him. Probably, he represents Amitabha before Buddhist theologians incorporated his world into the structure of the mandala. And as it turns out, it is this western *thangka*—the one that would have represented Amitabha—that remains missing from the original Five-Buddha set. We have not been able to locate it even to secure a copy, such as we did with the Honolulu Akshobhya. Its location remains a mystery. From a psychological perspective, the missing Amitabha would function to transmute passion (*raga*) into penetrating wisdom (*pratyaveksha-jnana*).

Wisdom Counterparts: The Northern Region

The northern sector of the mandala belongs to the green Buddha Amoghasiddhi. This crowned Buddha transforms jealousy (*irshya*) into all-accomplishing wisdom (*kriyanustha-jnana*).

On the wall facing Amoghasiddhi, visitors can examine a small but beautiful and historically important object from the northern reaches of the Esoteric Buddhist world (Figure 18). This *kesi* or silk tapestry depicts Green Tara, the female counterpart—"wisdom" (*prajna* in Sanskrit)—of Amoghasiddhi. In Esoteric Buddhist thought, every Buddha in the mandala has such a "wisdom" who works to catalyze his transformative capacities. Over time, a number of these female counterparts became increasingly important, either in their own right or in the embrace of their male counterparts as composite "mother-father" (*yab-yum*) deities characteristic of the fierce and sexualized "unexcelled" (*anuttara*) systems of meditation. Green Tara's iconography includes a small lotus supporting her right foot; combined with the three-dimensional effect of the tapestry, it appears as if Green Tara is stepping out of the artwork and into the gallery, as befits her attribution to effective action in the phenomenal world.

This silk tapestry is as historically important as it is theologically revealing; it comes from the lost kingdom of Xixia in northern China. Destroyed in 1227 by the Mongols, the Xixia capital of Khara Khoto contained a stupa that the Mongols left untouched. In the twentieth century, Russian archaeologists excavated the stupa and took its contents to the Hermitage in St. Petersburg (Piotrovsky 1993: 31–47). As far as we know, this *kesi* does not come from that cache, but we are indeed fortunate to be able to conserve and exhibit an object of this rarity, quality, and importance.

Sun in the Stupa: The Central Region

Having moved clockwise through the four quadrants of the mandala, visitors arrive at its central region. Here, surrounded by four *thangka* paintings in double-sided cases,

a schematic line diagram of a generic mandala has been projected as a series of laminates onto the gallery floor. It illustrates in ground plan many of the key aspects of a mandala, such as protective circles of flames and thunderbolts, as well as a square palace embedded within them.[16]

From the center of the mandala diagram rises a magnificent gilded stupa, a replica of Nepal's famous Svayambhu Stupa created in the eighteenth century (Figure 19). While perhaps not immediately obvious, its form too reiterates that of the gallery, for each side of the stupa corresponds to one of the four symbolic directions, and each directional Buddha appears in a small shrine in his customary quadrant. This leaves the fifth Buddha, the central axis, unaccounted for. Yet the representative of the axis is in fact here. He is the inhabitant of the gilded stupa, and his eyes are just visible on the cubic edifice (*harmika*) just atop the stupa's hemispherical superstructure. He is the Sun Buddha, Vairochana. Sun-like, he simultaneously occupies the center and the summit of the cosmos, which is itself marked by an hourglass-like stepped pedestal of Mount Meru—the *axis mundi* in most Buddhist systems. From the perspective of Esoteric Buddhist ritual psychology, Vairochana transmutes delusion (*moha*) into knowledge of the structure of reality (*dharmadhatu-jnana*).

Along with this subtly hidden form of Vairochana, visitors will find two more paintings of this transcendent deity in the center of the gallery. Like the *thangka* of Ratnasambhava and Amoghasiddhi, both of these Vairochana paintings face outward from the center of the room. The Vairochana painting that faces Akshobhya's blue wall is one of the museum's oldest and most important *thangka*. Dating to the eleventh century, it is executed in the rare Sharri or Indian style (Figure 60, on website). The figures are flexible and relaxed, and a prominent yellow palette is emphasized; in *thangkas* executed in this manner, the various figures depicted in the painting gaze mutually at one another, at Vairochana, and at the viewer (Jackson 2011: 1–15).

Across from the Sharri Vairochana floats another painting of Vairochana. This *thangka* is the last of our three fourteenth-century paintings. Like Ratnasambhava and Amoghasiddhi, it utilizes the deep detailing, red palette, and shrine-like forms characteristic of the Beri or Nepalese style (Jackson 2010).

Moreover, and perhaps more importantly, the entire painting is executed on a background of tiny Buddhas. Initially, this Buddha background might seem a simple multiplication of forms.[17] On closer examination, however, an interesting pattern emerges, for the apparently undifferentiated field of Buddhas is actually composed of the Buddhas of the directions. Indeed, the diagonal rows of color-coded Buddhas converge over the head of Vairochana to create a kind of shrine (*kutagara*) made out of the Five Buddhas (Goepper 1996: 96).[18] Thus a single Buddha—in this case Vairochana—appears in the context of a mandala comprised of all Five Buddhas (Figure 14). In other words, the part—the Vairochana painting—contains the whole mandala in which he appears.[19]

The pattern goes deeper still, for around the head of each Buddha appear occupants of the sector of the mandala over which he presides. The same holds true

of the Ratnasambhava and Amoghasiddhi in the exhibition. So at multiple scales, the whole contains the part contains the whole; this is a pattern that repeats at multiple scales and can thus be described as fractal in structure.

Silenced Objects? The Stupa Speaks Again

When standing at the center of the gallery near the replica of the Svayambhu Stupa, visitors can see the reverse sides of the paintings that occupy the double-sided cases at the four cardinal directions. The reverse of each painting features a characteristic shape: that of the stupa. From a symbolic perspective, the stupa represents the mind of the Buddha and is thus the very type of negentropy, a hieroglyph of the suspension of temporality involved in the realization of nirvana. From the perspective of its content, the stupa-shaped inscriptions perform several interlocking functions, each imparted to the artwork by a lama in the context of an "empowerment" (Sanskrit, *abhishekha*; Tibetan, *rab gnas*) ceremony—the same term that designates the "empowerment" of a student by a teacher to perform a given mandala visualization. In this case, however, the lama empowers the painting to embody and preserve the essence of the being painted on its surface (Bentor 1996: 1–6).

The empowerment (*abhishekha*) of the painting proceeds in three phrases. Each is recorded on the *thangka* as part of its stupa-shaped inscriptions and is described on the same interactive tablet as the one that reveals the hidden shrine structure on the Beri Vairochana painting. The first phrase consists of the mantra of the Buddha on the front, construed as the verbal aspect of that being; in the case of Vairochana, its Sanskrit has been transliterated into the Tibetan script "*om sarvavid svaha*." The second phase is a formula understood as a summary of the Buddha's most important insights, loosely translatable as "The Tathagata explained the causes of those things that arise from a cause. The Great Renunciant has also explained their cessation." In Buddhist thought, the inscription of this phrase on an object transforms it into a virtual stupa, so in this case form, function, and semantics all go together. Finally, the third phrase is a benediction invoking peace as the highest virtue of a Buddhist monk.

Even taken together, however, all these consecration procedures are mere temporary measures. In order to empower the object in perpetuity, the lama must first visualize the being in question entering the relevant painted image. Subsequently, the lama will seal the intelligence of each visualized being into the painting at three locations: the brow, throat, and heart of the image. The three syllables *OM AH HUM* written in Tibetan script serve to seal the intelligence of the depicted being into the painting in perpetuity. It is this procedure that transforms an artwork into a working, consecrated object—a holy object that transcends the phenomenal world and is thus "numinous" in Jung's and Ames' sense. By foregrounding the consecration procedure in this exhibition, we answer in traditional terms how such objects are "thought to contain … mysterious powers," as well as to present their conception in a manner theoretically capable of accommodating both insider and outsider perspectives (Ames 1994/5: 61–2).

At this point it will be apropos to meet another objection commonly cited by poststructuralist critics of museum exhibitions: that "museum objects are dumb" (Crew and Sims 1991: 159). Such a perspective parallels that of Adorno, who accuses museums of the "neutralization of culture" (Sherman 1994: 7). But given the extensive translation work involved, can it be said that the objects in *Enter the Mandala* have in any way been "silenced," except by some theoretical sleight of hand? After all, the exhibition translates the messages that these objects tell us in their own words and interprets them through traditional commentarial works.

Constructed Contexts: Authentic or Artificial?

Enter the Mandala is a conscious curatorial construction. It makes no pretentions to replicate either the original physical or cultural context in which any of its constituent objects might have appeared. How then might *Enter the Mandala* comprise an "authentic" environment for the exhibition and exploration of Vajrayana art and thought?

Perhaps the first item to recognize in this connection is that "the representation of an object within a museum context is no more artificial than its original interpretation" (Ames 1994/5: 61). Beyond this perhaps obvious truism, there are more difficult questions of historical authenticity when it comes to displaying sacred objects in a museum environment. At this historical level, Buddhist and especially Vajrayana architecture across cultures utilizes what might be called a fractal structure, such that macrocosmic forms are built from microcosmic copies of themselves. The result is a pattern that repeats itself at multiple scales. For example, important monuments like the Alchi Sumtsek in Ladakh (Goepper 1996) are mandalas that contain mandalas that contain still more mandalas. Since *Enter the Mandala* is formally exactly that, that is, a mandala within a mandala, the fractal structure of the exhibition parallels the fractal structure of traditional Buddhist visionary environments.

At the level of functional authenticity, Buddhist practitioners have consciously constructed many sophisticated environments to orchestrate specific kinds of visionary experience. Perhaps best known are "immersive" cave environments at Dunhuang excavated in order to catalyze visionary realizations corresponding to those described in certain Mahayana Sutras. Here, mirrors were placed around meditators to create infinitely receding, mutually embedded perceptions of oneself. This was apparently done in an effort to help meditators perceive the fundamental structure of awareness, such that the entire environment becomes a "mirror hall that bounces the reflections of the Buddhas and bodhisattvas in all directions and projects the visualizing individual's own presence to the Buddha assemblies" (Wang 1995: 265).

Enter the Mandala's installation is obviously not an attempt to reconstruct any specific physical or architectural environment like the Alchi Sumtsek or the Dunhuang caves. However, the nature of its construction does create a visual parallel to Wang's description of the Dunhuang mirror-meditation environment. Standing at the center of the mandala gallery, visitors can see reflections of the gilded Nepalese Stupa recede

infinitely in all four directions, mandalas within mandalas as far as the eye can see—a situation in which visitors themselves are immersed. So while the *Enter the Mandala* gallery is an artifice, there are aspects to its visuality that reveal both artistic and philosophical precedents that would be familiar to traditional devotees.

Perhaps ironically, the combined notions of artificiality and authenticity reveal an important point of convergence and conversation between the museum environment and that of Vajrayana visualization: like the gallery itself, the process of visualization meditation too involves conscious creation. In such practices, meditators first construct and then enter a three-dimensional mandala structure in the mind's eye. Indeed, both architectural and meditative contexts are constructed as well as imagined; in fact, the single Sanskrit term *utpatti* can apply to both English terms. This analysis might even suggest a "curious complicity shared by these two spatial constructions" (Branham 1995: 34), namely, the mandala gallery space and the mandala visualized in traditional meditations. In both cases, a holistic perception must be reconstituted from fragmentary cues.

Secular Contexts: Killing Objects or Creating Meaning?

In its original textual context, that is, when it was initially written in 1995, the "curious complicity" cited above referred to the alleged confusion between museum space and sacred space that can arise when religious objects are exhibited. By creating even a virtual mandala space within a presumably secular art museum gallery, are we not mixing metaphorical oil and water, violating the sacred perspective of insiders and in the process creating an ersatz, voyeur spirituality for outsiders? Indeed, at one level, one might contend that the gallery occupied by the mandala had been *de facto* transformed into a kind of simulated sacred space by the incorporation of mandala imagery that defines such spaces traditionally.

The issue is slightly different when approached from the perspective of the objects in the exhibition and revolves around the question of whether exhibiting a sacred or consecrated work within the secular space of the museum robs that object of its sacred nature. Are sacred objects of "real" (i.e., sacred) significance only to their community of practice, and do they lose this quality when taken out of their original sacred context? If so, it becomes possible to argue that sacred or consecrated objects have no place in a secular museum, where visitors will necessarily include nonadherents to the tradition. To outsiders, interest in such objects can be interpreted as orientalism or worse, a kind of metacapitalism in which surplus value concentrates in the most useless of objects, with the museum becoming a kind of metabank for these metacommodities (Starn 2005: 75).

Museum analyses influenced by Marxist theory in this fashion can be extreme and perhaps even caricature a practical question: Does the museum context strip a sacred object of its associated meanings, perhaps most especially its numinosity? This point of view is represented by Quatremere, for whom "the museum 'kills art to

make history' by wrenching works of art out of their original context" (Starn 2005: 81). While a truism in one sense, a criticism of this sort nonetheless raises the contrary question of whether the secular museum, perhaps ironically, might actually add meaning to the objects such institutions conserve and exhibit by providing them with a kind of metacontext.

A diametrically opposite way to approach this question is through the hermeneutic approach characteristic of Hegel. For him, "instead of being alienated by passing through time and space, art is perfected as an object of conscious understanding by being removed from its original setting and put in a place for contemplation and study" (Starn 2005: 82). From this perspective, the museum context is perhaps uniquely capable of generating ever-greater levels of meaning as scholarly and practitioner communities synergize in this evolving hybrid space. And to the extent that the numinous and the meaningful overlap, the museum context can be understood as potentially capable of revealing rather than obscuring the sacred character of objects under its care.

7 Discovery and Display: Case Studies from the Metropolitan Museum of Art

DENISE PATRY LEIDY

Glimpses of Buddhist Thought and Imagery 1870–1915

By the time the Metropolitan Museum of Art was established in 1870, perceptions of Buddhism, alternatively romantic and disdainful, had already begun to seep into late Victorian culture in both the United States and Europe. Echoes of Buddhist concepts can be found in the work of the New England Transcendentalists who were active in the early part of the nineteenth century. Purportedly Buddhist ideas were often incorporated into the work of occult movements such as Theosophy, which were popular during the second half of that century. For example, Helena Blavatsky (1831–91), one of the founders of the Theosophical Society, claimed to have acquired her deep knowledge of cosmic secrets from great adepts, whom she called *mahatmas*. She communicated with these masters, who were hidden from the phenomenal world somewhere in India or Tibet, on a spiritual plane. Both she and Henry Steel Olcott (1832–1907), the cofounder of this society, which was established in New York in 1875, took Buddhist precepts in Sri Lanka in 1880. Olcott was the author of the 1881 *Buddhist Catechism*, one of the first Western volumes dedicated to the study of Buddhist texts.

Moreover, although not well understood, certain types of Buddhist imagery had also permeated Western design. For example, peculiar beings, often known as "*pagods*" or "*magots*" and loosely based on East Asian Buddhist figures, were depicted in European ceramics and metalwork, and were even made in sugar to decorate tables. An example (Figure 20) produced in the early eighteenth century at Meissen in Germany has the elongated earlobes symbolic of a spiritually advanced being and the bald head and clothing of a Buddhist monk. This figure's unkempt appearance and mad laugh conflate East Asian representations of the *arhats*, the disciples of the historical Buddha Shakyamuni, and popular figures such as Budai (Figure 21), one of the Chinese avatars of the Buddha Maitreya.[1] It is ironic that the arhats, who are often shown as unkempt and unattractive in East Asian Buddhist imagery—in part to symbolize their advanced state of being and in part as a reflection of their Indian origins—were transformed in Europe to represent another version of foreignness: that of individuals who were understood to be either Indian or Chinese.

Figure 20 Buddhist Divinity; German, ca. 1710–20; Porcelain (Meissen Manufactory). H. 3 ⅞ in (9.8 cm). The Metropolitan Museum of Art.

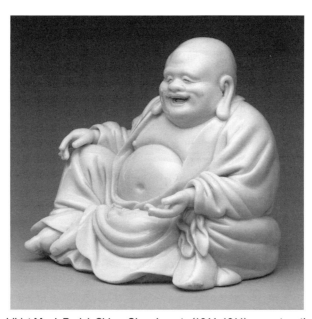

Figure 21 Buddhist Monk Budai. China, Qing dynasty (1644–1911), seventeenth century. Porcelain (Fujian Province, Dehua ware). H. 6¾ in (18.4 cm). The Metropolitan Museum of Art.

Both the words *pagod* and *magot* are found as early as the sixteenth century in European sources; both are derogatory. Pagod, which was initially a Portuguese term and served as the basis for pagoda, a word later applied to a type of Buddhist building, was originally defined as a temple-like structure used by Indians and other idolaters. By the seventeenth century, it was also understood as the description of the idols found in such monuments. Magot, on the other hand, was the name of a small, capricious monkey. By the eighteenth century, however, it also served as a definition for representations of Indian or Chinese figures such as that in the Meissen sculpture discussed above. Drawing rooms throughout Europe were filled with such figures, which also inspired costumes for masquerades and exotic clothing worn by musicians and other entertainers.[2]

It seems unlikely that iconic Buddhist sculptures or paintings served as the prototypes for these whimsical European figures. By the mid-seventeenth century, when such figures had become widely represented in European decorative arts as part of the vogue for Chinese or Chinese-inspired things known as chinoiserie, certain Buddhist figures had also become part of the repertory of East Asian decorative arts. Depicted in porcelain, jade, and metalwork or in the form of fanciful Japanese netsuke, the arhats, Budai, and other popular deities were understood, in this context, as primarily auspicious and protective figures rather than as icons.

Many of the first examples of Buddhist imagery to enter the Metropolitan Museum's collection were introduced as motifs in the decorative arts, and the objects in question were selected primarily for the materials in which they were crafted, such as porcelain. The discovery of the clays needed to produce porcelain was the most important and transformative event in global ceramic history; this extraordinary material remains synonymous with "china" in Western languages. First used in China in the eighth century, porcelain became the primary Chinese material in the fourteenth century, was traded globally beginning in the seventeenth century, and was only made in Europe after the early eighteenth century when the materials for making a hard paste porcelain were discovered in Meissen. Over 1,000 examples of Chinese porcelain, purchased by the museum in 1879 from the dealer Samuel Putnam Avery (1822–1904), which sometimes show Buddhist imagery, were acquired to serve as educational resources for collectors and the general public and as inspiration for American design and manufacturing.

The first iconic work of Buddhist art—defined here as a work of art with Buddhist imagery, the primary focus of which was ritual or devotion—acquired by the museum, a portable shrine from Japan (Figure 22), was also added to the collection as an example of a particular material, in this case lacquer. Used as a protective covering and an artistic medium in East Asia for millennia, lacquer was treasured and collected in the West as early as the seventeenth century. Often displayed at World's Fairs in the second half of the nineteenth century, Japanese lacquer, which is characterized by the abundant use of gold in the decoration, was also collected and imitated in other materials. The widespread interest in this material and its designs at that time can also be traced to the fascination with Japanese art, known as japonisme (1865–95).

As is the case with Chinese and Japanese porcelain, some Japanese lacquers were produced primarily as export goods.

The exterior of this shrine, which is covered in black lacquer, opens to display a bodhisattva seated against a gold background. It was given to the museum as part of a group of nearly 200 lacquers (largely Japanese but some Chinese) by Stephen Whitney Phoenix (1839–81), an important early donor. The bodhisattva wears a white robe that covers his head and is painted with a gold arabesque, sits on a rocky ledge, and has a large moon encircling his head; a small vase is at the proper right. The figure represents one of the many East Asian variants of the Bodhisattva Avalokiteshvara, a form of manifestation known as the White-Robed (Japanese *Byakue Kannon*), which illustrates the belief that like water on moonlight, the phenomenal world is illusory. Some of the manifestations of Avalokiteshvara (known as *Guanyin* in Chinese and *Kannon* in Japanese), which developed in China around the tenth century are female; others were mistakenly understood to be women. Representations such as this, particularly those in which the head is covered and which are often introduced in the guise of decorative arts, contributed to the popular perception that Avalokiteshvara was female and a type of Buddhist Madonna.[3]

Three miniscule Cambodian images of seated Buddhas with their proper right hands in the characteristic earth-touching (*bhumisparsha mudra*) gesture, acquired in 1885, represent the first examples of Buddhist works of art acquired as religious images in the museum's collection.[4] One of the clay sculptures is covered with gold lacquer, a material that was also sometimes used in Southeast Asia. The other two are clad with silver. They were part of a gift of Cambodian antiquities from Frank Vincent (1848–1916), the author of *The Land of the White Elephant: travels, adventures, and discoveries in Burma, Siam, Cambodia, and Cochin-China*, a fanciful but still useful record, which was first published in 1873 and became a sensation; a fourth edition was issued in 1884.[5] The acquisition of these pieces, which marked the beginning of the South and Southeast Asian collections in the museum, reflects the growing Western interest in the Theravada traditions of Buddhism in the second half of the nineteenth century.

The first European use of the term Buddhism is found in a 1797 essay entitled *On the Literature and Religion of the Burmans* by Dr. Francis Buchanan (1762–1829), a Scottish physician and botanist who would later serve as the surgeon to the governor general of India. Throughout the nineteenth century, British diplomats, administrators, and scholars would continue to explore the subcontinent, discovering and translating canonical languages such as Pali or Sanskrit and unearthing monuments such the Mahabodhi Temple in Bodh Gaya in 1811 and the Great Stupa at Sanchi in 1819. Western study of Buddhism, which by the mid-nineteenth century was understood to have originated in India, intensified after 1861 when Alexander Cunningham (1814–93) was appointed as the first archaeological surveyor for the British government, a position that would lead to the creation of the still-active Archaeological Survey of India.

In the late nineteenth century, discussions of Buddhism generally focused on two traditions. One, known as northern Buddhism and practiced in Tibet, Mongolia, and China, was understood to be a degenerate and impure form of the original teachings of the historical Buddha Shakyamuni. The other, termed southern Buddhism and practiced in Sri Lanka and parts of Southeast Asia, was thought to embody a more authentic and less idolatrous practice. The former, reflecting religious tensions in the West at the time, was frequently compared to Catholicism, the latter to Protestantism. The perception that the Buddha was an ascetic reformer who was opposed to the elaborate rituals found in the so-called northern traditions and in Hinduism also reflects the strained relations found between different branches of Christianity during this period.

The use of Pali for Theravada texts contributed to the perception that this aspect of practice was closer to the teachings of the historical Buddha. Academic study of this language, which is closely related to Sanskrit but has a simpler structure and grammar, began in the West in around 1869 with the publication of the first dictionary and intensified after 1881 when the Pali Text Society was established by Thomas William Rhys David (1843–1922), a British civil servant posted to Sri Lanka. Additional studies of Pali and Buddhist texts were issued by the Harvard Oriental Series founded in 1891 by Henry Clarke Warren (1854–99). The Metropolitan Museum's acquisition of two Pali-language manuscripts, one in 1889 and a second in 1919,[6] reflects the importance awarded to the Theravada canon in early Western scholarship. Both are written on the palm leaves traditionally used for religious texts in South and Southeast Asia, and both have wood covers. One is painted with gold on a red background; the other is carved. The early cataloging of the manuscripts as being Indian and dating from the eighteenth century echoes the confusion regarding South and Southeast Asia and their respective practice traditions at the time. Both manuscripts were most likely made in Burma in the late nineteenth century; Buddhism had essentially disappeared from India after the twelfth century.

The acquisition of the small Cambodian sculpture and the two Pali manuscripts also reflects the growing interest, both popular and academic, in Buddhism and its artistic traditions that characterized Western culture in the second half of the nineteenth century. Sir Edwin Arnold's *The Light of Asia*, an 1879 epic poem detailing the life of the historical Buddha and paralleling it to that of Jesus Christ, was a huge success; by 1885, thirty official editions of this influential rendering had been published. Moreover, during the period from 1879 to 1907, essays regarding Buddhist thought and practice, many penned by travelers, were often featured in magazines such as *The Century*, *The Atlantic*, or the *Overland Monthly*, deepening American engagement with this religious tradition. The 1844 publication of *L'Introduction de l'histoire du bouddhisme indien* by Eugène Burnouf and the 1860 work *The Buddha and his religion* by Jules Saint-Hilaire Barthélemy (1805–95) were quickly followed by works focusing on artistic traditions. These included *Buddhism in Tibet: illustrated by literary documents and objects of worship* by Emil Schalgintweit in 1863, *The Buddhism of Tibet or Lamaism* by L. Austine Waddell in 1895, and *Fine Art in India and Ceylon* by Vincent Smith in 1911.

It is interesting to note that, despite the discovery of major monuments in India and the publication of works focusing on South Asian and Tibetan art, perceptions about the presumed purity of the southern versus the northern traditions of Buddhism also impacted the collecting of Indian and Tibetan art in the Metropolitan Museum. One of the first Indian Buddhist sculptures to enter the collection, a bodhisattva (Figure 23), which is part of a group of seven stone sculptures purchased in 1913, typifies taste at that time. This piece, which dates to around the third century, shows the bodhisattva standing on a square base carved with images of a male and a female devotee worshipping a begging bowl. He wears jewelry, which in early Buddhist art often served to distinguish representations of bodhisattvas from those of Buddhas; a long sarong-like garment; and an elaborate shawl. The naturalism found in the rendering of the hair, face, and torso and in the treatment of the folds of the clothing indicates that this sculpture was carved in Gandhara, an ancient name for an area in the northwest of present-day Pakistan.

From the first to the seventh century, this region served as both a Buddhist center and a crossroads linking East to West over an interlocked series of land routes often known as the Silk Road. The discovery and study of Gandharan art is linked to the excavations of sites such as city of Taxila by Cunningham and his team, as well as to translations of the writings of Chinese pilgrim monks such as Faxian (337–ca. 422) and Xuanzang (ca. 602–664), who recorded their visits to this region in some detail. James Legge first translated Faxian's journey to India and Sri Lanka in 1886, Samuel Beal translated Xuanzang's diary of his travels in 1884, and Thomas Watters offered a second rendering in 1904. The writings of these intrepid travelers, which are the earliest records in any language of early centers in South and Southeast Asia, remain seminal documents in the study of Buddhism and Buddhist art.

Gandharan sculpture, as it is often termed in art history, was extolled in early Western scholarship because it was thought to echo the artistic traditions of ancient Greece and Rome, which, in turn, were understood as the foundations of Western culture. Although more stylized than is found in early Mediterranean traditions, the naturalism in Gandharan art was often contrasted with the imagery that was being discovered on the subcontinent at the time. Moreover, the multiheaded and multilimbed (and sometimes terrifying) deities found in the later or northern Buddhist traditions, and in Hinduism, were incomprehensible and unappealing to early Western audiences. It is unlikely to be coincidental that the first examples of Tibetan art, a gift of three paintings, were not added to the Metropolitan Museum's collection until 1931.[7] With the exception of jewelry and a few paintings and sculptures, little Himalayan material was added to the collection until the 1990s.

The Department of Far Eastern Art 1915–86

The museum's Department of Far Eastern Art was not formally established until 1915, at which time, as the name states, the focus of the museum's attention and of its collecting and display of Buddhist art was the traditions of China, Korea, and Japan.

This emphasis can be traced, at least partially, to the 1893 World Parliament of Religions, which coincided with the Columbian Exposition in Chicago, a World's Fair held in celebration of the 500-year anniversary of Christopher Columbus' discovery of the New World. Two of the most lionized presenters at this event were the Ceylonese Angarika Dhammapala (1864–1913), a lay practitioner and writer deeply involved with the revival of Buddhism; and Soen Shaku (1860–1919), a Rinzai Zen monk who was one of a group of four clerics and two laymen representing Japanese traditions. The presence of this Japanese delegation helped spur Western interest in eastern Buddhism, a term coined to distinguish East Asian practices such as Chan/Zen or Pure Land from the mistrusted and denigrated northern Buddhism of Tibet and the southern Buddhism or Theravada of Southeast Asia.

Soen's introduction to Paul Carus (1852–1919), one of the organizers of the World Parliament, who had a deep interest in Buddhism, led to the arrival of D. T. Suzuki (Suzuki Daisetsu Teitaro, 1870–1966) in the United States. Suzuki's writings on subjects such as Zen, Mahayana, and other aspects of Eastern philosophy arguably served as the foundation for the academic study of Buddhism in the United States, as did his visits to American universities and his teaching at Columbia University from 1952 to 1957. Suzuki, who joined the Theosophical Society in around 1911, also founded the Eastern Buddhist Society in 1921. This group continues to publish the scholarly journal *Eastern Buddhist*. The emphasis on East Asian traditions in the late nineteenth and early twentieth century is also reflected in Nanjio Bunyiu's (1849–1927) 1893 publication list of Chinese translations of Buddhist texts, and works such as the 1883 *L'Art japonais* by Louis Gonse or the 1887 *L'art Chinoise* by M. Paléoligue.

The interest in modernization (Westernization) that characterized the Japanese government during the Meiji period (1868–1912) may also have helped to spur the Western fascination with Japan, as well as the use of Japanese Buddhism as the entry point for Chinese and Korean traditions. In addition to adopting a constitutional monarchy based on a Prusso-German model, the Japanese government also fostered Western systems of education and a taste for Western clothing. Although Buddhism was briefly suppressed under a policy known as *haibutsu kisshaku* (suppress Buddhism, kill the Buddha Shakyamuni), it was later revised, and, as was also true in Sri Lanka, often served as a basis for discussions of national identity.

Buddhist monuments and famous works of art such as the Great Buddha or *Daibutsu* in Kamakura, an over fifty-foot-high bronze sculpture of Amitabha (Japanese *Amida*) cast around 1252, were illustrated on posters that extolled the beauties of Japan and promoted tourism. Rudyard Kipling (1865–1936), who mentioned this colossal sculpture in his 1901 novel *Kim*, had praised it earlier in a series of poems he wrote after visiting Kamakura in 1892. The Metropolitan Museum holds three works documenting this impressive piece, which is now classified as a National Treasure: a photograph taken by Shinichi Suzuki (1835–1919) in the 1870s, another taken by Adolf de Meyer (1868–1929), and a watercolor by John La Farge (1835–1910), painted in 1887 after his return from Japan.[8] La Farge, who wrote articles on Japanese Buddhism for *The Century*, had visited Japan with Henry Adams (1838–1918),[9] the

grandson of President John Quincy Adams (1767–1848), with whom he traveled widely in the late nineteenth and early twentieth centuries.

In addition to such casual visitors, other Americans, and in particular Ernest Francesco Fenollosa (1853–1908), who lived and studied in Japan for many years, helped to deepen American interest in Japanese and East Asian artistic traditions. The son of a Spanish-born musician, Fenollosa was appointed as a professor of philosophy at the Imperial University of Tokyo in 1878 and quickly become engrossed in the study and preservation of Japan's artistic heritage. He participated in the first inventory of national treasures, which included the discovery of important Buddhist sculptures and paintings that would have otherwise been destroyed under the *haibutsu kisshaku* policy. In 1880, Fenollosa, who had converted to Buddhism, returned to Boston as the first curator of the recently established Department of Asiatic Art at the Museum of Fine Arts.

His personal collection of East Asian art was sold to the physician Charles Godard Weld (1857–1917) with the stipulation that it was to be given to the Museum of Fine Arts, Boston. An additional gift of over 40,000 pieces donated in 1911 by William Sturgis Bigelow (1850–1926), a friend who had also become a Buddhist, further expanded Boston's position as the center for the study of East Asian art in the United States. Fenollosa also wrote a volume on Chinese and Japanese art (published in French in 1911 and subsequently in English), and his colleague Okakura Kakuzo (1862–1913) contributed influential works such as *The Ideals of the East with special reference to the arts of Japan* (1904) and *The Book of Tea* (1906).

It seems likely that the multifaceted ties between the United States and Japan also helped to spur the establishment of the Department of Far Eastern Art at the Metropolitan in 1915. Many of the works that remain masterpieces in the Chinese and Japanese collections, such as an extraordinarily rare seventh-century dry lacquer sculpture of Buddha Amitabha (Chinese Amitou),[10] currently the centerpiece of the later Chinese Buddhist sculpture display (Figure 24), were acquired in the period between 1915 and 1950. The sculpture was purchased from Yamanaka and Company, a Japanese firm with an office in New York that played an important role in the dissemination of East Asian art in the first half of the twentieth century. C. T. Loo et Compagnie, based in Paris, also played an important role in the development of the museum's collection.

An elegant painting showing the Water-Moon manifestation (Figure 25) of the Bodhisattva Avalokiteshvara (Korean *Gwaneum*), a form that is often conflated with the White-Robed type discussed above, may also have been acquired in Japan. It was given to the department in 1914 in honor of Charles Stewart Smith (1832–1909), a patron and collector who visited Japan on his honeymoon, and who had previously given a collection of Japanese ceramics to the museum in 1893.[11] Although this painting, which shows the bodhisattva seated a promontory overlooking the water, was originally cataloged as Japanese, features such as the shape of the face, the diaphanous drapery, and the pattern of large medallions in the shawl indicate that it was made in Korea during the first half of the fourteenth century. The initial

cataloging as Japanese is not unusual; scholarship regarding Korean Buddhist art, and the role played by Korea in the transmission of Buddhism to Japan, has evolved significantly during the last twenty years, as has appreciation for all aspects of Korean art. The gallery dedicated to Korea, which opened in 1998, was the final space in the development of the museum's Asian department.

The 1915 establishment of the Department of Far Eastern Art resulted in the allotting of two small spaces for the display of its permanent collection as well as for the presentation of special exhibitions[12] on different themes in Asian art history. It is interesting to note that, as was the case with first types of objects collected by the museum, many of these early exhibitions also focused on materials. For example, a loan exhibition on view from October 19 to November 27, 1938 (Figure 26) and entitled *Chinese Bronzes from American Collections* featured both ritual bronzes from the Shang (ca. 1600–256 B.C.E.) and Zhou (1046–256 B.C.E) dynasties, along with fourth- to eighth-century gilt bronze Buddhist sculptures.[13] While there are certain technical parallels between the casting of early ritual bronzes and that of fourth- and fifth-century Chinese Buddhist sculptures, it is unlikely that an exhibition displaying both would be presented today. The disparity in dates for the production of the objects and, more importantly, their divergent cultural contexts would preclude such a presentation.

The large gilt bronze altarpiece[14] shown in the center of the case at the back in the photograph recording this exhibition remains one of the museum's most important works of early Chinese Buddhist sculpture. Extremely rare and complicated, it is dedicated by inscription to the Buddha Maitreya and is dated to 528 during the Northern Wei (386–534) period. This altarpiece is one of two similar works[15] in the

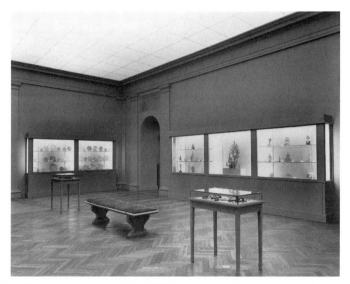

Figure 26 Archival photograph, detail of 1938 exhibition *Chinese Bronzes from American Collections*. The Metropolitan Museum of Art.

collection said to have been found in Hebei Province in 1918 by General Wang Shizhen, sold by Yamanaka to Mr. and Mrs. John D. Rockefeller Jr., in New York in 1925, shown in the 1938 exhibition, and then purchased by the museum. It is interesting to note that the larger and more complicated example, which is the one pictured in the photograph, now has more components. Recent scientific examination of both has determined that two of the small attendants on the second altarpiece belong to the larger piece. It seems likely that they were moved to enhance the appearance and appeal of this second altarpiece when the works came on the market.

Another Buddha,[16] a Japanese sculpture of Vairocana (Japanese *Dainichi*) purchased by the museum in 1926, again from Yamanaka, served as a centerpiece (Figure 27) in the special exhibition *An Aristocracy of Robes: Five Hundred Winters and Five Hundred Springs*, which opened on November 4, 1959, and closed on January 31, 1960. As the title implies, this exhibition, which included loans as well as objects from the permanent collection, was intended as a celebration of the skill and beauty of Japanese textiles, which, like Chinese court costumes, were in vogue at the time, influencing fashion and other types of design. This twelfth-century Japanese wood sculpture of a Buddha, which is now featured in the gallery dedicated to Japanese Buddhist art, would, once again, not be shown with kimono and other costumes in a special exhibition today; nor would a curator install the robes to look as if they are praying to the Buddha, or, in the case of the two placed closest to the sculpture, show them as if they are kneeling.

An Aristocracy of Robes was as much an extravagant celebration of Japanese culture as an exploration of the history of textiles and costumes. It was accompanied by programming that included a tea ceremony, a practice introduced to Japan from

Figure 27 Archival photograph, detail of 1959 special exhibition *An Aristocracy of Robes*. The Metropolitan Museum of Art.

China with certain aspects of Buddhism, as well as links to the 1953 Japanese motion picture *Jigokumon* or *Gate of Hell*. The tragic story of a samurai who loves a married woman, this was the first color film to be released outside of Japan and is filled with beautiful costumes not unlike those shown in the exhibition. This movie, which was inspired by Kabuki Theater and directed by Teinosuke Kinugasa (1896–1982), won the Grand Festival Prize at Cannes in 1954 and an Oscar for best costume design in 1955.

1986: The Department of Asian Art

The change of name from the Department of Far Eastern Art to the Department of Asian Art in 1986 reflects the expansion of the department beginning in 1970, when C. Douglas Dillon (1909–2003), a diplomat and politician who served as the secretary of the treasury from 1961 to 1970, was appointed as the president of the museum's board of trustees. Under the stewardship of individuals such as Dillon and Mrs. Brooke Russell Astor (1902–2007), the museum actively expanded both its collections of Asian art and its gallery spaces to include 54 rooms on the second and third floors of the north wing of the museum, making the collection one of the most comprehensive and extensive in the world. (It is a Western concept to collect art from around the world; those in Asia tend to focus on their respective traditions.)

The galleries are arranged chronologically, by countries, and sometimes by materials.

Some works of Buddhist art, such as stone, metal, or wood sculptures, are permanently on display. Others that are more fragile, such as paintings and textiles, are rotated every six to eight months due to conservation mandates. Buddhist imagery is also found in galleries dedicated to the decorative arts. Only two galleries in the department are dedicated to Buddhist art; both display Chinese sculptures, which represent one of the strengths of the Asian collection. The size and scope of the department's holding of this material can again be traced to the interest in East Asian Buddhism that defined the first half of the twentieth century and to the accessibility of this material, which was acquired from both Japan and China. However, the rationale for the placement of a monumental Yuan dynasty (1271–1368) mural and some of the larger stone pieces in one of these two galleries (Figure 28; see also Figure 24) is also driven by the inevitable and inescapable realities of space and size. The gallery in question is the only one in the department that is tall enough to house this painting as well as the taller of these sculptures. There are also limits as to what can be done with the display in that space. Not surprisingly, the largest sculptures are also the heaviest; they need to be placed above crossbeams or other supports under the floor.

Appreciation for the museum's collection of Buddhist art, which continues to expand through gifts and purchases, has benefitted from the burgeoning of various disciplines within the field of Asian studies, and in particular, the vivacity of Buddhist studies globally over the last thirty years. In addition, archaeological discoveries,

particularly in China, have led to reattribution in terms of dating and provenance and to better understanding of iconography and iconographical programs. Scientific examinations of works of art, such as the two gilt bronze Chinese altarpieces discussed earlier, has also refined the understanding of particular works; carbon-14 and other types of testing can help determine a date, and the analysis of pigments, while also useful for dating, can determine how often a sculpture was refinished before entering the collection.

Wide-ranging interest in Buddhism has also raised new challenges. For example, the understanding that the pagods and magots in European decorative arts were inspired by Buddhist imagery, and the undeniably pejorative nature of these terms, suggests that a new cataloging is needed. However, scholars of European art remain unlikely to be familiar with terms such as arhat or Budai, and there are additional issues regarding which Asian language should be used in which context. *Luohan* is the Chinese term for the Sanskrit arhat; it is pronounced *rakan* in Japanese.[17] The use of any one of the possible Asian terms in the European galleries would undoubtedly be confusing; however, the current cataloging of these figures as "Buddhist disciples" hides the fact that such figures, cataloged more precisely, are also on view in the Department of Asian Art. While cross referencing solves some of these issues when the collection is online, the size of the Metropolitan Museum makes it unlikely that any viewer can easily see all the works of art in question or readily grasp the complexity that underlies the development of these bizarre European images.

Like most Western museums, the Metropolitan Museum has a department dedicated to the study and collecting of modern and contemporary art, which is defined as dating from 1900 onward. The establishment of such departments was initially based on the Eurocentric and inaccurate presumption that art would continue to be made in the West but that the East, particularly in the first half of the twentieth century, was no longer viable. It was assumed that the institution would stop collecting Asian art at some point, or that Asian traditions would not change over time. Asian art would then parallel departments like those for Greek and Roman or Medieval art, which covered a specific time period; works of art dating roughly to after the fourteenth century are housed in the European Painting and European Sculpture and the Decorative Arts Department. In contrast, the Department of Asian Art covers half the world and all of time. Discussions continue regarding which department should acquire and display contemporary works of art produced in Asia, or by Asian or Asian American artists working in the West, or by any of the many artists (working anywhere) inspired by Asian traditions, including Buddhism. In some cases, such as that of a collage entitled *Dissected Buddha* by Gonkar Gyatso (born in 1961) that is currently on loan to the museum, a piece that fit beautifully into the Asian galleries during a recent rotation (Figure 29), which has now been replaced, and which focused on exchanges between India and Tibet. In other cases, the Buddhist inspiration, either visual or conceptual, is not as obvious, and the work of art in question may fit more readily into the rubrics such as modern and contemporary.

Finally, engaging the over 6,000,000 annual visitors to the museum and gauging their needs and interests can be challenging (if not impossible) in a museum that has global collections, many of which represent religious traditions: and, in some cases, such as the Greek and Roman Department, traditions that have disappeared and are considered "pagan." It is unlikely that every visitor to the Department of Asian Art is familiar with Asian art in general or Buddhist art in particular. It is hoped that most visitors benefit from explanations found on the text panels that help explain why a group of objects are shown together, or on the labels that provide information regarding individual objects. Some, on the other hand, may be religious practitioners for whom the works can serve as the focus of worship or devotion. The global holdings of the museum and the size of the audience often lead to crowded galleries, which can make practice, or even the slow, scholarly examination of a work of art, challenging. This is unfortunate; such crowded galleries are, however, a blessing from the perspective of curators who labor to make the didactic material informative and the works of art on view accessible and engaging.

8 Mapping Cultures, Digital Exhibitions, Learning Networks: Creative Collaborations at Austin College and the Crow Collection of Asian Art

IVETTE M. VARGAS-O'BRYAN

I often quietly observed Isaac teach the Unity 3D program, Jessica develop the class video, Charlotte and Qian arrange the images from the Crow Collection of Asian Art (CCAA) and the Rubin Museum of Art on the Omeka website, Katie and Todd tackle animations on a map, Zhiwei explain the purpose of QR codes, Lexi illustrate Newar art and Buddhism, Sara demonstrate Tibetan music, and Kacey express excitement about the exhibit. During these times, I was struck by the thought that as educators, we can talk about student learning goals and engagement using all the latest pedagogical phrases like outcome-based, inquiry-based, or experiential learning; high-impact practices; triangulation theory; and so forth, in which learning is supposed to be organic, engaging, productive, cooperative, and self-initiated, and here I was witnessing it all. Museum education programs spend considerable time and money in order to engage audiences, create participatory experiences, and represent the "traditional" (Golding and Modest 2013; Simon 2010). In this case, I was the lucky participant-observer in my own religious studies course, where I had to let go (as the Buddhist tradition would say) of manufactured knowledge and preconceptions and be taught, as magic was occurring at every meeting, including the final project, the exhibition.

This is a story about productive collaborations and active learning between a liberal arts college, a museum, and international scholars and artists online, which produced a museum exhibit in over one semester and a summer of discussions. It is also about representation and cultural preservation. This chapter examines the use of the digital humanities in the Mellon Foundation–funded course project "Mapping Cultures, Tibet," which took place at Austin College (Sherman, Texas), the Trammell and Margaret Crow Collection of Asian Art Museum[1] (Dallas), and online as a tool for collaborative engaged learning and creative interpretation about Tibetan religions and cultural interactions through the arts. This chapter will primarily focus on the formation of collaborative teams, the representation of images, the creative layers of interpretation, and the cultural preservation.

The Pedagogical Lens of the Mapping Cultures Project: Collaborative Mapping, The Digital Humanities, and Tibetan Cultures

To ask for a map is to say, "Tell me a story."

<div align="right">(Turchi 2004: 11)</div>

As Peter Turchi notes in his study of maps, this is a project that tells a story about a culture and its interpreters, embedded in relationships of religion, politics, and social dynamics. "Mapping Cultures, Tibet"[2] was envisioned as a multifaceted undergraduate course-project that focused on exposure to the complex Tibetan cultural, particularly religious, relationships and cultural preservation aimed at a diverse audience (specifically, college students, museum visitors, and online researchers). First, mapping in the widest sense of the word provided a way to systematically lay out the dimensional quality, especially development, hierarchies, and relationships of the subject matter. In this case, it was to think about how a culture has been presented over time and how to represent it for diverse audiences—and this required collecting, reflecting, discussing, organizing, applying, and presenting materials in traditional and new and informative ways.

In addition, the history of Tibetan Buddhism in particular is one of intersections and collaborations with other cultures often reflected in texts and images. The representation of Tibet in religious and cultural perspectives has been fraught with challenges (Harris 2012). In order to engage students in the complexity of Tibetan religion and cultural relationships, a hybridic pedagogical approach combining traditional methods in the liberal arts with technology, particularly the method of the digital humanities, was utilized. Sean Michael Morris and Jesse Stommel (2014) further clarify the pedagogical lens, stating:

> Hybrid Pedagogy provides a platform upon which participants can engage in meta-level thinking about teaching and learning. We focus less on building an archive for the preservation of ideas, and more on building networked communities of inquiry consisting of scholars, pedagogues, alt-academics, post-academics, and students.[3]

The term "digital humanities" (or alternative terms like digital pedagogy and digital research) has been defined in various ways[4]; in general, it provides an opportunity to expand the horizons of pedagogy in the humanities by exploring teaching and learning through the use of digital resources in courses and projects.[5] What the digital humanities allowed us to do was to represent Tibetan religious traditions and cultural relationships beyond the traditional modes of representation such as the display of art objects in a museum without dismissing the value of that approach. It also allowed a different sort of depth and creative interpretation not possible before in a classroom based on a collaborative interpretive lens. Rather than focusing

solely on the traditional medium of textual analysis and interpretation in a classroom setting, which would have attracted a limited, specialized undergraduate audience of majors and minors in a given field like religious studies or art history and the typical delivery of material, the digital tools facilitated a more complex interpretive lens from a diverse student cohort and teams of experts. In this project, the juxtaposition of the study and use of religious and historical texts, anthropology, the arts, museum education, and connoisseurship with technology utilized by collaborative teams (consisting of Austin College students, scholars, museum staff, and artists in Texas and Asia chosen for their skill sets) facilitated multiple perspectives and creative interpretations that went beyond one specific field of study or discipline or one particular method.

Critical to effect multiperspectival mapping was the development of "learning spaces," sites that facilitated engagement in traditional and evolving pedagogies. In "Mapping Cultures, Tibet," mobile classroom spaces situated within three locations—the traditional college (Austin College), a museum (CCAA), and online with several scholars and artists in Nepal and China—made possible interactions with diverse materials and collaborative learning (Figure 61, on website) based on the skills and the experiences of the collaborators.[6] The locations also became sites where teams of collaborators worked together either to provide background and/or engage directly on project development (Figure 62, on website).[7] For example, the locations became flexible learning spaces where at one time, we would meet in a traditional classroom, another time in a museum, and another time in a lab listening to a lecture from China or Nepal. Each "location" provided a new perspective for the visual, written, and digital maps and projects that were envisioned and constructed by students and collaborators.

After several intensive weeks of collecting and documenting traditional historical and literary materials as well as art objects, films, photographs, and other resources from our collaborators in Dallas, Texas, and abroad in Nepal and China, followed up by reading, discussing, writing, and blogging about the materials with lecturers from the college, museum and institutions abroad and amongst themselves student participant-researchers, along with museum staff and myself, produced an exhibition at the CCAA entitled *Taking Shape: Perspectives on Asian Bronzes* at the CCAA. This was under the curatorial direction of Caron Smith (CCAA curator) and myself, the director of "Mapping Cultures, Tibet." CCAA staff particularly Director Amy Hofland, Austin College alum Agathe Dupart, the current curator, Karin Oen, Digital Marketing Coordinator Kasumi Chow, and others provided critical support during the entire process. Utilizing images mostly from the CCAA permanent bronze collection which were enhanced digitally, some objects from the Rubin Museum of Art in New York, other media resources like documentary films, and textual materials, students had the opportunity to create a juxtaposed space where digital projects and research on the Web-publishing site Omeka[8] and on iPads were placed in conversation with an onsite exhibition of bronze objects.[9]

The Art Objects and Sacred Subjects in a Juxtaposed Exhibition Universe: A Participatory Representation of Images through Communities of Inquiry

Taking Shape was the culmination of a multilayered project based on traditional research, including the methods of museum education enhanced by digital technology in order to represent Tibetan Buddhism and cultural relationships through the arts. In art history and literature, the term "representation" has been used in numerous ways; it is a foundational concept in Western aesthetics and semiotics with a modern political understanding. Representation implies that people organize the world and reality through the act of naming. As W. J. T. Mitchell notes, "Representation (in memory, in verbal descriptions, in images) not only 'mediates' our knowledge ... but obstructs, fragments, and negates that knowledge" (Mitchell 1994: 188). Because of the need to represent what was read and viewed from multifaceted perspectives so as to create a somewhat balanced and inclusive view of Tibetan religions and cultural relationships through the arts, the central focus of "Mapping Cultures, Tibet" became to devise, as much as possible, diverse interpretive lenses around Buddhist and other related images that had cultural resonances to Tibet. The project's goal for the representation of images was based on the premise that the images were not merely objects of art to be viewed in a museum or classroom setting (or, by extension, images linked with words on a page and intellectually processed), but, as Richard H. Davis has noted about Indian images, as "social beings whose identities ... are repeatedly made and remade through interactions with humans" (Davis 1997: 7–8). The use of the images also crossed borders culturally and symbolically, from secular objects representing technological development in the history of art to the sacred subjects of Buddhist scriptures and practice with cultural resonance.

For the bulk of "Mapping Cultures, Tibet," each team of collaborators, through mini projects, created layers of interpretation that juxtaposed the museum display of objects with digital animation and research projects. Briefly, this section will review some of the results of this collaborative work, which merged images and texts.

The Onsite Exhibition

At the museum site, the curators devised a two-pronged exhibition centered on relationships connected to Tibet that were forged through the arts; one side focused on bronze-casting technologies, and on the other, the religious and cultural relationships through style, doctrine, and ritual significance. The latter was the side that the teams of collaborators made their major contributions. The physical thematic exhibition worked on by the collaborators utilizing mostly bronze objects from the CCAA collection, displayed five major themes in display cases: gurus, major figures, protector and healing deities, meditational healing deities and *yidams*,[10] and border-crossing figures (Figure 63, on website). These images were surrounded by

other larger and miniature Buddhist images and ritual implements positioned on platforms and in display cases. In this layout, it was critical to show that although the images originated in diverse locations from South Asia, Tibet, Nepal, China to Japan, they also converged in their long-term and significant relationships with Tibet, particularly from the sixteenth to the nineteenth centuries, as reflected in the religion and the arts. Some of these relationships had a political nature to them; one example is represented by the pair of Jadeite bowls inscribed with selections from Buddhist scripture in Tibetan script, such an object symbolizes the meeting of Chinese and Tibetan cultures or the co-option of Tibetan cultures by the Chinese Qing Dynasty (Figure 30).

The theme of relationships was further examined in the section showcasing the development of bronze casting technologies across Asia. This comprised images in display cases representing the transfer of patterns, musical qualities, the lost-wax technique, molds and ductile qualities, and surface treatment and inlays with interpretations on museum placards reflecting cultural relationships with Tibet through technology. Finally, a lama table with an image of Gautama Buddha surrounded by ritual implements was positioned in its own display case across from the penta-themed display cases, while a Tibetan *thangka* (cloth painting) was placed on the almost opposite wall in an adjacent corner. This corner was transformed during the "opening" event of the exhibition into a practice space where a Buddhist monk in the Tibetan tradition gave a dharma talk and led a meditation with the participation of museum visitors and student-collaborators.

The convergence of textual knowledge with physical image was further enhanced through the use of 3-D visual technology. Here, multidimensional representations of key figures in Tibetan Buddhism that crossed cultural borders made possible a different depth of engagement with the images.

3-D Visual Technology

One of the underlying concerns of the projects and final exhibition was to provide a venue for representing Tibet an culture historically and in contemporary contexts; however, because of Tibet's turbulent political history and current situation, there were challenges to address in order to bridge the gap between representing the past and the present as well as the secular (object) and the sacred (icon). One of the ways in which the representation of Tibetan Buddhism and cultural relationships through art maintained both a traditional outlook and a flexible and creative interpretation at the same time by both the producers and the audience was through the use of 3-D animation[11] exhibited on iPads (see Figure 68, on website).[12] Increasingly today, virtual 3-D environments become sites through which religious and spiritual topics are presented and continuously negotiated (see Radde-Antweiler 2008; Wagner 2012), yet here there was also negotiation between the sacred and the secular worlds.[13] Through the use of 3-D animation, the images from the CCAA permanent collection important to Tibet an culture were transformed into animated

figures that moved and were placed in a recreated digitized Tibetan landscape (Figure 31), with a voiceover narrating one of the famous stories of the Bodhisattva Avalokiteshvara (Tibetan *Chen ras gzigs*) (Figure 64, on website). The narrative recalls the bodhisattva viewing and taming the wild land of Tibet, interpreted as lacking the civilizing effects of Buddhism. Textual background derived from readings like the Mani Kabum, a heterogeneous collection of Buddhist teachings and myths focused on the cult of the Bodhisattva Avalokiteshvara particularly as the patron deity of Tibet, provided a narrative foundation for the permanent collection about the transformation of Tibet from a land of violence and chaos into a "civilized Buddhist holy land" (see Dpal–'byor-bzang po 1983: 124–5; Kapstein 2006: 2; Kapstein 2013: 90–107 for instances of this narrative appearance).

One of the critical results of using this visual technology was the transformation of fluid space (geographic and cultural Tibet, and imaginative interpretations of these lenses) into a bounded place (the mapped-out converged imagined and real Tibetan territory with Buddhist images), one that harkens back to ancient Tibetan concerns for the land of Tibet as religiously and culturally significant (Huber 1999).[14] This connection of Tibetan culture with the land of Tibet has been utilized by contemporary Tibetan artists like Tenzin Rigdol to symbolize Tibetan identity; in his case, the actual land of Tibet was used as a central element for representing Tibetan culture as inextricably linked with its landscape (in the case of Rigdol, using dirt transported from Shigatse, Tibet) (Jolly 2011).[15] Rather than de-territorializing "Tibet" and its culture, that is, removing it from its land of origin, "Mapping Cultures, Tibet" represented the land of Tibet as described in texts and imagined by project producers through modern technology, thus maintaining traditional notions of Tibetan Buddhism as being tied to a particular land and cultural relationships.

What was also significant was that this new and yet old topography, drawing from a traditional narrative, was mapped out with Buddhist images; seven figures and two ritual implements placed on the landscape created several layers of interpretation themselves. With the transposition of the objects from the onsite exhibition into a 3-D dimensional landscape, the sacred significance and cultural resonance of the images became apparent through an active visual dimension. On the interpretive level, this technology facilitated the collapsing of borders between the secular and the sacred. In other words, there was a transformation of art objects to "animated" icons and a repositioning of them to a sacred space than what was possible with the onsite exhibition of objects (see Barasch 1992 for an example of this transformation in the Christian context and Davis 1999 on how images are enlivened).[16] On a subtle level, the figures suspended on a digitized Tibetan landscape (see Figure 31), it was reminiscent of early Tibetan Buddhist narrative accounts of the *srinmo*, the demoness lying on her back signifying native traditions in Tibet, with the Buddhist temples literally pinning her down, that is, the civilizing and appeasing effect of Buddhism on the indigenous traditions (Gianotti 2010: 69–97).

More explicitly, besides the symbolic power of the civilizing effect of Buddhism, figures on the digital map signified the transmission and borrowings of religious

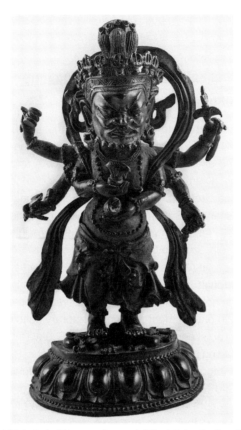

Figure 32 Six-armed Mahakala (Nag po chen po), Tibet, late nineteenth century. Bronze. Crow Collection of Asian Art.

traditions between cultures that centered on Tibet. For example, Avalokiteshvara (Figure 64, on website) is the central religious and political figure in Tibetan history who not only "appeased" the ground on which all the other Buddhist figures later stood, the land being central to Tibetan culture; he is also symbolic for linking Buddhist Asia throughout the centuries and merging the sacred with the secular in the *sprul sku* (reincarnation system relevant to Tibetan Buddhism). Ganesh/ Ganapati (Figures 65 and 66, on website) represents the close interrelationship between Hinduism and Buddhism as well as between India and Tibet. The figure of the *mahasiddha* in the exhibition represents the idealization of narrative genres onto the Indian landscape through Tibetan ideologues. Others like Mahakala (Figure 32 and Figure 67, on website), Kalachakra, and Parnashavari reflect the transmission and adaptation of Indian Buddhist figures in the Tibetan Buddhist landscape and their central significance in Tibetan Buddhist history and throughout East Asia. Finally, the ritual objects represent the Vajrayana of Tibet, focused on tantric ritual practices[17] (Figure 32). This 3-D visual technology took to a new level the traditional networks of communication and influence between the cultures represented by the objects

displayed in the museum making possible potential new creative visual interpretation of the virtual relationships by the audience-viewers.

The Research Dimensions in Visual Technology and Cultural Preservation

What further reinforced the interpretive value of these 3-D figures juxtaposed against the onsite exhibition were projects displayed on the class website using Omeka. This included an online image display of CCAA and Rubin Art Museum objects with captions; an archive of research papers and annotated bibliographies documenting students' research progress regarding Tibetan culture, religions, and the arts; a glossary of Buddhist terms; and a collection of biographies of contributors.[18] These research projects not only provided background and cross-cultural materials, some even enhanced the visual content by presenting the voices of local communities of art collectors and artists in Nepal, Tibetan filmmakers and Buddhist practitioners in Tibetan communities in the Tibetan Plateau as well as scholars abroad. The local perspective took the art objects directly into a practice environment and contemporary cultural contexts.

For example, local artist and art collector Naresh Shakya from Nepal contributed to the project by providing the Newar perspective on Tibetan Buddhist development through the arts. His informative lectures via skype on Buddhist art which included the use of images and his guidance of student-collaborator Lexi Levy's research on illuminated manuscript paintings provided other views of Tibetan Buddhist art and cultural relationships that were not always evident in the physical or digital display of the objects themselves. With this collaboration it became clear that the exhibition objects enhanced digitally in a 3-D landscape and through research and displays on a website were representing a complex network of cultural relationships involving Newar artists who traveled to and from Tibet to produce art and impact the culture.

In addition, the inclusion in the exhibition of the Plateau Cultural Heritage Protection Project, a UNESCO and Bridge Fund organization that trains Tibetan youth in videography in order to preserve cultural heritage on the Tibetan Plateau, accentuated the underlying concerns of the larger project—cultural preservation.[19] Documentary film footage of local rituals and downloaded music of contemporary Tibetan communities in Qinghai, clips documenting local Tibetan filmmakers, and a class video on the contributions of the Tibetan student videographers group allowed the images in the exhibition to be seen through a more local, cultural, and contemporary lens. It was no longer simply about static displayed art objects, an archival database on Tibet, or even virtual imagined sacred icons, but a representation and display of an active Tibetan culture in ritual and narrative contexts reflecting a rapidly changing context providing depth to the material objects in the exhibit.

The Video

One of the unanticipated results of this creative production of an onsite and online exhibition and website research archive was the production of a class video. This video production coalesced the work of Tibetan artists and videographers abroad, and that of teams of collaborators in Texas and Asia in order to display the virtue of cultural preservation through technology. This final project became an example of the multimedia dimension of "Mapping Cultures, Tibet."

Conclusion

> On this beautiful thousand-string lute that conveys the truth,
> There are one thousand changing notes that are factual and correct.
> You who have taken up and sung
> This unblemished song of our history
> Have awakened many beings from enduring sleep.
>
> (Jamyang Norbu 2013)

As Jamyang Norbu implies with his reference to a "thousand changing notes," the "Mapping Cultures, Tibet" project required several methods that exposed and facilitated to project the underlying layers of meanings that wrapped around the image of "Tibet." I was reminded of the Tibetan artist Gonkar Gyatso's exhibit *My Identity*,[20] in which he appeared in four photographs with different garb and transformed spaces depending on ideological changes and cultural representations (and co-options). His work reflected convincingly that despite the external changes and relationships he has experienced, he is still the same cultural person, the same artist, a Tibetan, going through his own ideological journey and activism, transported but maintaining identity through art. "Mapping Cultures, Tibet" challenged the notions of representation of traditional classroom learning and museology by focusing on hybridic pedagogies made possible through collaborative engagement between communities and individuals on a local and global level and technology. In the end, the displays and repositioning of objects/icons using traditional and virtual mediums attempted to deconstruct static notions of a representative Tibetan culture through religion and art and to open up conversations about Tibet and its representations. Overall, "Mapping Cultures, Tibet" was an experiment worthy of the experience.

List of Student-Researchers and Collaborators

Austin College Students

Sara Alary, Katie Armstrong, Zhiwei Cai, Isaac Cirlin, Kacey Eichen, Alexandria Levy, Qian Li, Todd McCormack, Jessica Nickasio, Charlotte Wright

Collaborators (abroad and in Dallas, Texas)

Crow Collection of Asian Art (Dallas, TX) especially Amy Hofland, Caron Smith, Karin Oen, Agathe Dupart, Kasumi Chow, Abraham Carillo, and Danny Skinner
Plateau Culture Heritage Protection Group (PCHP, Xining, China) and Klu rgyal 'Bum (director)
Dr. Gerald Roche (anthropologist, China)
Elena McKinley (instructor, Qinghai Normal University)
Naresh Shakya (art collector and artist; Ph.D. candidate in art history, Nepal)
Dawa Drolma and Wendekar, Tibetan Independent filmmakers (China)
Devin Gonier (instructor, Qinghai Normal University, China; Shambhala Institute)
Rubin Museum of Art Foundation and Museum (New York)
Shawn Green, Palyul Changchub Dhargyayling Dallas and Buddhist Compassion Center (Dallas)
Nick Sherman (videographer in Dallas, Texas)
Lama Tashi Nyima (Dallas, Texas)
J. Marshall Pittman, Collin College
Nancy Hairston [nancy@sculptcad.com]
Rubin Museum of Art (New York)

Austin College Collaborators and Supporters

Professors Patrick Duffey, Aaron Block, Mike Higgs, Brad Smucker, Brett Boessen
IT staff members Bill Edgette, Thomas Carter, Garrett Hubbard
AC Alum Chris Stoll and Simon Frazier
Mason Makarsvich (filming)

Other Supporters

Gray Tuttle, Columbia University
Spencer Keralis, University of North Texas
CUNY Digital Humanities Initiative and the CUNY Academic Commons staff
Rebecca Davis, NITLE

Part 3 Religions, Museums, Memory

9 Curating Asian Religious Objects in the Exhibition *Sacred Word and Image: Five World Religions*

JANET BAKER

The exhibition *Sacred Word and Image: Five World Religions* was organized in the spirit of fostering a better understanding of our commonalities and differences as people belonging to various religious traditions. Humble in size but vast in concept, it allowed viewers and readers to compare the basic ideas and practices and the rich variety of visual and textual means of expression which have characterized Buddhism, Christianity, Hinduism, Islam, and Judaism in the past 1,500 years. By comparing works from several religions, the cross-cultural and historical continuity that affected all of them can be traced across the Eurasian continent and beyond. The variety of materials used to document humankind's significant thoughts and beliefs during this long time span is astonishing: paper, palm leaf, vellum, wood, lacquer, silk, metal, and ivory.

In some instances, complete manuscripts or objects allowed viewers to perceive the original artistic and literary vision of the scribe and artist. Other examples preserve the decorative and symbolic images that tell a visual story linked to the tenets and values of a religion. These sacred objects were created to be used as part of rituals and devotions within their respective traditions. They embody in their sheer physical nature the ephemeral experiences of faith, forgiveness, redemption, purity, beauty, compassion, and sanctity. In an age when the printed word and image have been transformed into electronic form, it is revelatory to see how past civilizations used many languages as well as the means available to them at the time and in the place where they were created to produce lasting documents of thoughts, visions, beliefs, and hopes for a better world, both in the present and in the future.

This exhibition was conceived and executed under particular circumstances. In 2009, following the economic crisis in America, Phoenix Art Museum's then director James K. Ballinger instructed curators to create exhibitions "that draw upon the Museum's collection and those of local collectors, and to think of new perspectives to present objects that will open the eyes and minds of our visitors to new ways of thinking about art and culture." All of this was to be done on very limited budgets.

Sacred Word & Image: Five World Religions drew upon five Phoenix collections: those of Pari and Peter Banko, Amy S. Clague, Lionel Diaz and Jacqueline Butler-Diaz, Drs. Barry and Colleene Fernando, and James and Ana Melikian, in addition to the museum's own collection. More significantly, it produced the museum's first

electronic catalog, with no printed copies. Four authors contributed six essays to the catalog, which featured 157 pages and 184 photographs illustrating sixty objects (numerous objects had multiple pages or details). Total expenses (including honoraria, photography, catalog and exhibition design, and a brochure) did not exceed US $20,000.

The catalog brought together scholars from different disciplines and areas of world culture. Three of these essays were written by my colleagues Dr. Stephen Batalden, director of the Melikian Center for Russian, Eurasian and East European Studies at Arizona State University; Dr. Zsuzsanna Gulacsi, professor of Asian religious art at Northern Arizona University; and Dr. Sherry Harlacher, director of the Denison Museum in Ohio. It was a pleasure to work with each of them, and I thank them for their unique and excellent contributions. The remaining three essays were written by me. While the catalog essays covered the objects using the more traditional scholarly approach of tackling each religious tradition separately, with one essay discussing the interrelationship of the three religions of the Abrahamic tradition, I felt as the organizer that the presentation of the objects should not follow that approach, which would be too predictable and not encouraging of "new ways of thinking about art and culture," as Ballinger had admonished. Thus, I pondered what the most relevant and thought-provoking themes might be among the objects that I had selected from the aforementioned collections. While reviewing the photographer's finished digital images, ideas began to form in my mind. With little effort, this led to the five themes presented and discussed below: "Sacred Spaces and Places," "Language as Transmission," "Otherworldly Visions and Miraculous Events," "Symbols of Power," and "Divine Beauty." The installation layout and the brochure available in the exhibition reflected these themes.

To my knowledge, no other American museum has offered an exhibition that encompassed the five major religions of the world. Perhaps that explains the attention that this exhibition drew when it opened. Though small in its physical size, its outreach and impact resonated and has continued to do so. Opening on January 4, 2012, it was picked up a full month beforehand by *ARTSlant Worldwide* (December 7, 2011) with a photo and lengthy description. Coverage by the *Huffington Post* followed on January 26, 2012, and then the local press finally took note on January 29, 2012 with a full review by Richard Nielsen in the Sunday edition of *The Arizona Republic* (January 29, 2012), featuring three color photos. While Nielsen was known for his occasional dismissive comments about Phoenix Art Museum exhibitions, he did not offer such in this instance. Instead, he filled his review with what was generally agreed to be sincerely reverential reflections and a long quotation from this author's catalogue introduction.

Following the exhibition's closing on March 25, 2012 at Phoenix Art Museum, I assumed that was the last that would be said about *Sacred Word and Image: Five World Religions*, but I was mistaken. While the exhibition did not travel elsewhere due to the fragility of many of the objects, it has had an afterlife. Bruce M. Sullivan's scholarly review in *Material Religion* offered a succinct and balanced view of the

exhibition, which concluded with my comment regarding the public's response to the exhibition: "Not a single negative comment was registered from museum visitors: no one took the juxtaposition of sacred objects from the various religions as an act of irreverence." Indeed, as Professor Sullivan described it, the "250 linear feet of wall space, plus display cases in the middle of the gallery's floor, displayed objects so that one or more objects from one religious tradition were juxtaposed with similar objects from other religions. … Thus, Armenian Christian liturgical and clerical paraphernalia were next to a Buddhist monk's diadem worn for Tibetan tantric rituals" (Sullivan 2013: 532–4). This chapter describes my experiences and insights regarding *Sacred Word and Image: Five World Religions* with a broader audience through inclusion in this scholarly publication. Here I have chosen to focus in greater detail on a selection of Buddhist, Hindu, and Islamic objects from the exhibition, not all of which are depicted in images.

Sacred Spaces & Places

Reliquaries are containers either of the physical or bodily remains of saints or holy persons, or of written prayers. The veneration of holy relics has a long tradition in Christian, Islamic, and Buddhist practices. As Buddhism spread across Asia to China, Korea, and Japan, the form of the reliquary changed.

In 322 BCE, following the death of Alexander the Great, Chandragupta Maurya emerged as sovereign over an empire in India. During this period of great cultural, political, and religious development, Chandragupta's grandson Ashoka (r. 272–232 BCE) became the earliest and most renowned imperial patron of Buddhism. His conversion to the teachings of the Buddha, following the horrors of the battlefield, led to a propagation of those teachings across Asia through massive building projects and the sending of Buddhist envoys to the Hellenistic and the Singhalese worlds. His self-view as Chakravartin or ruler who set in motion the wheel of Buddhist law through the spread of the dharma became an example for later imperial leaders in Sri Lanka, China, Japan, and beyond.

At the demise of the Buddha, his ashes, following a custom long reserved for nobles and holy men, were enshrined under artificial hills of brick or earth. Emperor Ashoka is said to have distributed the Buddha's bodily relics into *stupas* throughout the realm. This enabled worshippers to think of the Buddha as a physical reality. The basic design of the stupa embodied precise orientation and proportions of the whole and its various parts, thus becoming an architectural diagram of the cosmos.

In Sri Lanka, the concepts of the Chakravartin and the stupa came to be embodied in the first historical dagaba (stupa) built in Kandy in 250–210 BCE by Devanampiyatissa; it houses the famous tooth relic of the Buddha. The form of Sri Lankan dagabas strongly echoes that of Indian prototypes—a square base topped by a hemispherical dome representing heaven, surmounted by a mast symbolizing the world axis, which in turn supports a multitiered spire representing the gods. A bronze example from the twelfth century dates from the reign of King Parakramabahu I and may have been

made for the ashes of a respected monk. During the Polonnaruva period, the shape of the half-dome became slightly attenuated (Listopad 2003: 29–36).

Buddhism spread across the Asian continent via land routes that traversed the arduous mountains and deserts of Central Asia and Western China, moving then into Korea and across the sea to Japan. First introduced to Japan from China during the reign of Prince Shotoku Taishi in the early seventh century, the new belief brought the written Chinese language to a previously illiterate Japan. The accompanying rituals, images, and architectural structures of Chinese Buddhism were soon copied in Japan under imperial sponsorship. By the Nara period, named after the city that was the capital from 710 to 784, a broad embrace of Chinese Tang Dynasty culture had been achieved with the goal of making Japan a "Buddha-land."

Empress Shotoku (r. 749–58 as Koken and 765–69 as Shotoku) patronized Buddhism due to her desire to make penance for the loss of life caused either by a smallpox epidemic in 735 or by the suppression of the Emi-no-Oshikatsu Rebellion in 764, leading to the creation of many small reliquary shrines. According to the official histories, the empress ordered one million of these pagodas to be made and distributed among the ten major temples in the Nara vicinity (Sewell 2003: 123).

The form of the wooden reliquary echoes that of early Buddhist architecture in China and Japan. The *sutra* or text contained inside was probably produced by woodblock printing and is one of the oldest surviving examples of printing known in the world today. Within each of the reliquaries was placed one of four different prayers drawn from the *Wugoujing Kuangjing*, a Chinese translation of a Sanskrit text (in Japanese *Mukujoko Daidarani-kyo*). Each of the four prayers begins with the same opening phrase or title, which translates roughly as "the purity of prayer," reflecting the empress's desire for a spiritual cleansing following the catastrophes that had occurred prior to or during her reign (Hunter 1978: 68–9).

A Japanese bronze container for sacred scriptures echoes the structure of the pagoda or reliquary. The container has a lotus finial on the lid and an inscription (now very obscured) which reads *Koan kannon-tatsu sannen nigatsu juichinichi* (Second month, eleventh day of the third year of the Koan era 1280). An example of such a container being used is recorded during the rule of Taira Kiyomori. Copies of the *Lotus Sutra*, chapter by chapter, were placed into ornamented bronze containers and presented to a Buddhist temple in 1164. The *Lotus Sutra* has twenty-eight main chapters, opening and closing chapters, a dedication, and other documents. It is one of the primary scriptures associated with the Tiantai (Japanese: *Tendai*) sect of Buddhism, founded in China in the sixth century. Regarded in this tradition as the fullest and most perfect of the Buddha's teachings, the *Lotus Sutra* affirms that Buddha-nature is inherent in all living beings and validates the use of all possible means to bring about salvation. Other teachings came to be regarded by the Tendai sect as earlier stages of the Buddha's transmission of doctrine (Baker 1993/4: 206).

Buddhism spread across northern Asia by land and reached Southeast Asia by sea. A marvelous example of the idealized Buddhist sacred space is the Burmese *hpaya khan* shrine, which is a miniature version of a temple building (Figure 71, on

website). It was likely produced in the Shan state in northeast Burma during the mid to late nineteenth century as a devotional object that would have accrued merit for the donor. The shrine demonstrates several uses of lacquer: lacquer used to gild wood, lacquer charged with cinnabar to provide a red pigment to contrast with the gold, and lacquer used as a cement to hold colored glass and mirrors (Isaacs and Blurton 2000: 126–8). The intricate patterns of scrolls, flowers, lozenges, and beading are characteristic of the richly ornamental style of the period and contrast beautifully with the simple yet elegant naturalistic modeling of the figures. Each has an inscription on the front of its base, indicating the disciple's name; and on the back of its base, indicating the directional orientation.

The shrine is elevated on legs with ball and claw feet to denote the transition from the earthly realm to that of the Buddha. At the top of the stairs, an intermediary transition is created by a terrace enclosed by a railing, upon which are seated eight disciples, each positioned on an assigned directional point of the compass. Their gazes are focused on the Buddha, who sits above them with his hands in the earth-touching *mudra*, symbolizing his call to the earth to witness his enlightenment. Above the Buddha, a five-tiered roof represents the mythical Mount Meru which exists at the center of the Buddha's cosmos and symbolizes spiritual ascent. The eaves are carved with various Buddhist symbols such as the peacock, which represents the Buddha's compassionate watchfulness. The five tiers are crowned with single finial pointing heavenward.

Prayer mats and carpets in Islam create a holy space for the sacred act of devotion by an individual wherever they may actually be at the time of the daily calls to prayer. A Turkoman prayer rug shows two distinct and identifiable architectural images. On the left is the sacred structure of Mecca, the Great Mosque, which contains at its center the Ka'ba, a cuboid-shaped building containing the Black Stone believed to have been sent to Ibrahim and Ismail from angels in paradise. No matter where they are on the planet, all Muslims turn in prayer five times a day to this location. Pilgrimage to Mecca is a lifetime goal of Muslims and one of the Five Pillars of Islamic practice. On the right is the mosque at Medina, where Muhammad died and was buried, the second holiest site of Islamic pilgrimage (Baker 2012: 136–50).

Language as Transmission

The written word is associated directly with sacred concepts and embodies those ideas literally in writing. The process of transforming oral traditions, rituals, and beliefs into the written work increases the degree of permanence and sanctity of that work. In Islam, the original language of the prophet Muhammad, Arabic, is the only acceptable one to be used in order to maintain the perfection of divine word as transmitted from Allah. A *Qur'an* produced in China during the Qing dynasty shows the influence of traditional Chinese motifs of landscape and bird-and-flower painting interspersed with traditional geometric Islamic motifs (Gulacsi 2012: 120–5) (Figure 72, on website). Other religions permit the translation of sacred texts into

the native languages of the people who embrace their teachings, leading to the development of bilingual or even polyglot language editions.

Buddhist writers recorded the major events of the Buddha's life, such as his birth, his departure from his princely home, and his quest for and moment of enlightenment. The exhibition included a long and beautiful indigo scroll with gold ink from Japan, elucidating the later tenets of the Nichiren sect, which emphasizes that all people have an inherent Buddha-nature and the capacity to achieve enlightenment during their present lifetime. This Buddhist sutra is made from individual sheets of handmade paper about 18 inches in length, which have been glued together horizontally; on these sheets the text is written by multiple hands within silver ruled lines. The writing is read from top to bottom and from right to left. The *Muryogi-kyo* is the introductory text of three canonical texts of Nichiren Buddhism: *The Sutra of Innumerable Meanings, The Lotus Sutra*, and *The Sutra of Meditation on the Bodhisattva of Universal Worthiness* (Baker 2012: 19–20). This particular copy was created for Jyoju-in Temple in Kamakura, Japan, and was most likely used for ceremonial and decorative purposes while at the same time maintaining the functionality of knowledge transfer. Members of the Japanese aristocracy commissioned scrolls such as these as a way to ensure their wishes were noted during temple rituals. Commissions such as this provided funding for the daily operations of the temple.

Nichiren Buddhism was founded in Kamakura in Japan in the thirteenth century by the monk Nichiren, who believed in the supremacy of the *Lotus Sutra's* teachings. His opposition to other schools of Buddhism caused both a large following and considerable political turmoil. Following the death of its founder, the sect split into several schools, some of which have become global movements.

An example of linguistic exclusivity exists within the traditions of Esoteric Buddhism as practiced in Tibet and China. A sumptuous horizontal silk panel features a Buddhist mantra or sacred prayer in *lantsa*-script in a single row of seven characters. The characters represent the transliteration of a Sanskrit invocation or prayer. They are written in an Indic script used in Nepal and Tibet for Buddhist invocations or prayers, and also in China for Tibetan Esoteric prayers. The first six syllables comprise a mantra that reads from left to right *Om mani padme hum*, which is often translated "O, the jewel in the lotus." This widely repeated mantra refers to the sacred Esoteric teachings of Tibet, comparing them to the most precious and pure of all things.

The seventh syllable, *hri*, is a "seed syllable" that symbolizes the Bodhisattva Avalokiteshvara, with whom this mantra is traditionally associated. To preserve their efficacy, all mantras and invocations are spoken or chanted using the original Sanskrit sounds, even when translated into Chinese or Tibetan, as the sounds themselves are believed to have mystical powers, even if their meaning is incomprehensible to those who hear them (Brown et al. 2000: 37–9).

Vajrayana or Esoteric Buddhism originated in India but developed more fully in Tibet as a movement that integrated aspects of magic and metaphysics with earlier Indian teachings from the life of the Buddha. By the eighth century, these

teachings had brought a diversified pantheon of deities and elaborate secret rituals to the Buddhist monasteries and political structures of Tibet, which survived until the mid-twentieth century. During the Ming (1368–1644) and Qing (1644–1911) dynasties of China, close ties between Tibetan priests and the Chinese emperors were manifest through an exchange of official gifts and imperial patronage of the Vajrayana sect. Although its shape and proportions suggest that this textile might have served as a cover for a Buddhist sutra or holy text, it is more likely that this panel was originally part of a vertical banner that hung in an Esoteric Buddhist temple in Tibet or China.

Otherworldly Visions & Miraculous Events

Visions of other realms beyond this earthly one are often expressions in religions of belief and hope. In much of Christianity and Buddhism, the belief in an afterlife has resulted in heavenly visions of places where suffering and evil are replaced by experiences of eternal peace, enlightenment, or joy. These visions may include images of deities, palaces, or natural elements, or the portrayal of spiritual or eternal states of being. A Japanese Buddhist vestment portrays a Buddhist paradise in which devout believers hope to be reborn in their next life (Figure 33). At the bottom are craggy rocks and waves, indicating the earthly realm. The heavenly realm is filled with birds of auspicious or mythological nature, such as the peacock, an emblem of beauty and dignity; or the double-headed phoenix, indicative of divine character. An angel is given the body of a phoenix and the head of a human. Scrolling clouds complete the visionary scene. Buddhist art truly excels in depictions of other worlds, conceived as the perfected cosmos.

On a much smaller scale, a pocket shrine reveals a vision of the paradise of Amida Buddha. This small rectangular shrine with rounded sides and hinged doors, which is ornamented on the exterior with lotus flowers in a pond and clouds, sun, and moon above, opens to reveal a delicately sculpted relief of Amida Raigo on the interior. The central panel shows a seated Amida Buddha (Buddha of Infinite Light) on a lotus throne under a jeweled canopy surrounded by cloud-like patterns. The two side panels show standing figures of Seishi on the right and Kannon on the left, two bodhisattvas representing wisdom and compassion, respectively. They stand under jeweled trees and turn toward the figure of Amida in a posture of reverence, their drapery showing an upturned edge to convey a sense of downward movement. Together, these three figures constitute a classic image of an Amida Raigo, which is a scene of these three figures descending to earth from the cloud-filled Western Paradise, where they reside in order to save those who call upon Amida's name (Baker 2012: 34–5). In particular, they rescue those who utter the name of Amida in a meditation practice called *nembutsu*, which is the endless recitation of Amida Buddha's name as a form of mindfulness.

These beliefs and practices were widely followed by Mahayana Buddhists across Asia belonging to the Pure Land sects, called Jodo Shu and Jodo

Shinshu in Japan. In Pure Land traditions, it is believed that there is a realm called Sukhavati where respite from karmic transmigration can be found. Upon entrance to this blessed place, the practitioner is then instructed by Amida Buddha and numerous bodhisattvas until full enlightenment is reached. These concepts are explained primarily in three texts: the Shorter *Sukhavativyuha Sutra*, the Longer *Sukhavativyuha Sutra,* and the *Amitayurdhyana Sutra.* In addition, many other Mahayana texts mention Amida Buddha.

In Tibet, the cold, dry natural environment has been favorable to the survival of works on paper, cotton, and silk. In addition to large banners, personal devotional images on a smaller scale could easily be rolled up and carried with the devotee. The central figure of this nineteenth-century *thangka* painting is that of the Bodhisattva Avalokiteshvara, the enlightened being who represents the universal power of compassion and mercy for all sentient beings (Figure 69, on website). In cosmic form, Avalokiteshvara has eleven heads, one thousand arms, and one thousand eyes, presenting a classic image of Esoteric Buddhism prevalent in Tibet. The multiple eyes, which are depicted in the palms of the hands, and the multiple heads symbolize his capacity to see and understand all human suffering through magnified power and energy. In each arm, Avalokiteshvara carries an attribute that symbolizes the ability to relieve different aspects of suffering. Attired as an Indian prince and standing on a lotus pedestal, which is a sign of purity, the figure is placed against a background of a paradisiacal landscape composed of clouds, waves, mountains, peonies, and the sun and moon.

The universal popularity of Bodhisattva Avalokiteshvara (Chinese: *Guanyin*; Japanese: *Kannon*) dates back to the eighth century in China and Tibet, at which time various sacred texts were transmitted propounding his myriad powers as a savior and rescuer of the distressed and suffering. His cult spread to Korea and Japan, with each country devising visual interpretations according to their spiritual needs and temperaments. Originally masculine, Avalokiteshvara is sometimes considered feminine in China and Japan. The reasons for this vary; often a feminine attribution is given to deities that embody virtues of gentleness or compassion, but in other cases feminine beings are given masculine status in order to ensure their access to a Buddhist paradise. From the viewpoint of Buddhist philosophy, however, the state of enlightenment transcends gender differentiation (Beer 1999: 3–58).

Symbols of Power

During much of the history of the world, literacy was very limited. Thus, the creation of images and symbols became powerful tools to bring understanding of abstract concepts and divine beings to a greater number of potential believers. These visual tools may represent virtuous traits and models of behavior as seen in the Eight Auspicious Buddhist Emblems; or as an indication of divine presence, as seen in the Buddha's footprint (*buddhapada*).

The fifth-century Sri Lankan chronicle *Mahavamsa* opens with an account of Sakyamuni Buddha's three miraculous visits to the island and a description of the origin of one of Sri Lanka's most revered relics, the footprint on Mount Sumanakuta (Adam's Peak). Forty-nine days after his enlightenment, the Buddha resolved to preach the dharma to all who would receive him. He saw Sri Lanka as a place where this doctrine would shine in glory and miraculously flew to the island. On his third and final visit, he ascended Mount Sumanakuta, where he left his footprint as a large depression in stone, which remains Sri Lanka's most visited site to this day (Harlacher 2003: 169–76).

Other Asian countries have similar tales, as footprints emerged as a symbol of the Buddha's presence in India as early as the second century BCE. Rarer than stone footprints are painted versions on cloth or on wooden manuscript covers. Long before the appearance of the Buddha figure, this aniconic symbol of his presence is recorded in histories of monastic pilgrimages. According to textual records, Buddha's footprints indicate his transcendent nature, for he "hovers above the ground, his feet emit rays of light, and blossoming flowers spontaneously appear in his wake" (Auboyer 1987: 125–7). His feet and hands are also covered with auspicious marks, such as the wheel representing the turning of Buddhist law (*dharmacakra*).

A rare painting on cloth shows the Buddha's footprint as much larger than life, with all five toes of even length and symmetrical shape (Figure 34). It is embellished with a variety of flowers in red, white, and yellow: water lilies, lotus, and jasmine. The golden lotus in the center is surrounded by trefoil palmettes, with a spoked wheel at its center. Luminosity is indicated by the undulating black aureole surrounding the footprint and its attendant figures below, who flank a double lotus throne. To the left is a figure of a monk, and to the right is a figure of a god, possibly Indra. This painting was likely to have been hung on special occasions outdoors or in a temporary pavilion (Harlacher 2003: 169–72).

A square panel with crossed vajras and the Eight Auspicious Buddhist Emblems (*bajixiang*), shows a central motif conceived as an eight-petaled lotus blossom (Figure 35). The emblems are:

Umbrella: symbolizing royal grace
Double Fish: symbolizing fertility, conjugal happiness, and protection from evil
Vase: symbolizing eternal harmony, abundant blessings, and ultimate triumph over birth and death
Flower: symbolizing truth, purity, and creative power
Conch Shell: symbolizing majesty and the voice of the Buddha
Endless Knot: symbolizing longevity, eternity, and receipt of the Buddha's assistance
Canopy: symbolizing spiritual authority, reverence, and authority
Wheel: symbolizing the Buddhist Wheel of Cosmic Law and thus the Buddha and his teachings (Beer 1999: 171–87)

Each emblem is placed within a petal of the lotus. Arranged around the perimeter are stylized lotus blossoms with scrolling foliage. The shape and symmetry of the textile suggest that it was intended for use as a suspended canopy, to be seen from below.

The symbol of the vajra is emblematic of the power of knowledge over ignorance. This term is associated with the hardness of a diamond and thus the enduring and indestructible nature of the Buddhist teachings and enlightenment. The form of the vajra varies, but it is usually depicted as a handheld symbolic weapon with three prongs at either end. The crossed vajras fuse the two shapes into a wheel-like motif with additional cosmic implications, suggesting both the power and the stability of the universe (Beer 1999: 233–43).

The Eight Auspicious Buddhist Emblems were introduced to Chinese art from Tibetan Buddhism during the Yuan dynasty (1279–1368) and became a popular decorative motif during the subsequent six centuries. The extraordinary quality of the weaving and the design, together with the inclusion of ten five-clawed dragons, suggest that this work was made by imperial command, perhaps for the palace, for an imperial temple, or for presentation to a temple in Tibet. The size and proportions indicate that it was intended to cover the title page of the stacked folios of a lavish Tibetan Buddhist manuscript.

Tibetan books were copied in many Chinese monasteries, with a preference for Chinese silks to cover them (Brown et al. 2000: 83–5). During the course of history, some religions came to merge secular power with religious leadership. Objects of personal adornment such as crowns and vestments mark the authority, power, or worldly renunciation of their wearers. A Buddhist ritual crown depicting the Five Cosmic Buddhas or Five Jinas (conquerors) might have been worn by a high-ranking Buddhist monk. Each Buddha presides over one of the five cosmic directions (center, north, south, east, and west) and is associated with one of the elements of the cosmos (space, water, fire, earth, and wind). Each Buddha is also associated with a virtue (teaching, humility, meditation, giving, and fearlessness). Buddhism has always developed systems for categorizing phenomena, qualities, and attributes.

Divine Beauty

The concept of sanctity has often been translated into anthropomorphic form to facilitate a great understanding and connection between divine nature and human nature. Hinduism, Christianity, and Buddhism frequently use images of perfected or transcendent human beauty and specific physical features to convey the divinity and sanctity of spiritual beings. Judaism and Islam are traditions that do not include figurative images in sacred art because of the Second Commandment, which prohibits the creation of any idol in the likeness of created things.

In Hinduism, deities portrayed with animal features and multiple arms or heads are based on the rich literary traditions that describe their superhuman personalities and powers. The bronze sculpture produced in India is among the most technically accomplished in the world, since the lost-wax process employed allows for each

piece to be cast individually. Works depicting Shiva Nataraja, or Shiva as Lord of the Dance, are particularly noted for their tensile strength and vigorous movement.

In the iconography of Nataraja, Lord of the Dance, Shiva destroys and remakes the universe through his physical manifestation of primal rhythmic energy. The circle of flames represents the world's destruction. Entwined in the deity's flowing, matted hair is a figure of the goddess Ganga, who created the life-giving Ganges River when she fell to earth, breaking her fall with Shiva's locks. The drum held in one hand signifies the pulse of time that marks our existence, while the flame in another marks the end of existence. Shiva's left foot is raised in a gesture that promises the release and salvation of the soul, and his right foot tramples on a prone figure symbolizing ignorance and evil. The movement that the figure of Shiva Nataraja embodies is that of the never-ending energy of the cosmos, which was itself created by Shiva. From ancient times in India, dance has constituted not only an art form but also an expression of religious beliefs. The harmony of music and physical movement evokes human emotions, which are in turn linked to the more abstract concepts of life, death, and rebirth in Hindu philosophy and mythology (Kanna 2003: 6–7).

Familial relationships and masculine and feminine ideals of character are also part of a deity's identity. Two single manuscript covers feature the same deities: the "holy family" of Shiavite Hinduism, comprising Shiva, his consort Parvati (center), and their sons Kumara (with four arms) and Ganesha (with an elephant head). All but Parvati are shown as multiarmed, indicating their superhuman powers. Shiva is a complex and ambivalent figure, often associated with polar opposites in the cosmos, such as asceticism and eroticism, male and female. He has numerous other names and iconic forms, but here we see Shiva in a less awesome aspect, that of the family man. Parvati is shown smaller than the three male figures and is seated gracefully, facing her husband. Her breasts are bare and she holds a lotus flower. She is known as the goddess of love and devotion, of female creative energy and fertility. Together, the couple symbolizes the blessings of marital fidelity as well as the power of renunciation and asceticism.

Both of their sons are said to have originated through miraculous births. The elder son Kumara is known for his intelligence and handsomeness. Ganesha, with his elephant head, is one of Hinduism's most popular deities. He is the god of auspicious beginnings, wisdom, and good fortune. Ganesha was created by the goddess in the absence of Shiva to keep her company and guard the threshold. When Shiva returned from long years of ascetic practice, he found an unknown man barring his way at his door, and thus a fight ensued. Ganesha lost his head, but the goddess demanded that it be replaced, so Shiva's host took the first head they found for that purpose, and Shiva then named him leader of his host and the guardian of thresholds, empowering him to remove or place obstacles.

The carved manuscript cover is rendered in full relief and fine detail, with the vermillion powder clinging to the more deeply carved areas. Each of the three figures is shown seated on a lotus throne set within curved niches. Ganesha has only one elephant head but wears a crown upon it. The painted manuscript cover (Figure 72, on

website) is rendered in rich color and detail, with flamboyant gestures and numerous weapons adding drama and movement to the scene. In this work, Ganesha has multiple heads; some are of an elephant and some are not. Each personality is shown with a different color skin and skirt.

Hindu narrative epics reveal human-like attributes such as passion, chastity, love, or valor in the personalities of the gods. In the eighteenth and nineteenth centuries, the Kangra School of painting flourished in northern India and was particularly noted for illustrations of a number of the great Hindu devotional texts, among them the *Gitagovinda*, which celebrates the union of the individual with the divine through the symbolic figures of Krishna and Radha.

Krishna first appears in the *Mahabharata* epic (ca. 200 BCE–200 CE) where he was a warrior prince and crafty advisor. His primary mission was to annihilate the warriors that are overpowering the Earth and not adhering to the dharma. Later texts such as *Bhagavata Purana* and *Gitagovinda* focus on his youth and love affair with Radha. The *Gitagovinda* describes their passion and its consummation in a forest in richly wrought imagery. In the painting of *Krishna and Radha Under an Umbrella*, lush landscape and architectural settings are filled with blooming flowers, rabbits, birds, ducks, peacocks, and a rainbow. The divine lovers are dressed in lavish jewels and flower garlands, with Krishna wearing a crown.

In Buddhism, the image of the historical Buddha conforms to specific texts that describe the ideal proportions and features of the Buddha, thus using a physical ideal of perfection to symbolize spiritual perfection. The attire of the Buddha indicates his identity as a monk who has renounced worldly attachments such as wealth, marriage, sexuality, and children. A stunning example from the Kandyan period in Sri Lanka shows the degree of stylization and formalization that had been reached under royal patronage in the eighteenth century in this island kingdom (Figure 70, on website). The beautifully proportioned body of the standing figure is accentuated by the gently undulating rippled effect of the drapery in an unbroken pattern that runs its entire length from neck to ankle. Shimmering in the light, it creates a breathing, living feeling that is counterbalanced by the solid and stoic calm of the powerful shoulders, head, and neck. While mudra or hand gestures are commonly used on Buddha figures across Asia to convey sacred messages to the lay people, the distinctive projection atop this Buddha's head is quite unique to Sri Lankan examples. The *sirispata* or flame of enlightenment represents the inner spiritual perfection or divine state of spiritual beauty that the Buddha has finally entered through his long path of self-discipline (Listopad 2003: 40–9).

Conclusions

This exhibition caused me to think long and hard about the evolution of religious traditions on a global scale and the issues of similarity, difference, and means of expression of certain common human ideals. The two religions with the longest historical perspectives—Hinduism and Judaism—seem at first to be very different

in basic ways. One is polytheistic, the other monotheistic. One tells the story of human history through words and images, the other primarily through words. Yet, closer examination reveals them to be more similar in ways that might escape mere superficial examination. I hope that viewers were encouraged to think about the true content of the stories expressed in those two traditions and realize that each of them reveals moral truths and virtues through complex human dramas. The gods of Hinduism and the Biblical heroes of the Old Testament have more similarities than one might initially assume. They are idealized yet flawed in character.

Buddhism and Christianity each evolved out of an earlier religious tradition as a means to seek an answer to unresolved questions about human imperfection and suffering. With each of these two religions, the answer seems to be given to us in the form of a perfected man—Buddha or Christ. Yet, an examination of the tenets of these two religions reveals them to be fundamentally very different. In Buddhism, the path to enlightenment lies within each of us. In Christianity, the path to salvation lies in giving oneself up in faith to Christ as the intercessor with God.

The use of language is a complex issue in the dissemination of religious ideas. There are two approaches that most religions take—that of exclusivity and inclusivity. In Islam, the Qur'an's exclusive use of Arabic as the permissible language limits the comprehension of potential adherents. Purity of Allah's message through the prophet Muhammad is the goal. In Judaism, we see the use of other languages combined along with Hebrew in an effort to reach the displaced populations of Jews across the world who have lost touch with their historical and religious roots. With Christianity, we see a long tradition of using only Latin and Greek within Catholicism finally change under Protestantism to embrace every language known on the globe, aiming to reach new adherents as instructed by the writers of the Gospels.

The question of human suffering and how it is connected to our relationship with divine nature is a complex issue. In Judaism, this question and its potential answer is set out clearly in the very beginning of the scriptures of the Bible. Christianity provides the unequivocal resolution and a well-defined course for the believer to follow. Islam, as the third and final revelation of the God of Abraham through his prophet Muhammad, is equally emphatic. These three traditions are very different in their fundamental elements from the view of human nature that emanated from the early writings of Hinduism, such as the Upanishads, which were characterized by a pluralism of world views. Likewise, Buddhism evolved into a religion with many different paths or schools of thought as to the means to enlightenment. The written texts of Buddhism are vastly more numerous than those of Christianity.

The subject of divine beauty is one in which desire seems to be felt universally among those religions that permitted such representational imagery. In Hinduism, Buddhism, and Christianity, we see that each religion looked to the ideals of beauty within the cultures in which they existed for both physical ideals as well as models of virtue. The sensuality of Hindu female figures could not be imagined within the realm of Christian art simply because Christianity's ideals of womanly virtue exclude sensuous

expression. In Christian art, the Madonna with her divine son is elevated to the highest level of adoration. Despite his divine status, the image of Christ never deviates from a purely masculine image, resplendent in masculine body proportions and facial hair. In Buddhism, the ideal of spiritual beauty is expressed in the genderless embodiment of the Buddha, whose transformation into an enlightened being transcends all physical limitations.

In conceiving this exhibition and its electronic publication, I was confronted with the issues that many of us face coming from academic training in the late twentieth century. We have been taught to think of these religious traditions as separate: Judaism and Christianity as "Western" religions; Hinduism and Buddhism as "Eastern" religions. The reality is that there is not such a clear boundary between these religious traditions. Were I to do a similar project in the future in which various religions and cultures were compared in one exhibition, I would hope that both the electronic catalog and the exhibition would be organized by theme, not by religion. This approach would require that each author be familiar enough with all of the five religious traditions to be able to write about them equally well within a thematic focus. It is my hope that in the future of religious and art-historical studies, this approach will become more prevalent. Religion scholars are aware of the cultural interchange and mutual influence between religions, and that each religion is not so much a clearly bounded compartment but more of a center for currents flowing in various directions. This exhibition was intended to demonstrate, through selected objects, our shared humanity and some of the commonalities between religions.

It was my sincere hope that each visitor to the exhibition *Sacred Word and Image: Five World Religions* and each reader of its catalog would find their own understanding and appreciation for the interconnectedness and distinctions of the five religions and their ideals as enhanced by the beauty and meaning of the artistic and literary works represented. It is through such works that have come down to us through the passage of time that we can participate in the continuum of world cultural history and the timelessness and universality of the quest of the human heart and mind to seek answers to profound questions: Who are we? Why are we here? How should we conduct our lives on this earth? What lies beyond this life? Most importantly for the twenty-first century is the question of how we can live together as a global society. Our past is the key to our future.

10 World Religions Museums: Dialogue, Domestication, and the Sacred Gaze

CHARLES D. ORZECH

The power of religion to move and motivate people means that St Mungo is more than an attempt to create an interesting exhibition. It is an intervention in society, a contribution towards creating greater tolerance and mutual respect among those of different faiths and of none.

Mark O'Neill (1993: 22)

Comparison requires the postulation of difference as the grounds of its being interesting ... and a methodological manipulation of difference, a playing across the "gap" in the service of some useful end.

Jonathan Z. Smith (1982: 35)

At the center of the modern, airy, and light-splashed gallery of the St. Mungo Museum of Religious Life and Art in Glasgow, Scotland, is an image of the Buddha "touching the earth," indicating his triumph over the forces of Mara. In close proximity are two other Buddhist images, one of the Buddha in meditation and the other of the thousand-armed version of the great Bodhisattva Avalokiteshvara. Backing up, one sees the source of much of the light in the room—three glorious stained-glass windows of obviously Christian origin and theme (Figure 36). Depending on one's ideological predisposition, this is either reassuring or jarring. Perhaps if one is a young child it might naturalize the proximity of two quite different religious traditions.

Museums structured on religious themes are no new thing. Many collections throughout history (private as well as public) have been dominated by objects whose original purpose was cultic. During the colonial period, such objects often functioned as exotica, as examples of heathen benightedness or savagery, or as the display of booty.[1] More recently, some museums (such as the Museum of the History of Religions in St. Petersburg) were instituted to demonstrate a pedagogy of progress— showing the visitor a past now left behind for the modern utopian society (Paine 2005; 2013: 81–5). Ideological agendas are not limited to heavy-handed museums such as the Creation Museum in Kentucky (Duncan 2009).[2] In every instance, we can see museums as mechanisms that interpellate the visitor—that call on the visitor to inhabit certain attitudes concerning the objects and that seek to produce a particular

kind of subjectivity.[3] Such agendas can be overt, covert, or even the product of numerous individual curatorial biases and choices.

While there have always been collections dominated by the objects of religion, museums organized around the category of world religions are a relatively new development. Leaving aside the notion that "religion" is a modern interpretation of a variety of cultural phenomena, the notion of world religions is a contemporary concern and is not unrelated to the popularization of the notion of world religions and the proliferation of classes and textbooks on the topic. The logical implications of Ernst Troeltsch's conclusion in *The Place of Christianity Among the World Religions* (originally published in 1923, shortly after his death) that religions are culturally contingent and therefore that Christianity is merely one among the world religions (though it may be the best for "us") is evident now in museums in Glasgow, Marburg, Quebec, Taipei, and elsewhere (Troeltsch 1957).

This chapter will examine dedicated museums of world religions. Such museums have much in common with early twentieth-century museums of anthropology. They are closely related to the notion of "religion" as a phenomenon *sui generis* and to the rise of comparative religions and the development of the discourse surrounding world religions in the late nineteenth and early twentieth centuries. The category of religion, and specifically of world religions, was taken up in academic settings in the second half of the twentieth century, and by the end of the century we see the emergence of dedicated museums of religion or world religions museums. I do not intend to recapitulate the already excellent scholarship and reflection on these topics by Crispin Paine (2000, 2005, 2013) and others.[4] Rather, I wish to reflect on the comparative category of world religions, on Asian objects as constitutive of the very category world religions, and on comparison itself. Walking into a museum we walk into a narrative. The narrative can have a single theme supported by many voices, or it can be a dialogue or a discussion, or even a debate. How does the structuring of a world religions museum and the placement of objects in displays create a narrative? How does the museum call the visitor to enter and contribute to this narrative?

The One and the Many: A Brief Genealogy of World Religions

Are the objects placed in museum collections focused on "religion" to be understood as exemplifying religion or religions? The question, and the taxonomic disparity it indicates, takes a central role with the emergence of the notion of religion from the Enlightenment onward. When Kant in his *Religion within the Limits of Bare Reason* posits that a natural religion based on reason alone is the truly "universal world-religion" (*Weltreligion*), he distinguishes an ideal type (religion) from its instantiations (religions).[5] The assumption that the religions represent historically accidental variations of a single type or reality is the foundation of much of the discipline of comparative religion which emerged in the nineteenth century and came to be the enshrined orthodoxy of mid- and late-twentieth-century introductory classes and textbooks in American

and British universities. As critics have noted, the focus of much of this comparative work has been the discovery of similarities along with theories of diffusion. This is evident, for example, in the works of the great twentieth-century comparativists such as Frazer and Eliade (Smith 1982: 21).[6]

It is with some justification that scholars point to the 1893 World's Parliament of Religions as a pivotal moment in the development, spread, and acceptance of the notion of world religions. The name of the 1893 World's Parliament of Religions seemed to signal an insistence on the value of difference and of equal representation (Seager 1995). The parliament metaphor might call to mind a vision of a United Nations of religions (and indeed it preceded both the United Nations and the League of Nations by decades). In this United Nations of religions, both the great states and the tiny are represented. The members of this body, much like the representatives of different constituencies in a democracy, meet for mutual benefit. The parliament was nonetheless dominated by a Western and "Christian" power block advancing arguments for religion as a singular entity with more or less adequate incarnations, often arranged in a progressivist and evolutionary hierarchy. Surprisingly, new voices, including those from East and South Asia such as Swami Vivekananda, adopted these arguments and turned them into a gospel of Eastern spirituality set to save the West from its materialism (King 1999: 93–4, 135–42). Indeed, as Tomoko Masuzawa has detailed in her study of the emergence of the category of world religions, the taxonomic logics behind these discursive developments were enmeshed in an effort to "distinguish the West from the rest" even when deployed by those from the East (Masuzawa 2005: 2).

Despite the geographic pluralism invoked, world religions, whether in scholarly discourse or in the twentieth-century classroom, encodes a hierarchy. Religions are treated as "Abrahamic" or "Asian," and as originating in the Near East (Judaism, Christianity, Islam), South Asia (Hinduism, Buddhism), and the Far East (Confucianism, Daoism, Shinto). The remaining "little traditions" are grouped variously under the categories "tribal," "minority," "animistic," or "primitive." Given limited time (or, in a museum, limited space), they are dealt with cursorily or not at all.

> This system has been closely associated with, and given its justification by, a racialized notion of ethnic difference. The three locations correspond to what the nineteenth-century science of comparative philology came to identify as three distinct groups of languages: Semitic (or Hamito-Semitic), Aryan (or Indo-European), and Turanian (roughly Oriental). (Masuzawa 2005: 3)

The genealogy—ultimately derived from a biblical hermeneutic based on the flood and Noah's sons—encodes a subtle comparative bias: Religions have diffused from a single source and have evolved into higher and lower forms.

> At its simplest and most transparent, this logic implies that the great civiliza-tions of the past and present divide into two: venerable East on the one hand and progressive West on the other. They both have been called "historical," but implicitly in different senses. In a word, the East preserves history, the West

creates history. In contradistinction from both East and West, the tertiary group of minor religions has been considered lacking in history, or at least lacking in written history, hence its designation as preliterate. ... These societies are relegated to a position in some sense before history or at the very beginning of history, hence, primal. (Masuzawa 2005: 4)

In short, the apparent admission of "other" religious traditions to the club of religion was accomplished at the expense of equality. All are human perceptions of the divine, but the difference that counts privileges "the West over the rest."

By the time the World's Parliament of Religions was resurrected in the early 1990s, this taxonomy was in widespread distribution and found in most American and British university and secondary curricula. It is often used to structure academic departments. Thus, in Britain it is common to find departments of "Theology and Religious Studies" whose two wings are overtly characterized as pertaining to Christianity and world religions, respectively. The resurrected parliament — rebranded "The Parliament of the World's Religions" — represents a consolidation of this discourse. The Council for a Parliament of the World's Religions asserts plurality and individual difference:

The Council for a Parliament of the World's Religions seeks to promote interreligious harmony, rather than unity. The problem with seeking unity among religions is the risk of loss of the unique and precious character of each individual religious and spiritual tradition; this understanding is key to our framework. Interreligious harmony, on the other hand, is an attainable and highly desirable goal. Such an approach respects, and is enriched by, the particularities of each tradition. Moreover, within each tradition are the resources (philosophical, theological and spiritual teachings and perspectives) that enable each to enter into respectful, appreciative and cooperative relationships with persons and communities of other traditions.[7]

The metaphor of religions as individuals who are representatives in a parliamentary system operating in a single pluralistic society is obvious. Yet, the preservation of individuality under a representative system that champions harmony can result in two undesirable difficulties. On the one hand, true difference can be flattened or suppressed in the pursuit of harmony. On the other hand, without effective safeguards it relegates minority groups to permanent second-class status. Such an approach makes it easy, then, to regard such religions as exotic multicultural evidence of the success of the system. Critics of multiculturalism have noted these problems.[8] Even more troubling, the popularity of the notion of world religions and of world religions courses and the implicit comparison and hierarchy they enshrine reinforce a picture of the world divided into developed, developing, and undeveloped traditions, a picture that oddly corresponds to the dominant political and economic realities of the present world (Zizek 1997).[9]

This, of course, is now well known, at least in scholarly circles. I have rehearsed this debate to foreground an important concern with regard to the recent development of exhibits and entire museums shaped by the category world religion(s). Placing

objects together in a collection is never random or accidental. There is usually some underlying principle, whether consciously programmatic or emergent. Spatial proximity invites comparison, and comparison, as culturally deployed and enshrined, implies contiguity. If a tradition frames itself as unique (through revelation, etc.) its proponents will object to any form of comparison, overt or implied. So any such exhibit of world religions or any museum devoted to world religions must tread carefully and periodically reflect on the ideological aims and risks of its exhibits.

Museums of World Religions: St. Petersburg, Taipei, Glasgow

Although the rise of the notion of world religions is historically situated in the last century and a half, it is not the first instance of a comparative religion. Indeed, Buddhists in India practiced a kind of comparativism with regard to Brahmanic traditions and other "heterodox" traditions. So too, East Asian Buddhists, faced with a growing torrent of scripture and practice all claiming authority of the Buddha, applied a rubric that encompassed but also hierarchized Buddhist teachings in a scheme based on when and to what audience the Buddha gave a particular teaching. Called "dividing the teachings" (*panjiao* in Chinese), it was developed in a most sophisticated manner to include Confucian and Daoist teachings by the medieval Japanese cleric Kukai in his *Aims of the Three Teachings* (798 *Sango shiiki*).[10] It was, in effect, an appraisal of the major religious systems known to Kukai and a critique in which Buddhism was deemed superior. Confucian and Daoist teachings were not summarily dismissed but rather given a kind of grudging appreciation. This was a concept of world religions *avant la lettre*.

I invoke this ancient comparativism first to help dismiss any notion that such endeavors are uniquely modern, and second to underscore that any comparative endeavor is conditioned by its historical and cultural presuppositions. A world religions museum—however admirable and desirable its goals—is not ideologically unbiased. To their credit, both the St. Mungo's Museum and the World Religions Museum in Taipei are explicit about their goals.

Collections and exhibits of religious objects are no new thing and take many forms. The appendix to this chapter provides links to examples ranging from displays of religious objects in museums of art, to those in church treasuries, to those in dedicated exhibits of world religions, to those in dedicated museums of world religions.

I will turn now to dedicated museums of world religions and briefly examine museums in Marburg, St. Petersburg, and Taipei before turning to more extended consideration of the St. Mungo Museum of Religious Life in Glasgow.[11] Among the interesting dimensions of world religions museums is that they often straddle the sacred/secular divide. Most, if not all, have been designed as educational institutions rather than as simple repositories or displays of cultural and artistic treasures. Although traditional museums increasingly see their mission as outreach or impact, world

religions museums usually have overt missions that are religious or quasi-religious. While they might be informed by secular academic history and enlightenment values and discourses, they nonetheless aim to transform those who enter them. Unlike secular university departments of religion or religious studies, such museums often serve as meeting spaces and resources for religious as well as secular groups.

Museums invite visitors to listen to and engage a narrative. Depending on how they are structured, museums of world religions can invite visitors to contribute their own voices to the story or even challenge the story and debate its merits. The Museum of Religions (*Religionskundliche Sammlung*) at the Philipps-Universität in Marburg, Germany, was established through the efforts of Rudolf Otto in 1927, and it is arguably the first such public museum dedicated to the comparative study of world religions. The collection was conceived as a teaching collection and since 1981 has been housed on three floors in the Neue Kanzlei. A single room houses the monotheistic religions of Judaism, Islam, and Christianity, and Oceania and Africa occupy two rooms. But the real focus is on Asian religions, with rooms dedicated to Hinduism, Buddhism, Confucianism, Shinto, and Tenrikyo. Some of its exhibits are overtly comparative (burials, for instance) and a strong focus on Buddhism reflects the interests of its founder.[12]

The St. Petersburg Museum of the History of Religions was founded in 1932 as a museum technically in the service of promoting atheism and communist understandings of religion (Paine 2013: 81–5). As such, its original remit was in part didactic and in part a scientific salvage operation. But with the demise of the Soviet Union it has morphed (in 1990) to become the Museum of the History of Religion. It has always approached religion as part of a scientific study of culture. The museum's current virtual site gives an excellent view of the arrangement of the objects (http://www.gmir.ru/eng/virtual/excurs/). Twelve rooms are arranged in a building comprising a central set of rooms flanked by two wings. Occupying the central front of the museum are rooms dedicated to Catholicism and Orthodoxy, with a room on Protestantism occupying part of the wing adjacent to Catholicism. The remaining rooms in the wing focus on Islam (front of the wing), Buddhism, religions of China and Japan, and Indian religions. At the center of the wing is a room depicting the Sukhavati or Western Pure Land of Amitabha. The other wing of the museum is divided into six rooms: Archaic and Primitive Beliefs, The Silver Treasury department (at the rear of the wing containing mainly Orthodox objects), three rooms titled "Religions of the Ancient World" comprising "Polytheism," "Judaism," and "Concepts of the Soul and After-life." "The Rise of Christianity" is at the front of the wing and abuts the "Catholicism" and "Orthodoxy" rooms at the center. The plan, then, instantiates an obvious historical and evolutionary scheme from primitive beliefs through the religions of the ancient world (including Judaism!) through the rise of Christianity, thence into Catholicism and Orthodoxy and thence to Protestantism. Islam abuts Catholicism at the front of the wing and Asian traditions are arrayed in rooms at the back with a central place given to Buddhism. Displays are grouped in discrete rooms.

Although different in many ways, both the Museum of Religions at the Philipps-Universität and the St. Petersburg Museum of the History of Religions are configured according to long-standing museum practice. Just as museums of art are often arranged in discrete rooms according to century or era, genre or style, so these museums put different religions or groups of religions in noncontiguous spaces. By entering a room one leaves one religious world and enters another. Such an arrangement tends to reinforce developmental schema and limit overt engagement between traditions. The Museum of World Religions in Taipei Taiwan and the St. Mungo Museum of Religious Life and Culture in Glasgow, Scotland, take a distinctively different approach.

According to the main page of the website of the Museum of World Religions in Taipei, "The Museum of World Religions belongs to all faiths. Its founding is inspiring and encouraging interfaith dialogue so that we all work together to create peace and understanding in the world we share."

Founded by the Buddhist monk the Venerable Hsin Tao, the museum was designed with input from faculty of the Harvard Divinity Center for the Study of World Religions. The building was designed by the famous architectural firm Ralph Appelbaum Associates, who have also designed, among other museums, the Holocaust Memorial Museum in Washington, DC. The aim of the museum is overtly educational and religious. As stated on the "About the Museum" page:

> The traditional education system also fails to provide a good conduit for religious belief. In response to these various problems, Master Hsin Tao's dream of the World Religions Museum is to pioneer a correct form of religious education, to satisfy the public's spiritual needs, and to provide a leisure place that serves both education and enjoyment. He hopes to raise the standards of Taiwan's artistic and cultural life, as well as to establish a tourist destination of international reputation for Taiwan.[13]

The museum's floor plan and virtual tour features provide an excellent overview of the presentation of the world's religions. What is immediately noticeable is the very open floor plan. The main exhibits are spread over two floors. One enters on floor seven. Eight permanent exhibits are devoted to Buddhism, Daoism, Christianity, Islam, Hinduism, Sikhism, Judaism, and Shinto. There is also an exhibit focusing on Taiwanese popular religion as well as two rotating exhibitions treating ancient religions (Egyptian) and indigenous religions (Maya). Floor six presents life-cycle rituals across a variety of religious traditions. The spherical Avatamsaka World theater occupies a two floor atrium-like space at one end of the building. The entire museum assumes the ultimate underlying unity of religious traditions and is structured on a ritual process. The quotation on the page introducing "The Hall of Life's Journey" from the Sikh Guru Gobind Singh sums up the underlying message: "The same Reality is the creator and preserver of all; Know no distinctions between them, The monastery and the mosque are the same; So is the Hindu worship and the Muslim prayer. Humans are all one!"

Although the museum is structured by this underlying perennialist message, one nonetheless senses that the Avatamsaka World, with its message that "One is all and all is one" expressing the idea that there is "wisdom and character common to all religion and all life," somehow represents the implicitly Buddhist-tinged goal of the museum and the summit of a mild form of *panjiao*. In the words of the founder,

> The MWR promotes an interreligious and intercultural movement we call "life education." The unity-in-diversity exemplified by the interaction of the three religions of China forms the base of our tradition, stimulates a model of creativity, and contributes to the harmonious evolution of the world.[14]

Perhaps more important for our discussion is that despite the open floor plan, "interaction" is actually not what one finds here—everything has been structured to promote a vision of "unity in diversity." To use a musical metaphor, the museum promotes a kind of singing in a choir.

The St. Mungo Museum of Religious Life was opened in 1993 and appears—on first glance—to be designed around a similar ideology to that of the Museum of World Religions in Taipei. In the words of Mark O'Neill, who helped to design the museum, "The power of religion to move and motivate people means that St. Mungo is more than an attempt to create an interesting exhibition. It is an intervention in society, a contribution towards creating greater tolerance and mutual respect among those of different faiths and of none" (O'Neill 1993: 22). Greater tolerance and mutual respect does not necessarily imply that all religions are, in the end, pointing to the same goal. Further, O'Neill's comment indicates the role of those who have no religion but who are interested in it as an important element of human societies.

The St. Mungo Museum is housed in a modern building constructed to imitate traditional Scottish Baronial buildings and it blends in with the nearby cathedral. The ground floor houses a shop, a café, and a function room and embraces a Zen rock garden.[15] Temporary exhibits are housed on the second floor while the main exhibits occupy the first and third floors. The first floor has a room devoted to "Religious Art," a room with a bronze statue of the Hindu god Shiva, and a display of "Religious Life" organized around life-cycle rites. The third-floor landing features a large window with a splendid view of the cathedral and the necropolis. The "Scottish Gallery" on the third floor is devoted to the diversity of Scottish religious life and history.

This is a relatively small museum and its size dictates an arrangement of intimacy between the objects. The result is that the objects must share quite intimate visual space and are inevitably in dialogue. In the words of David Morgan, the "sacred gaze" of the museum visitor and the images is unavoidable (Morgan 2005).[16] Looking at a statue of the Buddha, there are Christian stained-glass windows beyond and an image of Christ in my peripheral vision. Turn around to face a prayer rug and an exhibit of the Muslim names of god, and again to the back of these are stained-glass windows. The near life-size Shiva Nataraja is installed on a plinth in a side room and

illuminated again by stained glass (Figure 37). A pieta is installed in a glass case opposite the window. The room displaying "Religious Life" brings together material on life-cycle rites in a series of contiguous glass cases with different religious traditions shown cheek by jowl. The view from one end of the Zen rock garden is dominated by the great cathedral. From the other end one can see a clootie tree, representative of traditional Scottish spiritual practices (Figure 38).

The dialogic nature of St. Mungo is reflected in visitor comments. An integral element of the museum is its comment boards where visitors are encouraged to write their reactions, praise, and criticism. By 2004, nearly 40,000 comments had been transcribed and cataloged by the museum staff. Jemima Fraser has analyzed a representative sample of these comments in her doctoral thesis (2004). Many comments reflect the successful achievement of the Glasgow City Council's objective that the museum promotes tolerance and respect: "The museum helps to confirm that we are all part of one big family—the message is one of tolerance and love" (Fraser 2004: 153). As Fraser's analysis demonstrates, visitors to the museum are encouraged to construct new meaning for, and a new vision of, religion in Glasgow.

The success of the museum, I would argue, is indicated not only by positive and appreciative comments, but also by comments that are critical of the displays or the project as a whole. The possibility of controversy was anticipated and, as much as possible, planned for. According to the architect David Page, the

> driving notion was to give each object its own space and place. We could not treat these objects as if they had been found in an archaeological dig, these were objects of faith and we had to create for each a metaphorical respect by carving out its own space.[17]

Harry Dunlop, one of the curators, indicates that a good deal of thought and effort went in to thinking about placing the objects in spaces that might arouse complaint:

> In the Art Gallery we realised having all faiths together could be quite threatening for Christians, but we tried to give each object a ritual space. In the Religious Life gallery all the faiths have equal space and the cases on the afterlife were determined by the number of grave goods we had.[18]

Nonetheless, some visitors objected:

> I think the room with the Dali paintings should only have Christian objects in it and the other room the Buddha and other statues. It creates a chaotic impression and disturbs appreciation of the painting.

Or, in the words of another visitor,

> It would be better to separate out all religions.[19]

Despite the stated goal of giving each object its own space, the proximity and choice of objects produces interaction. In the Museum of World Religions in Taipei, the objects in closest proximity to one another are in the display of religious architecture.

In the St. Mungo Museum it is icons—a statue of the Buddha, an image of Christ—that are close to one another. The "gaze" of the images and that of the visitor meet unavoidably.

Much in the way of critique has been written concerning the ideological pitfalls and unintended consequences of multiculturalism. At its worst, efforts to promote the values of pluralism and multiculturalism—though well intentioned—can result in a flattening of difference in the service of majorities, elites, and the market. It can, in effect, be a form of ethnicity management that glosses over real points of dispute rather than seeking to clarify and negotiate them. We should not lose sight of the fact that democratic pluralism is a hegemonic ideology that is in direct conflict with the hegemonic values of theocracy. Tolerance, in short, is a category of the dominant and it explicitly excludes intolerance.[20] It is not my aim to advocate intolerance but to underscore that meaningful dialogue cannot take place when key differences are kept off the table and are swept metaphorically under the rug. In a particularly insightful essay, Diana Eck observes that the dialogical method is not mere friendly interreligious discussions with the goal of harmony. Dialogue includes perception of difference, disagreement, and dispute:

> dialogue is the discipline of thought that enables us to gain clarity about our own situatedness, our own forms of questioning our own position—whether methodological, political, religious, secular, even antireligious—so that our own subjectivity, own our language, and our own categories are not privileged and universalized unwittingly in our work.[21]

It is due to the planning and forethought of the designers and curators of the St. Mungo Museum that, within the remit given them by the Glasgow City Council—a remit to promote toleration and to celebrate cultural diversity—they produced a museum that does not homogenize religious difference. In the words of Mark O'Neill,

> In a museum of world religions we decided that being "neutral" in the name of tolerance seemed like an evasion. Despite the apparent triumph of moral and cultural relativism, there are limits to tolerance and for us this includes persecution of minorities, religious discrimination—and feminine genital mutilation.[22]

Indeed, while "carving out a space" for each object, they nonetheless placed the objects in close visual proximity where a visitor must encounter them dialogically.

Looking at a summary of more recent comments by visitors to the St. Mungo Museum raises the possibility that some of the most challenging dimensions of the museum have been lost or domesticated, with comments echoing the tolerance theme. The 2006 return of Salvador Dali's St. John to the Kelvingrove Museum has deprived St. Mungo of one of its most controversial and riveting pieces of art. The strongest sentiments continue to be voiced about displays involving Protestant-Catholic conflict and about the depiction of female genital mutilation.[23] Rather than seeing these as a problem to be addressed, I suggest that these displays provide

an opening to genuine difference and dialogue. It may well be that the museum would want to reconsider its displays with an eye to enhancing difference. This could be done through the use of the temporary display space, by directly engaging communities to provide input and participate in the design of exhibits, and by offering dialogical workshops. Granted, this approach is not the safe way to proceed, but the management of St. Mungo has already shown its approach to comparison goes beyond superficial delineations of similarity to take difference seriously. As Jonathan Z. Smith noted, "Comparison requires the postulation of difference as the grounds of its being interesting … and a methodological manipulation of difference, a playing across the 'gap' in the service of some useful end" (Smith 1982: 35).

Appendix

In each category I provide a link to a single example of the category. Some categories overlap.

Religion in museums:
Displays of religious objects in cultural or aesthetic frameworks (Christian art, etc.
 http://www.lacma.org/islamic_art/intro.htm)
Displays of religious objects as religious objects (Medieval Christianity
 http://thewalters.org/exhibitions/treasures-of-heaven/)
Displays of religious objects by group (Abrahamic religions, etc.
 http://www.museumofthenewsouth.org/exhibits/detail/?ExhibitId=82)
Displays of religious objects under the rubric of "world religions"
 (http://www.phxart.org/exhibitions/2516de50-ed85-4491-630e-461b5a5fd051)

Museums of religion:
Church treasures: Displays of objects held by religious institutions
 (http://www.museumsinflorence.com/musei/cathedral_florence_museum.html)

Museums/theme parks of one religion:
Creation Museum (http://creationmuseum.org/)
The Holy Land Experience (http://www.holylandexperience.com/)

Savage and salvage: Socialist museums/museums of atheism (http://www.presentpasts.
 info/article/view/10/18)

Museums of religion reflected in local religious life (http://www.museedesreligions.
 qc.ca/home)

Museums of religious life:
St. Mungo's (http://www.glasgowlife.org.uk/museums/st-mungos/Pages/default.aspx)

Religionskundliche Sammlung (http://www.uni-marburg.de/relsamm/ausstellung/
ausstellung/permanentexhibition?set_language=en)

Museums of world religions:
Taipei (http://www.mwr.org.tw/content_en/introduction/origin-concept.aspx)
Birmingham (http://www.mwruk.org/concept.htm)

Museums in the virtual world:
Online presence of brick and mortar museums (https://www.britishmuseum.org/explore/
online_tours/britain/enlightenment_religion/enlightenment_religion.aspx)
Displays of religious objects and images by tradition Pacific Asia Museum
(http://www.pacificasiamuseum.org/buddhism/base.htm)
Museums of world religions (http://www.thereligionmuseum.org/exhibits.html)
Museum of online museums (http://museumlink.com/virtual.htm)

11 Detritus to Treasure: Memory, Metonymy, and the Museum

MICHAEL WILLIS

Dove, diavolo! Messer Ludovico, avete pigliato tante Coglionerie?

From the title page of Horace Walpole's
***Catalogue of the Royal and Noble Authors* (1758)**

Much is made of the British Museum as "a place of memory" in a book called *The Museum of the Mind* (Mack 2003). For anybody who works in a museum, John Mack's proposition that a museum is "necessarily a place of memory" will come as an unexpected and worrying assertion. The museum is certainly a place where certain kinds of memories are celebrated and fabricated, but in the final analysis the museum is really a place of amnesia. Curators know this very well. In the first place, museum buildings are old and were constructed in and for political economies that exist no more. And the objects in the buildings are necessarily divested of the meanings they once had. Left in the ground inadvertently or deliberately buried alive, they have been prised from their resting places only by archaeological intrusion. Otherwise they have been wrenched from other settings by economic realities, wars, revolutions and socioreligious change. In all cases, whatever the historical cause, objects are divested of context, meaning, and power. This is recognized in the theoretical literature, in the work of Krysztof Pomian (1990), for example, who noted long ago that the removal of objects from their more habitual round of circulation, their organization into some recognizable sequence, and their display are the defining principles of a collection.

In the context of the essays in this volume, it is telling that that there are no traditions of ghosts in the British Museum and never have been. The ghosts could not be bothered and are long gone. To put the matter another way, places are only haunted if they have occupants, meaning, and memories. The remodeling of museum buildings and the regigging of displays to conform to new and meaningful agendas only serves to emphasize the distance between us and the objects now in permanent institutional care; distance and loss of memory are as ubiquitous as they are disconcerting. And for the curators who have the unenviable task of actually working in museums—rather than directors or professors who are called in to make reassuring or witty observations—life is an everyday struggle against amnesia: against objects forgotten or misplaced; against the misguided conservation of earlier generations, which has eroded the memories embedded in the fabric of the pieces; and against inherent and

natural deterioration, which mocks us, as if the objects are asserting their own right to destroy their memories and themselves. More prosaically, the curator struggles to recover lost connections, forgotten provenances, and neglected records.

One example makes some of these points clear (Figure 39). This painted panel of Durga was acquired by the British Museum in 1845 from John Doubleday, an artist who worked at the museum from 1836 to 1856. It is among the oldest—if not the oldest—example of the temporary figures used in the festival of Durga *puja*. As every student of Indian religion knows, Durga only associates with the image during the prescribed festival days. When she departs, the image is thrown into a body of water or a river and left to dissolve into its constituent parts. The British Museum's Durga, however, has been plucked from its natural trajectory of creation, consecration, worship, deconsecration, and destruction. It was never consecrated but bought new in the early decades of the nineteenth century. Carried to London, it became a precious specimen and document of Indian religious practice. As ephemera from the start, it was never made to last and so poses challenges in its institutional home. The British Museum—like all museums—is in a constant struggle against the tendencies inherent in the materials it holds. This is a rather grand way of saying that in order for the object to be preserved for study and display, it requires—and will require for as long as we can see ahead—the steady attention of conservators (Figure 74, on website).

Scientific knowledge, backed by the British treasury, is directed toward the preservation of this item. Like a patient in hospital, the object has been subject to a careful case study, tests, probes, photography, X-rays, and an analysis of samples. Is this then a "sacred object" in "secular space"? In the Indian and orthodox sense, the answer is certainly "no." Even if the Durga was consecrated—which it never was—its collection, storage, and treatment have eliminated any sanctity that might have adhered to it. But in a world where money counts, where the holding institution confers status, where a collection's pedigree invests prestige and authority, and where, more generally, objects enjoy a degree of fetishistic attention undreamt of in traditional contexts, then the answer is indeed "yes." But this "yes" is refracted through a complex lens. Here there is no joyous rapture, a comforting reaffirmation of the endless and endlessly renewed tradition of Durga *puja*, but a strange sense of distance, a disconcerting feeling that everything is much older and much newer than it seems. I would prefer, as a result, to assert that this object is special, that is, indicative of a life process and religious tradition; but that it is not sacred in itself. It is only made so in the imagination of the viewer.

The matter of the viewer is complex. Reducing the narrative of a developed field in museum studies to the workaday world of the curator—and giving a personal perspective for which I might be given a degree of ethnographic indulgence as a native informant—I start with my own position about twenty years ago. At that time, curators were normally specialists: armed with particular skill sets, the study of unusual languages, and a knowledge of the traditions of scholarship in the field, curators were responsible for studying the collections and presenting them, either in publications or in displays. The public were expected to come along, have a good look, and to

go away instructed. In this somewhat innocent world, curators tended to present the typologies and hierarchies of their time. The British Museum display (shown here in Figure 75, on website), shows how "sacred objects" were presented in a "secular space" in the years before and after the Second World War. The arrangement looks old fashioned, and we have moved on considerably in terms of style. But there has been almost no movement in terms of the underlying strategy. Museums firstly preserve, so they seldom innovate. This is especially true at the micro level, that is, the level of the individual object and the individual display case. Objects still sit in their cases and carry labels that tell us what the objects are, where they are from, how old they are, and what they might mean. No matter that much information now comes electronically in a handheld device; the template is little changed. The debate at the curatorial and exhibition level is about the length of the information panel or label, its color and design, the complexity of the language used in the explanation (electronic or printed), and what is relevant and what is not. Heated arguments are had about what to include (why have three Buddha images if one will tell the story?) or whether the registration number should appear on the label (why does the visitor need to know the object number?). Alongside, education departments have played an important role in engaging visitors with public programming. Meanwhile, governments, museum trustees, and directors have expanded museums dramatically in size, scope, and ambition over the last three decades. Museums have become new civic centers, places of entertainment, leisure, tourism, and commerce, and—through instrumentalist public policy—defined as socially inclusive and therapeutic institutions.

Alongside these efforts and dynamic changes, something else has happened: viewers now arrive with their own agendas and well-developed attitudes. These attitudes do not generally include a feeling of deference. Having been tutored to tolerate—or sometimes to reject—the plurality of opinions found in modern society, visitors expect their own opinions to be accepted and accommodated in the public places supported by the taxes they pay. Appeals to the idea that the museum is a place where the visitor needs to reconnect directly with "works of art" are accordingly misguided. These ideas are based on a series of assumptions—shaped mainly by Kenneth Clark in the 1950s—about social hierarchy and the nature of art as an autonomous aesthetic experience, purged of its political and religious meanings. While meaningless art might have a social, political, and economic use, the personal encounter with a "work of art"—some kind of transformative connection based on subjective sensory responses—is a palpable illusion. This is best illustrated by the classical sculpture shown here (Figure 76, on website). In this figure of *Europa*, we do not encounter a piece as it will be displayed in a museum space—a point that is obvious enough. Acquired by the British Museum in the 1860s, it was found in parts and has been assembled and reassembled on a number of occasions (Figure 77, on website). What this shows is that all experiences of seeing "works of art" are mediated through a long chain of interpretations, historic decisions, discoveries, and conservation campaigns. We do not look on an ancient sculpture as it was, any more than we read an ancient text as it was once read. We happily examine the *Meghaduta* or the *Mahabharata* thinking

we have access to an ancient work and the minds that first created it. But we have no such thing or experience. What we are reading is a redacted text that has passed through innumerable hands and copies until, finally, it has come to the modern editor who prepares the *editio princeps*. Just as most classical sculptures contain bits and pieces from many periods built around an old core, so the text is an assemblage built by many over the *longue durée*. This rather spoils the fun, but critical historicism tends to do that. As Johannes Bronkhorst has pointed out, the Indologist and historian will, sooner or later, fall out with snug comforts of received orthodoxy (Bronkhorst 2011).

From these general concerns I would like to turn to questions of value. Museums are often regarded as "treasure houses" and sometimes criticized as being filled with loot. As the word "loot" is of Indian origin, it is perhaps worth looking at some primary documentation that reveals how those in the nineteenth century regarded the objects they were collecting. As we will see, this documentation shows that most Indian objects were something of little or no value from the financial point of view. From the letters kept in the British Museum I give here one example of the exchange between Sir Alexander Cunningham, the first director general of the Archaeological Survey of India, and Sir Augustus Franks, the keeper of the then Department of British and Medieval Antiquities (for whom see Caygill and Cherry 1997). The letter, not previously published, is given here in full. To this I add a few footnotes by way of commentary.

To Augustus Franks

Simla
1st May 1881

My dear Sir

I have much pleasure in advising you that I have today packed up a complete set of the Gândhâra photographs, 23 in number, along with a set of other photos of the risers of the flight of steps, which I hope may be of use in determining the arrangement of the fragments—the negatives are now deposited in the Indian Museum in Calcutta, but these photographs I had by me, and I hope you will kindly accept them from me.[1]

The whole of the sculpture in these plates, with only one or two exceptions, were dug up at Jamâl-garhi—either by myself, or by a Company of Sappers under my superintendence. I gave special instructions that every piece should be marked with the letter J for Jamâl-garhi, and all the pieces so marked, of which there are numbers now in the Lahore Museum, were found there during the excavations made by the Sappers.[2] Many of these were left near Jamâlgarhi, as they were considered to be of inferior interest, to those which I had photographed. Most of these photographed specimens are now in the Indian Museum in Calcutta: and are beyond my control—the specimens sent to England were only the second best I believe—I should have liked myself that all the finer specimens should have been sent to England, but I had only a partial voice in the selection.

With regard to your other specimens of Gândhâra sculpture I believe that all those presented by Colonel Johnstone came also from Jamâl-garhi—those from Captain Blair must have been found at Takht-i-Bahi.

With regard to specimens of the Bharhut sculptures I think it probable that some may be obtainable hereafter. I propose to visit Calcutta towards the end of the year, when I will see how all the sculptures are arranged in the Indian Museum—The Gateway with a portion of Railing on each side has been set up in the Museum—which is a great advantage, as the whole and the parts can now be examined in connection with their neighbors. I have up at Simla a single specimen of a round medallion which was found in a village, with the name cut away, and with the medallion on the back cut away.[3]

Perhaps a little pressure put upon the authorities may incline them to part with a few more the Gandhara sculptures. I will sound some of them as I should like to see more specimens sent to England. You will get nothing **worth having** from the Lahore Museum—just one month ago I saw the selection that had been made to send you—There is a wide spread feeling that Indian sculptures are thrust aside in England—But now that you have got rid of thousands of bottles of preserved entrails and disemboweled peltry, I suppose there may be room for less perishable articles.[4] And as you are now setting up some of the Indian sculptures I will do my best to procure more for you—the cost of the freight to England is chief drawback. But I think that I can manage to get the Indian government to pay the freight—

I have no doubt that casts of some the Bharhut sculptures can be obtained at a trifling cost—If you will kindly let me know which piece you would like to have I will make enquiries about the cost and let know the result[5]—

The arrangement of the pieces of the different risers of the flights of steps was made by the Officer of Engineers who superintended their excavation. I discovered the steps; but the actual excavation was made by the Sappers shortly afterwards. Some of the pieces may have got mixed up, as I found a few that I could not join properly, that is to my own satisfaction. Some are undoubtedly quite correctly placed, such as the Wessantara Jâtaka—All of them however do not represent Jâtakas as there are lines of dancers with musicians, one line of figures carrying along ornament which I take to be a cylinder of muslin, such as I have seen in Burma from 50 to 200 feet in length.

Any further information that you may wish to have I shall always be ready to give.

I remain
Yours truly
A Cunningham

A number of points about value become clear from this letter. The first and most important is that Indian sculpture had almost no commercial or sale value in the nineteenth century. The sculptures discussed in this letter are specimens, and they can be had from the site free of charge; the only impediment to acquisition was the cost of freight to England. This is worth noting because it reminds us that the British were not in India for antiquities. Such things were a liability. The revenues of empire came from the cotton, tea, and indigo trade and from tax revenues on agricultural lands. To think that the British regarded antiquities as great treasures is to completely misunderstand the historical situation and to impose our own market values on the past.

This is made nowhere more clear than in the example of the gift of the Bridge collection of Indian sculpture to the British Museum in 1872. I have written about this gift in some detail (Willis 1997). The heart of the matter—as far as the present discussion goes—is that the Bridge family inherited a large collection of medieval Indian sculpture, comprising over 120 items. They were collected by John Bridge (1755–1834) who imagined they had great value. His heirs soon discovered that nobody wanted them. In the end, Augustus Franks arranged for the pieces to be donated to the British Museum—on the strict condition that the museum pay for their removal from the Bridge estate! So it is the same story once again: nobody wants this stuff and the main problem is the cost of moving heavy stones from one place to the next. In all this, of course, there is no question of the sacred. They are merely specimens—and not very good ones as Cunningham tells us—of the religious ideas of India. To represent these ideas, one does not even need originals. As Cunningham's letter makes clear, plaster casts will serve. Nowadays we have different ideas about casts, and many museums have thrown them away because they are "not the real thing." But this is a relatively recent trend, driven by the art market after the Second World War. Thanks largely to the eager contribution of art historians who have lent their connoisseurial pens to the task, the market has turned antiquities and curiosities into commodities. Luckily, many casts survived the putsch, with some from Sanchi preserved in the British Museum.

As a way of bringing this essay to a close, I would like to return to the question of amnesia with which I started. As mentioned already, curators struggle to reestablish links between records and objects. This is because museums are sometimes centuries old and many generations of workers have passed through the gates. When a curator retires, knowledge sometimes disappears. It may be written down somewhere, but the new starter has to find it and, more often than not, has no idea where to start. The situation is much changed by institutionally supported databases that capture much information. But the data needs to be discovered and entered. This is especially so with regard to acquisitions from the first half of the nineteenth century, when the protocols of recording keeping were not yet regularized. An interesting case of this is the inscribed tablet shown here (Figure 40).

This inscription is fragmentary, with only the right-hand portion preserved. The other parts disappeared more than a century ago and have never been found. The inscription is written in Arabic and is beautifully carved in a style of calligraphy unique to Bengal. It gives the titles of an important Bengal Sultan: Sayf al-Din Firuz Shah. I give here the translation:

> [during the reign of the Sultan of the age] who is strengthened by the assistance of the Supreme Judge, a *jihadi* in the Path of the Merciful, the Caliph of God by proof and evidence, Sayf al-Dunya [wa al-] Din [Abu'l Muzaffar Firuz Shah Sultan, may God perpetuate his kingdom and authority] …

Sayf al-Din Firuz Shah was of Ethiopian descent and ruled as king from 1486 to 1490. But where this inscription came from was information that was not known to anybody

Figure 40 Inscription from the Firuz Minar at Gaur, fifteenth century (British Museum).

in the museum at the end of the twentieth century. There was also no active memory of the donor, even though the name Col. Franklin is written on the top. For a number of years, the idea circulated that the inscription really belonged to the Royal Asiatic Society and that the British Museum had put pressure on the society to hand it over. This was certainly the long-held view of Simon Digby.

When Dr. P. K. Mitra visited the museum from Bengal in connection with his research, I decided to look into the matter. Details about William Franklin (1763–1839) were soon forthcoming (Archer 1969, vol. 1, pp. 199–201). He joined the East India Company's Bengal Native Infantry in 1783 and traveled to Persia in 1786. In 1810–11 he visited Rajmahal and Gaur in Bengal. Promoted to Major in 1810, he was invalided out of service in 1815 and retired in India. Given these published dates, it was a relatively simple matter to examine the old registers from the early nineteenth century in the museum. As these were indexed at the time, the date of the arrival of the inscription and its correct number were soon found. The records make clear that Franklin donated the tablet to the museum in 1826 (the object numbers in the British Museum normally begin with the year the piece arrived).

Meanwhile I found an old record slip in my department based on the notebooks of Augustus Franks. This says: "1826.7-8 Eight Arabic inscriptions on slabs of black marble from the ruins of Gaur. Col Wm Franklin." These notes were made in the late nineteenth century. Beyond that, there seemed to be no further evidence. The trail went cold until I spoke to Ian Jenkins in the Department of Greek and Roman Antiquities. He pointed me toward an old collection of documents from the eighteenth and nineteenth centuries, which were bound together in a volume titled *Letters on Antiquities* (now held in the Greek and Roman library). Letter no. 126, "Hindostanee Inscriptions from Gour," dated November 11, 1826, shows there were three inscriptions in total from Franklin and that the "eight" in Franks's notebooks represented the total number of fragments. This shows that Franks never saw *Letters on Antiquities*; he simply counted the pieces in his department. In other words, the connection between the tablet and the documentation of 1826 was already severed

by Franks's time. How this happened is explained by two developments at the British Museum between 1826 and 1890. The first was the complete demolition of the old building and the construction of the current building over several decades. Concurrently, the number of departments proliferated. The first Department of Antiquities and Coins was created in 1807 but, as collections and knowledge grew, new departments were needed, the Department of Greek and Roman Antiquities coming into existence in 1860. We do not need to give a detailed account here. The key matter is that the Greek and Roman department is the direct descendant of the first Department of Antiquities and retains a number of the earliest records, including *Letters on Antiquities*. The archival point is that unless we remember the institutional history of an organization, we will never find the relevant documentation. I give this story to illustrate my opening point about the museum as a "place of amnesia" and the struggle in which curators are engaged on the path of memory.

The letter of November 11, 1826 is a significant rediscovery because it is from Franklin and states that the inscription is from the Firuz Minar at Gaur. This is corroborated by Franklin's *Ruins of Gaur* (British Library, IOL MS, p. 16), in which he reports that the inscription was found at Goamalti. Creighton's publish account of Gaur (Creighton 1817: ii) tells us that an indigo factory was placed at a location called Gowmalty in the midst of the ruins of Gaur. The Firuz Minar is one of the most prominent monuments at the site and has drawn the attention of Western visitors since the eighteenth century. In the British Museum there is a hand-colored etching by W. Baillie of the minaret, prepared before 1799 (Figure 78, on website). In this etching we can see the door to the tower at the bottom and above that the empty niche for the inscription. The minaret has since been restored and repaired several times, but with the inscription already in London from 1826, there is no memory of it. By the time I arrived and walked around, the niche had vanished entirely, completely replaced by new brick.

So where are we with this inscription? Is it a sacred object in a secular space? It has every potential to be so. After all, it mentions God and it mentions a powerful king who describes himself as a Caliph and *jihadi*. Both these terms have acquired fresh meaning in recent years. For the moment, the memories embedded in this object lay dormant. But the quiet life it has enjoyed on public view for three decades may be overthrown at any moment by new interpretive contexts and freshly imagined meanings on the part of the viewers who come to the museum. Objects are interpreted and classified in certain ways today, but that will be superseded by new research and popular opinion. To put the matter another way, the orthodoxies of the moment are only of the moment. It is in this that the museum is "the place of memory" and finds an identity: if we can just remember that the museum is a place of forgetting, we will remember what is important in a collected object; it represents our struggle to remember and our ever-evolving dialogue with the human past.

Notes

Introduction

1. As observed by Charles Lachman, "The most commonly performed activities at virtually all Buddhist temples center on burning incense, making prostrations, and worshipping before painted and sculpted representations of Buddhas and Bodhisattvas" (2014: 367). Diana Eck (1996: 3) makes a similar point about Hinduism and the practice of *darshan*: "The central act of Hindu worship, from the point of view of the lay person, is to stand in the presence of the deity and to behold the image with one's own eyes, to see and be seen by the deity. … Since, in the Hindu understanding, the deity is present in the image, the visual apprehension of the image is charged with religious meaning."
2. http://www.newarkmuseum.org/TibetAltar.html [accessed June 7, 2013].
3. http://www.newarkmuseum.org/ [accessed October 7, 2014].

Chapter 1

1. The case of the Sivapuram bronzes is parallel in some respects to that of the Pathur Nataraja, discussed in Davis 1997: 222–59. In Davis 2009, I discuss the case of the Sivapuram Nataraja more briefly. I am grateful to the organizers of the Five Faiths Colloquium at the Auckland Museum, Chapel Hill, NC, for the opportunity to present this material.
2. On dating the Sivapuram bronzes, see Srinivasan 1963, Schwindler 1975, and Lerner 1976. A useful overview of the discussion of dates is in Pal (2003: 222–4).
3. ASI 279 of 1927, in *Annual Report of South Indian Epigraphy*, 1926–7, p. 84.
4. Annual Report for 1950–1. Administrative Report of the Government Museum, Madras (Madras: Superintendent, Government Press).
5. I interviewed several persons involved in the Sivapuram Nataraja case at different points: U. C. Chandramaulishwaran, R. Nagaswamy, K. A. Rajashekhara Nair, Pratapaditya Pal, Ben Heller, Doris Wiener, and M. S. Nagaraja Rao.
6. "Idol Wing Judgements" of the Economic Offences Wing, Government of Tamil Nadu, Police Department, sets out a different time frame, but largely agrees with Chandramouleeswaran's reconstruction: www.tneow.gov.in/IDOL.judgement [accessed August 4, 2014].
7. The act was passed in April 1947, shortly before Indian independence, but it was still in effect in 1969. Later it was supplanted by the Antiquities and Art Treasures Act of 1972.
8. On juristic personhood in the Pathur Nataraja case, see Davis 1997: 248–52. For a broader historical treatment of the concept, see Sontheimer 1964.

9. Heller (1973: 37). In the interview, Heller goes on to speak of his anguish over the sale of, and the controversy surrounding, the Nataraja and the joy he had derived from his discovery through Indian visits of the "philosophic discoveries of Hindu and Buddhist religions" (37).

10. Economic Offenses Wing, Police Department, Government of Tamil Nadu, "Idol Wing Judgements." http://www.tneow.gov.in/IDOLjudgement.html [accessed August 3, 2014]. The Economic Offenses Wing did not reply to my email inquiries.

11. Norton Simon Museum website: http://www.nortonsimon.org/.

Chapter 2

1. I am grateful to the Cleveland Museum of Art and its staff for inviting me to guest-curate *Indian Kalighat Paintings*. I am especially grateful to Griffith Mann, who was chief curator of the museum at that time, and to Heidi Strean, director of exhibitions and publications. Thanks also to Sonya R. Quintanilla and Deepa Manjunath for the editorial suggestions. http://www.clevelandart.org/events/exhibitions/indian-kalighat-paintings/gallery-views [accessed July 21, 2014]. http://www.clevelandart.org/sites/default/files/documents/Kalighat_Plan_Layout1-24x36_%281%29.pdf [accessed July 21, 2014].

2. Though there certainly are other groups who hold stereotypes about Kali, they may merely be reflecting the sentiments of those already mentioned. This list is thus not exhaustive but picks out four typical models.

3. The exhibition title wall bifurcated the Prints and Drawings gallery exhibit into two distinct rooms. Since the exhibition, the Cleveland Museum of Art has been renovated significantly, and the wall upon which one found the introductory graphics and labels no longer exists.

4. The outdoor sign was above the northwest corner of the intersection of 55th Street and Chester Avenue in Cleveland. Though there may have been other signs, I am aware only of this one.

5. Leaving aside, of course, Carol Duncan's insightful analysis in her *Civilizing Rituals* (1995) of the museum as a kind of temple.

6. See, for example, the controversies at the Virginia Museum of Fine Arts and the curatorship over the Confederate Memorial Chapel. http://vmfa.museum/about/grounds-history/ [accessed July 21, 2014].

7. http://www.clevelandart.org/art/2003.145 [accessed July 21, 2014].

8. http://www.clevelandart.org/art/2003.110.a [accessed July 21, 2014].

Chapter 3

1. Vicky Hallett, "Sackler's 'Art in Context' lets participants practice yoga in the gallery," *The Washington Post*, November 19, 2013. http://www.washingtonpost.com/lifestyle/wellness/sacklers-art-in-context-lets-participants-practice-yoga-in-the-gallery/2013/11/19/410163e0-4bcb-11e3-9890-a1e0997fb0c0_story.html [accessed November 30, 2013].

2. http://www.asianart.org/exhibitions_index/yoga-opening for the Opening Night festivities of Friday, February 21, 2014, and http://www.asianart.org/events/289 for the Yoga Festival on Saturday, February 22; [accessed March 1, 2014]. "AcroYoga" is a

combination of acrobatic movements and yoga with a partner, as described, for example, here: http://www.bodytoblissyoga.com/acro-yoga/ [accessed May 15, 2014].

3. http://valleyartcenter.weebly.com/yoga-in-the-gallery-march-1-2014.html [accessed April 2, 2014].

4. http://www.mobilemuseumofart.com/ai1ec_event/vinyasa-yoga/ [accessed July 12, 2014].

5. http://dhyana-yoga.com/about/ [accessed July 15, 2014].

6. http://www.imamuseum.org/familyactivities/family-day shows yoga for kids as a regular feature of monthly "family day" activities.

7. https://www.wichitaartmuseum.org/programs_events/calendar#838 [accessed July 15, 2014].

8. http://www.decordova.org/calendar/yoga-adults-summer-2014 [accessed July 15, 2014].

9. http://www.horniman.ac.uk/visit/events/iyengar-yoga-saturdays and http://www.umlauf-sculpture.org/programs/classes-workshops?

10. http://umlaufsculpture.org/?attachment_id=1299 [accessed April 15, 2014].

11. http://memphiscottonmuseum.org/news-and-events/events/yoga-at-the-cotton-museum [accessed January 10, 2014].

12. http://www.rubinmuseum.org/events/load/2645 [accessed June 30, 2014]. The museum hosts more eclectic classes: "How do you find balance? That is the question we are asking throughout the museum this spring through the exhibition Bodies in Balance: The Art of Tibetan Medicine. We offered the query to some of our favorite yoga teachers who hail from studios in our Chelsea neighborhood and beyond. They each created a yoga class in response. Come experience yoga as a tool for finding balance, strength and flexibility, not only in your body, but in your mind and spirit, as well." http://www.rubinmuseum.org/events/load/2628 [accessed June 30, 2014].

13. http://www.clevelandart.org/events/exhibitions/yoga-the-art-of-transformation/sunday-yoga [accessed June 17, 2014].

14. http://crowcollection.org/learn/ [accessed July 15, 2014].

15. http://www.asianart.org/exhibitions_index/yoga-opening [accessed March 1, 2014].

16. http://www.mercurynews.com/entertainment/ci_25191826/yoga-art-san-franciscos-asian-art-museum-unveils [accessed February 26, 2014].

17. Katherine Rosman, "The New DJs: Fitness Gurus," *Wall Street Journal*, February 6, 2013; [accessed May 2, 2014] at http://www.wsj.com/articles/SB10001424127887323 7019045782741836653869400.

18. NPR Archives, http://ttbook.org/book/mc-yogi-sacred-hip-hop-0 for October 23, 2011; [accessed May 2, 2014].

19. http://www.asia.si.edu/events/contemporary-voices.asp [accessed June 10, 2014].

20. http://yogarave.org/us/ [accessed July 1, 2014].

21. http://www.artofliving.org/us-en [accessed July 1, 2014]. Waghorne's study (2014: 285) in Singapore observes that "Singapore—ultramodern, cosmopolitan, deliciously multi-ethnic, and increasingly the model for development in Asia—presents a fascinating case study of new contexts and new packaging for yogic techniques."

22. http://yogablaze.com/events/seattle-yoga-rave-at-bellevue-arts-museum [accessed July 1, 2014].

23. http://yogarave.org/us/ [accessed July 1, 2014].
24. http://www.artofliving.org/us-en/yoga-rave-new-way-having-fun [accessed July 1, 2014].
25. http://www.rom.on.ca/en/activities-programs/rom-friday-night-live [accessed June 8, 2012].
26. http://www.rom.on.ca/en/activities-programs/events-calendar/rom-friday-night-live-light-season-finale [accessed December 1, 2012].
27. http://www.rom.on.ca/en/activities-programs/rom-friday-night-live [accessed May 23, 2013].
28. http://www.rubinmuseum.org/events/load/2729 [accessed July 18, 2014].
29. http://www.whitebylole.com/philosophy/ [accessed June 25, 2014].
30. http://www.thisweekinsarasota.com/2012/05/vinyasa-vino-a-yoga-and-wine-benefit-for-girls-inc/ [accessed January 15, 2014].
31. http://yogaonunion.com/events_may2012_vinyasa-violin-vino.html [accessed January 15, 2014].
32. http://cantonartsdistrict.com/ai1ec_event/vinyasa-and-vino-yoga-evening/?instance_id [accessed March 30, 2014].
33. http://www.dma.org/press-release/april-late-night-feature-tribute-ray-charles [accessed January 15, 2014], and although this particular "third Friday" event was in April 2005, similar gatherings are a staple feature of the calendar for the DMA and many museums.
34. http://www.medmob.org/ [accessed June 24, 2014].
35. https://tickets.childrensmuseumofphoenix.org/public/show.asp?shcode=185 [accessed July 20, 2014]; http://www.sackids.org/programs--events.html [accessed July 20, 2014]; https://www.childrensmuseummissoula.org/ [accessed July 20, 2014]; http://cmany.org/saturdays/ [accessed July 20, 2014]; and http://www.ccm.org/events/162 [accessed July 20, 2014].
36. From the museum's Winter 2010 Events brochure, http://nortonsimon.org/assets/Uploads/WinterattheNortonSimonMuseum.pdf [accessed January 15, 2014].
37. http://www.yoginos.com/homepage/about-yoginos [accessed March 2, 2014].
38. Wachob 2011; see also http://www.yoginos.com/partnerships/museums [accessed March 2, 2014].
39. https://www.facebook.com/events/226976027342777/, dated September 16, 2011; [accessed March 2, 2014].
40. http://www.yoginos.com/training [accessed March 2, 2014].
41. Personal communication, July 29, 2013.
42. From advertising for an educator workshop at Asia Society Texas Center, in Houston: http://asiasociety.org/texas/events/yoga-art-connecting-body-mind-and-heart-through-creativity-and-arts-education [accessed January 15, 2014]:
Current brain, academic, and cardiovascular research provide evidence that practices related specifically to yoga and its breathing techniques offer:

- focus and clarity of mind to access and channel creativity
- twenty-seven percent increase in GABA levels (calmness, anti-anxiety)
- improved academic achievement through learning how to improve focus, handle stress, and overcome obstacles
- increased academic interest through integrated movement in traditionally sedentary academic settings.

See a slightly different version with a description of five training modules here: http://www.yoginos.com/training [accessed March 2, 2014].

43. Personal communication, July 10, 2013.

44. Personal communication, May 21, 2013.

45. While events come and go, and outdoor yoga can only occur in summers in Baltimore, this museum has featured yoga in the galleries for over a decade. See the calendar here: www.artbma.org/calendar/.

46. http://blogs.yogajournal.com/yogabuzz/2011/08/yoga-at-the-museum.html [accessed May 29, 2013].

47. Personal communication, April 2, 2013; Karin Oen is a curator and at that time was also serving as director of education at the museum, organizing the extensive slate of wellness programs including yoga, meditation, and *tai-chi*.

48. Personal communication, Amy Lewis Hofland, August 14, 2014.

49. Personal communication, April 9, 2013; anonymous.

Chapter 4

1. http://www.museumofvancouver.ca/exhibitions/exhibit/bhangrame-vancouvers-bhangra-story [accessed August 23, 2014].

2. http://news.ukpha.org/ [accessed August 24, 2014]. There has been some controversy that such activities are named as "Punjabi" but focus on Sikhs. For the 2014 exhibition on Sikh participation in WWI, see *Empire, Faith and War: The Sikhs and World War One*, https://www.soas.ac.uk/gallery/efw/ [accessed August 17, 2014].

3. http://www.nationalsikhmuseum.com/ [accessed May 23, 2014].

4. http://virasat-e-khalsa.net/ [accessed November 14, 2014].

Chapter 5

1. Toward the end of the exhibition, the Board of Trade made a grant of £5,000 to buy objects from the exhibition for the Museum of Manufactures, intended to supplement the Government School of Design.

2. The term *creative industries* is here used in its broadest sense to include artists, designers, those working in the media, teachers, and lecturers.

3. That is, Theravada, Mahayana, and Vajrayana Buddhism.

4. For example, during the *Return of the Buddha* exhibition at the Freer/Sackler Gallery in 2004 and *The Dragon's Gift; The Sacred Art of Bhutan*, held at the Rubin Museum in 2008.

5. Now forming the National Museum of World Cultures after a merger with the Africa Museum and the Ethnological Museum Leiden.

6. Reviews in British newspapers: the *Daily Telegraph*, April 29, 2009; the *Evening Standard*, March 27, 2009; the *Financial Times*, April 25, 2009; and the *Independent*, May 6, 2009. Reviews in the *Asian Art Newspaper*, June 2009; *Eastern Art Online*, May 5, 2009; and BBC China.com, June 12, 2009.

7. Given by Julian Raby, director of the Freer/Sackler Gallery.

8. In fact, within Nepal even today both Buddhists and Hindus worship Bhairava, and the same would once have been true in India of several deities, including a stone image of the goddess Purnesvari to be included in room 18.

Chapter 6

1. The process of creating a mental image is called generation stage (*bskyed rim*), the process of entering that image in the mind's eye is "subtle" generation stage, while the process of manipulating the forces of the subtle body is called "perfection stage" (*rdzogs rim*). See Kirti Tenshap 2011: 444; 441.
2. Asian Art Museum accession numbers 1991.1, 1991.2, and 1991.3 comprise the objects in the Asian Art Museum collection.
3. Sets of paintings of this type should generally be understood as a group technically termed a "five Jina thang ka," as opposed to discrete representations of similar figures in more general settings (Luczanits 2003: 37). This schema belongs in particular to the Collection of All the Principles of the Buddhas (*Sarvatathagatatattvasamgraha*) (see Chandra 1987).
4. The mandala is thus both a cosmogram and a psychogram, a state of affairs that might be interpreted as reflecting key opinions of the Yogachara school of Buddhist ideal-ism, which affirms that even apparently objective aspects of the world are "mind only" (*chitta-matra*).
5. A didactic panel in the gallery depicts another painting in the Asian's collection (1997.2) that uses this linear approach to configuring cosmic space.
6. Such centers-and-surrounds are the key structural elements for creating an integrated world of experience, a sacred cosmos (Eliade 1959: 30–40). Whether sculptural, as with the stupa, or painted, as with the *thangka*, artworks depicting the Five Buddhas and thereby the cosmic center and its various aspects conform precisely to Eliade's descrip-tion; they "are regarded at once as replicas and manifestations" of the cosmologizing activity they both represent and embody. Indeed, the founding of the four directions and the central axis is the fundamental act that virtually transforms profane or secular space into sacred or holistic space.
7. For information on how the equivalences of *samdha-bhasha* work, see Wayman 1973: 131–2.
8. According to the traditional texts that describe how to navigate a mandala, the visionary journey first requires initiation (Sanskrit: *abhishekha*; Tibetan: *rab gnas*) from a qualified teacher. Such an initiation literally "empowers" the meditator to undertake visionary travel through the mandala in the mind's eye. In museum parlance, we might translate such a virtual initiation as a "transformative" journey, perhaps one that "purifies or restores order to the self or the world through sacrifice, ordeal, or enlightenment" (Duncan 2005: 13). Duncan goes on to say that the "outcome that museum rituals are supposed to produce can sound very like claims made for traditional, religious rituals."
9. All of the objects in *Enter the Mandala* reflect important aspects of the system of visuali-zation known to Tibetan gnoseological schemata as yoga tantra, the fundamental set of

texts and practices in which the Five Buddha schema holds pride of place, and which feature the royal imagery that dominates the iconography of the Five Buddhas (for a detailed analysis, see Weinberger 2003).

10. In order to avoid visitor confusion, we have clearly marked and called out the Honolulu *thangka* as a reproduction.

11. The power of microcosmic copying of the basic form of the stupa functions as a device to amplify the force contained in the artwork; see Laksha chaitya ceremony (B61D10+) in the Asian Art Museum for an example of such a practice. For the Lotus Sutra context, see Hurvitz 1976: 38–9.

12. Seen from above, of course, the temple is also a quincunx, a form isomorphic to the mandala, oriented to the four directions and its central axis.

13. As part of a tradition disseminated by pilgrimage and mission, Buddhist artists created a variety of model sacred sites. Perhaps most impressive of these are detailed reconstructions of the Mahabodhi temple, a late Nepalese version of which appears in Circle of Bliss (Huntington and Bangdel 2003: 70–3). The tradition is an old one; other models created during the Pala period are extant at, for example, the British Museum.

14. The display of objects in fragmentary form can help provide the basis for an "object based epistemology" of the kind cited by Conn; according to him, such procedures lost "pride of place" in the early twentieth century to more theoretical approaches. However, the fact that objects have so often dissolved "into discourse may also re-enchant them" (Starn 2005: 83).

15. For an analysis of how the Taima Mandara relates to parallel Shingon mandara of the Lotus and Diamond Worlds, see Ten Grotenhuis 2009: 13–32.

16. However, we introduced a small ritual flaw into this line rendering so that the diagram would not represent any actual mandala that had ever been formally consecrated.

17. The repetition of Buddha forms could take place for any number of reasons, but it usually involves the generation of merit, the force that determines the quality of rebirth.

18. Literally translated, the kutagara is a specifically pointed or apex shrine. Such pointed structures are characteristic of palaces rather than temples and underscore the royal valence of the imagery (Davidson 2002: 140). Given that there are a few other paintings exhibiting pointed shrines of this type, and that they all come from western Tibet, there may have been an architectural model(s) for *thangka* exhibiting this peculiar iconographic feature. (Klimburg-Salter 1998: 258–65). Since there are prominent diagonal geometries in the Alchi Sumtsek shrines, it is possible that this important site was home to this innovation. For a visual example in mural painting, see Goepper 1996: 96.

19. We have constructed an interactive tablet next to the Vairochana that assists visitors in discovering this pattern for themselves.

Chapter 7

1. If a Sanskrit term exists for a particular Buddhist deity, it is used herein. Otherwise, as in the case of Budai, the language in which the image developed is cited.

2. Discussion of these figures is based on the essay by my colleague Danielle Kisluk-Grosheide cited in the bibliography and on the pertinent entries in the online Oxford English Dictionary.

3. It is interesting to note that this particular manifestation, which was much admired in the United States in the late nineteenth century, also served as the inspiration for the Adams Memorial in the Rock Creek Cemetery in Washington, DC. It was commissioned by Henry Adams as a memorial to his wife and sculpted by Augustus Saint-Gaudens (1884–1907).

4. The sculptures can be seen on the Metropolitan Museum website. Search under collections, collections online, and then by accession number. This is the number assigned to an object when it is acquired by the museum. The accession numbers for the three pieces are 85.11.1, 85.11.2, and 85.11.3. The sixteenth-century date is too optimistic; they were most likely made in the late nineteenth century.

5. It is interesting to note that Vincent has a sketch of a very similar Buddha on p. 241 of the 1884 edition, which is cited in the bibliography.

6. Accession numbers are 89.2.2157 and 19.53.123.

7. Accession numbers 31.129.1, 31.129.2, and 31.129.3.

8. Accession numbers 2005.100.505 (43b), 1980.128.2, and 66.143.

9. This is the same Henry Adams who commissioned the Saint-Gaudens memorial mentioned in note 3.

10. Accession number 19.186.

11. Smith purchased his collection from Caption Frank Brinkley (1841–1912) who was working in Japan at the time. Brinkley was the author of one of the first Japanese-English dictionaries.

12. Museums generally distinguish between the permanent collection, the works of art that they own, and special exhibitions, which are often comprised largely of loans from other institutions. Buddhist art is also featured in special exhibitions presented by the department; however, the only exhibition to focus exclusively on this tradition was *Sacred Visions: Early Paintings from Central Tibet*, on view from October 6, 1998, to January 17, 1999.

13. Information on earlier exhibitions and programs is based on documentation available in the museum's archive.

14. Accession number 38.158.1.

15. Accession number 38.158.2.

16. Accession number 26.118.

17. Although they are mentioned in Sanskrit texts, arhats are not depicted in South or Southeast Asian art. They are found in Tibet as well as East Asia; however, it was China, not India, that served as the source for the Tibetan representations.

Chapter 8

1. Throughout the chapter, the acronym CCAA will be used.

2. This is the project name. The actual title of the course was: REL250/350: Mapping Cultures: From Religion, Art, Land to Environment.

3. http://www.hybridpedagogy.com/journal/hybrid-pedagogy-digital-humanities-future-academic-publishing.

4. I avoid defining the term "digital humanities," which has been dealt with in numerous ways in academic scholarship.

5. As an educator, the digital humanities allowed me to tap into the skills and passions of a young audience of passive Millennials and Generation Zs, a different cohort of students than earlier generations; that is, those who actively engage with technology and less directly in face-to-face human communication. The goal was to retool students' skills into practical means of engagement and creativity alongside the employment of traditional methods of learning. The digital humanities also had the potential to forge collaborations with individuals and institutions that were not easily accessible in person. This would also expose students to my own network of professionals.

6. My vision was that each person had something to contribute. Recruitment of a cohort of students with certain skill sets spanning a variety of disciplines, but particularly those who had a background in religious studies, Asian Studies, art, and computer science, was critical for teamwork and project goals. These locations also became sites for the inversion of authority, where teachers became students and vice versa in order to engage skill sets in creative ways.

7. The main collaborators include students from Austin College, CCAA staff, online scholars, and artists. Other scholars and supporters contributed to the project development. See list of collaborators at the end of the chapter.

8. The Web-publishing program Omeka, established by the Roy Rosenzweig Center for History and New Media at George Mason University, provided the platform for the bulk of the projects, website http://mappingcultures.austincollege.edu.

9. The exhibit remained at the museum from April 12, 2013, until September 2013.

10. Meditational deities.

11. Unity is an animation program that several students, under Isaac Cirlin's direction and guidance from Austin College Professor Mike Higgs, learned throughout the course. http://unity3d.com/.

12. The transfer from the onsite to the online environment also automatically created a different level of engagement from the lens of the researchers and the audience. For example, on a basic level, in terms of the latter, the audience had to manipulate the iPads in order to engage with the exhibition objects on a virtual level.

13. There has been a surge of recent research on the use of virtual worlds and religion and the negotiations that take place.

14. Toni Huber offers discussion and analysis of the construction and meaning of Tibetan cultural categories of space, place, and person, and the practice of ritual and organization of traditional society in relation to them.

15. Tenzin Rigdol's exhibition was entitled *Our Land, Our People*.

16. The use of the term "icon" refers to its changed status as a sacred image.

17. It was also not an accident that the theme of transformation ran throughout the exhibit as it does in the religion. The museum exhibit was therefore transformed on iPads into the landscape of Tibet, with three-dimensional figures and sound enlivening the traditional mode of the representation of art objects at the museum, inviting an engaged learning experience.

18. Key items in the website collection (see http://mappingcultures.austincollege.edu/about) included: Exhibit and Layout, Exhibit Map, Image Descriptions and Information, Student Annotated Bibliographies, "Have Brush, Will Travel": The Newar People's Permanent Influence on Tibetan Art, Avalokiteshvara and the cult of Compassion, Language: Tibetan and Chinese, Modern Education and Tibetan Student Studies, Professions and Culture, Protector and Disease Deities, The 13th Dalai Lama and Foreign Relations, Tibetan Music, and Tibetan Tea. Included are video clips of lectures by anthropologist Gerald Roche and artist and independent scholar, Naresh Shakya, and video clips and documentaries of student interviews of Tibetan videographers and filmmakers by Austin College student-collaborators.

19. Thanks to the efforts of anthropologist and independent scholar Gerald Roche situated in Qinghai, China at the time, provided access to music collections and to Tibetan filmmakers and videographers and contributed to a substantial contemporary focus to the project and exhibition as a whole.

20. See http://www.tba21.org/program/exhibitions/63/artwork/581?category=exhibitions.

Chapter 10

1. For a striking premodern example of religious objects as booty see Richard H. Davis, "Trophies of War," in *Lives of Indian Images* (1997).

2. There is surprisingly little scholarship available on the museum. For the museum's website see http://creationmuseum.org/. For one of the few scholarly analyses, see "Faith Displayed as Science: The Role of the 'Creation Museum' in the Modern American Creationist Movement" (Duncan 2009). Jill Stevenson's recent monograph, *Sensational Devotion: Evangelical Performance in Twenty-first Century America* (2013) has a chapter on the Creation Museum as a performance of orthodoxy.

3. On the mechanisms of interpellation, see Louis Althusser, "Ideology and Ideological State Apparatuses," *in Critical Theory Since 1965* (1986), pp. 245–9.

4. Also see Lawrence E. Sullivan and Alison Edwards, *Stewards of the Sacred* (2004). Tomoko Masuzawa's *The Invention of World Religions: Or, How European Universalism was Preserved in the Language of Pluralism* (2005) traces the emergence of the category world religions.

5. Immanuel Kant, "Fourth Essay: Service and pseudo-service under the sovereignty of the good principle, or Religion and Pfaffentum" (2013: 86).

6. Frazer, *The Golden Bough* (Abridged ed. 1922). A clear picture of the role of similarity in Mircea Eliade's comparative method can be had through an examination of his *Patterns in Comparative Religion* (1963). For an overall appraisal of the comparative religion enterprise after the postmodern turn see Kimberley C. Patton and Benjamin C. Ray, eds, *A Magic Still Dwells: Comparative Religion in the Postmodern Age* (2000).

7. Homepage of the Council for a Parliament of the World's Religions, http://www.parliamentofreligions.org/index.cfm?n=1 [accessed November 8, 2014].

8. On the use of policy to manage diversity see Reza Hasmath, ed., *Managing Ethnic Diversity: Meanings and Practices from an International Perspective* (2011).

9. A radical critique (Zizek 1997: 44) argues that "the ideal form of ideology of this global capitalism is multiculturalism, the attitude which, from a kind of empty global position, treats each local culture the way the colonizer treats colonized people—as 'natives' whose mores are to be carefully studied and 'respected'."

10. Chanju Mun proposes that there are two styles of *panjiao*, one sectarian and one ecumenical. See *The History of Doctrinal Classification in Chinese Buddhism A Study of the Panjiao System* (2005). For Kukai's "Aims of the Three Teachings" see Hakeda (1973: 101–39).

11. Anja Lüpken (2010) has published a study of the three museums, though her approach and interests are different from my own.

12. It is difficult to visualize the actual layout of the museum from the floor plan available on the site, and until I have visited the museum I hesitate to so make further comments.

13. "About the Museum: Origin" page: http://www.mwr.org.tw/content_en/introduction/origin-concept.aspx [accessed November 8, 2014].

14. Statement by Hsin Tao, cited on the "Founder" page of the museum: http://www.mwr.org.tw/content_en/introduction/fonder.aspx [accessed November 8, 2014].

15. The museum website has an excellent floor plan and digital tour: http://www.glasgowlife.org.uk/museums/st-mungos/About/Pages/Digital-tour.aspx [accessed November 9, 2014].

16. David Morgan, *The Sacred Gaze: Religious Visual Culture in Theory and Practice* (2005); see esp. "Visual Practice and the Function of Images," pp. 48–74.

17. Interview with David Page, architect, April 2003, cited in Fraser, p. 95.

18. Interview with Harry Dunlop, curator, April 2003, cited in Fraser, p. 84.

19. Both comments cited by Fraser, p. 122.

20. Zizek (1997: 44) puts it well: "Liberal 'tolerance' condones the folklorist Other deprived of its substance—like the multitude of 'ethnic cuisines' in a contemporary megalopolis; however, any 'real' Other is instantly denounced for its 'fundamentalism', since the kernel of Otherness resides in the regulation of its jouissance: the 'real Other' is by definition 'patriarchal', 'violent', never the Other of ethereal wisdom and charming customs."

21. First comment from Diana L. Eck, "Dialogue and Method: Reconstructing the Study of Religion," in Patton and Ray (2000: 140).

22. Mark O'Neill (1998: 87–8) cited in Lüpken (2011: 110, n. 59). O'Neill has revisited the issue of tolerance, multiculturalism, and controversy in "Religion and Cultural Policy: Two Museum Case Studies" (2011).

23. Summary of private communication from Caroline Barr, Museums Manager-History, Glasgow Museums, September 5, 2014.

Chapter 11

1. The photographs are in the British Museum collection, donated by A. W. Franks.

2. A number of pieces in the British Museum are marked with the letter. See Zwalf 1996, numbers 13 and 132–8.

3. This item and no other Bharhut sculpture otherwise came to the British Museum.

4. A cynical reference to the creation of the new British Museum of Natural History in 1880.

5. No Bharhut casts came to the British Museum.

Bibliography

Allen, C. *The Search for the Buddha: The Men Who Discovered India's Lost Religion*. New York: Carroll and Graf, 2004.

Althusser, L. "Ideology and Ideological State Apparatuses." In *Critical Theory Since 1965*, edited by H. Adams and L. Searle, 245–9. Gainesville: University of Florida Press, 1986.

Ames, M. "The Nature of Numinosity and its Museological Reconstruction." *Journal of the Walters Art Gallery* 52/53 (1994/5): 61–4.

Anderson, B. *Imagined Communities: Reflections on the Origin and Spread of Nationalism*. London, New York: Verso, 1991 [1983].

"Anglo Sikh Heritage Trail Consultative Conference: A United Kingdom Punjab Heritage Association Project." Pamphlet, July 26, 2002.

Appadurai, A., ed. "Introduction: Commodities and the Politics of Value." In *The Social Life of Things: Commodities in Cultural Perspective*, 3–63. Cambridge: Cambridge University Press, 1986.

Appadurai, A. *Modernity at Large: Cultural Dimensions of Globalization*. Minneapolis: University of Minnesota Press, 1996.

Appadurai, A., and C. Breckenridge. "Museums are Good to Think: Heritage on View in India." In *Representing the Nation: A Reader/History, Heritage, Museums*, 404–20. London and New York: Routledge and The Open University, 1999.

Archer, M. *British Drawings in the India Office Library*. 2 vols. London: H.M.S.O., 1969.

ARTSlant Worldwide. December 7, 2011. http://www.artslant.com/ew/events/show/192285-sacred-word-image-five-world-religions [accessed December 8, 2011].

Auboyer, J. "A Note on the Feet and Their Symbolism." In *Kusumanjali: New Interpretations of Indian Art & Culture*, edited by C. Sivaramamurti and M. S. Nagaraja Rao, 125–7. Delhi: Agam Kali, 1987.

Axel, B. *The Nation's Tortured Body: Violence, Representation, and the Formation of a Sikh "Diaspora"*. Durham and London: Duke University Press, 2001.

Axel, B. "Diasporic Sublime: Sikh Martyrs, Internet Mediations, and the Question of the Unimaginable." *Sikh Formations* 1, no. 1 (2005): 127–54.

Baker, J. "The Relationship of Narrative Text and Pictorial Composition in Late Sixth-Century Paintings at Tun-huang." *Silk Road Art & Archaeology* 3 (1993/4): 199–222.

Baker, J. *Sacred Word and Image: Five World Religions*. Phoenix: Phoenix Art Museum, 2012.

Baker, J., and N. DeLeon. "Phoenix Art Museum Exhibit 'Sacred Words and Images: Five World Religions' Poses the Deep Questions of Meaning." *Huffington Post*, January 26, 2012. http://www.huffingtonpost.com/2012/01/26/phoenix-art-museum-exhibit_n_1224638.html [accessed January 27, 2012].

Barasch, M. *Icon: Studies in the History of an Idea*. New York: New York University Press, 1992.

Barrett, D. *Early Cola Bronzes*. Bombay: Bhulabhai Memorial Institute, 1965.

Batchelor, S. *The Awakening of the West: The Encounter of Buddhism and Western Culture*. Berkeley: Parallax Press, 1994.

"Bearded boxer wins court fight." CBC News, January 12, 2000. http://www.cbc.ca/news/canada/bearded-boxer-wins-court-fight-1.238851 [Accessed November 16, 2014].

Beer, R. *The Encyclopedia of Tibetan Symbols and Motifs*. Boston: Shambala, 1999.

Benjamin, W. "The Work of Art in the Age of Mechanical Reproduction." In *Illuminations: Essays and Reflections*, edited by H. Arendt and H. Zohn, 217–51. New York: Schocken Books, 1985.

Bennett, T. *The Birth of the Museum: History, Theory, Politics*. London and New York: Routledge, 1995.

Bennett, T. "The Exhibitionary Complex." In *Representing the Nation: A Reader: Histories, Heritage and Museums*, edited by D. Boswell and J. Evans, 332–61. London and New York: Routledge and The Open University, 1999.

Bentor, Y. *Consecration of Images and Stupas in Indo-Tibetan Tantric Buddhism*. Leiden: E.J. Brill, 1996.

Bhatti, S. *Translating Museums: A Counterhistory of South Asian Museology*. Walnut Creek, CA: Left Coast Press, 2012.

Bogel, C. *With a Single Glance: Buddhist Icon and Early Mikkyo Vision*. Seattle: University of Washington Press, 2009.

Brauen, M. *Grain of Emptiness: Buddhism-inspired Contemporary Art*. New York: The Rubin Museum of Art, 2010.

Bräunlein, P. J. "Material Turn." In *Georg-August-Universität Göttingen (Hg.): Dinge des Wissens. Die Sammlungen, Museen und Gärten der Universität Göttingen*, 30–44. Göttingen: Wallstein Verlag, 2012.

Breckenridge, C. "The Aesthetics and Politics of Colonial Collecting: India at World Fairs." *Comparative Studies in History and Society* 31 (1989): 195–216.

Broad, W. J. *The Science of Yoga: The Risks and the Rewards*. New York: Simon & Schuster, 2012.

Bronkhorst, J. "Indology, What is it Good for?" *Zeitschrift der Deutschen Morgenländischen Gesellschaft* 16, no. 1 (2011): 115–22.

Brooks, W. *Interpreter of Buddhism to the West, Sir Edwin Arnold*. New York: Bookman Associates Incorporated, 1957.

Brown, C., M. W. Grimm, A-Y. Pan, and J. Baker. *Weaving China's Past: The Amy S. Clague Collection of Chinese Textiles*. Phoenix: Phoenix Art Museum, 2000.

Buggeln, G. T. "Museum Space and the Experience of the Sacred." *Material Religion* 8, no. 1 (March 2012): 30–50.

Byrne, J. "'Authorized by Sri Pattabhi Jois': The Role of *Parampara* and Lineage in Ashtanga Vinyasa Yoga." In *Gurus of Modern Yoga*, edited by M. Singleton and E. Goldberg, 107–20. New York: Oxford University Press, 2014.

Campbell, J. *Pathways to Bliss: Mythology and Personal Transformation*. Novato, CA: New World, 2004.

Campbell, S. *Collector without Walls: Norton Simon and His Hunt for the Best*. New Haven: Yale University Press, 2010.

Caygill, M., and J. F. Cherry, eds. *A.W. Franks: Nineteenth-century Collecting and the British Museum*. London: British Museum Press, 1997.

Chandra, L., ed. *Sarvatathagatatattvasamgraha*. Delhi: Motilal Banarsidass, 1987.

Chang, T. *Travel, Collection, and Museums of Asian Art in Nineteenth-century Paris*. Burlington, VT: Ashgate, 2013.

Chidester, D. "Sacred." *Material Religion* 7, no. 1 (March 2011): 84–90.

Chisolm, L. *Fenollosa: The Far East and American Culture*. New Haven: Yale Publications in American Studies, 1963.

Chopra, R. "Commemorating Hurt: Memorializing Operation Bluestar." *Sikh Formations* 6, no. 2 (2010): 119–52.

Chopra, R. *Militant and Migrant: The Politics and Social History of Punjab*. London: Routledge, 2011.

Clifford, J. *The Predicament of Culture: Twentieth-Century Ethnography, Literature, and Art*. Cambridge, MA: Harvard University Press, 1988.

Cohn, B. *Colonialism and Its Forms of Knowledge: The British in India*. Princeton: Princeton University Press, 1996.

Conn, S. *Museums and American Intellectual Life, 1876-1926*. Chicago: University of Chicago Press, 1998.

Cooks, B. "Black Artists and Activism: Harlem on My Mind (1969)." *American Studies* 48, no. 1 (Spring 2007): 5–39.

Cooper-Greenhill, E. *Museums and the Interpretation of Culture*. London: Routledge, 2000.

Cort, J. E. "Art, Religion, and Material Culture: Some Reflections on Method." *Journal of the American Academy of Religion* 64, no. 3 (1996): 613–32.

Creighton, H. *The Ruins of Gour Described, And Represented in Eighteen Views; with a Topographical Map*. London: Black, Parbury, & Allen, 1817.

Crew, S., and J. Sims. "Locating Authenticity: Fragments of a Dialogue." In *Exhibiting Cultures: The Poetics and Politics of Museum Display*, edited by I. Karp and S. Levine, 159–75. Washington, DC: Smithsonian University Press, 1991.

Davidson, R. *Indian Esoteric Buddhism: A Social History of the Tantric Movement*. New York: Columbia University Press, 2002.

Davis, R. H. *Ritual in an Oscillating Universe: Worshiping Siva in Medieval India*. Princeton: Princeton University Press, 1991.

Davis, R. H. *Lives of Indian Images*. Princeton: Princeton University Press, 1997.

Davis, R. H., ed. *Images, Miracles, and Authority in Asian Religious Traditions*. Boulder: Westview Press, 1998.

Davis, R. H. "Chola Bronzes in Procession." In *The Sensuous and the Sacred: Chola Bronzes from South India*, edited by V. Dehejia, 46–63. New York: American Federation of Arts, 2002.

Davis, R. H. "Presence and Translucence: Appar's Guide to Devotional Receptivity." In *Presence: The Inherence of the Prototype within Images and Other Objects*, edited by R. Maniura and R. Shepherd, 87–104. Aldershot, UK: Ashgate, 2006.

Davis, R. H. "From the Wedding Chamber to the Museum: Relocating the Ritual Arts of Madhubani." In *What's the Use of Art? Asian Visual and Material Culture in Context*, edited by J. Mrázek and M. Pitelka, 77–99. Honolulu: University of Hawai'i Press, 2007.

Davis, R. H. "The Dancing Shiva of Shivapuram: Cult and Exhibition in the Life of an Indian Icon." In *A Place for Meaning: Art, Faith, and Museum Culture*, edited by A. Hughes and C. Wood, 81–92. Chapel Hill, NC: Ackland Art Museum, and University of North Carolina at Chapel Hill, 2009.

Davis, R. H. *A Priest's Guide for the Great Festival: Aghorasiva's Mahotsavavidhi*. South Asia Research. Oxford: Oxford University Press, 2010.

Davis, R. H. *Gods in Print: Masterpieces of India's Mythological Art*. San Rafael, CA: Mandala, 2012.

de Michelis, E. *A History of Modern Yoga: Patanjali and Western Esotericism*. New York: Continuum, 2004.

Devraj, R. "Non-Resident Nataraja." *Himalmag*, June 1999. http://old.himalmag.com/component/content/article/2326-Non-resident-Nataraja.html.

Dhavan, P. *When Sparrows Became Hawks: The Making of the Sikh Warrior Tradition, 1699–1799*. New York: Oxford University Press, 2011.

Dpal 'byor-bzang po. *Rgya-bod yig-tshang chen mo*. Chengu: Si-khron mi-rigs dpe-skrun-khang, 1983, 124–5.

Duncan, C. *Civilizing Rituals: Inside Public Art Museums*. London: Routledge, 1995.

Duncan, J. A. "Faith Displayed as Science: The Role of the 'Creation Museum' in the Modern American Creationist Movement." Unpublished honors thesis, Harvard University, 2009.

Eck, D. L. *Darsan: Seeing the Divine Image in India*. 3rd edn. New York: Columbia University Press, 1998.

Edwards, C., D. Francis, and S. Slack, "An Evaluation of Object centered Approaches to Interpretation." In *Museum Gallery Interpretation and Material Culture*, Victoria & Albert Museum conference proceedings (First annual Sackler Centre for Arts Education conference), edited by J. Fritsch, 156–62. London: Routledge, 2014.

Eliade, M. *The Sacred and the Profane*. New York: Harcourt, 1959.

Eliade, M. *Patterns in Comparative Religion*. Translated by Rosemary Sheed. Cleveland: Meridian Books, 1963.

Fenech, L. "Contested Nationalisms; Negotiated Terrains: The Way Sikhs Remember Udham Singh 'Shahid' (1899-1940)." *Modern Asian Studies* 36, no. 4 (2002): 827–70.

Fleming, B., and R. Mann. *Material Culture and Asian Religions: Text, Image, Object*. London: Routledge, 2014.

Fraser, J. W. "Museums, Drama, Ritual and Power." PhD thesis, University of Leicester, 2004.

Frazer, J. G. *The Golden Bough*. Abridged edn, 1922. London: Macmillan, 1890, 1900, 1911–15.

French, A. "Warrior Pose: A Former Pro Wrestler Reinvents Yoga for Aging Studs." *New York Times Magazine* (August 17, 2014): 18–23.

Fritsch, J., ed. *Museum Gallery Interpretation and Material Culture*. Victoria & Albert Museum conference proceedings (First annual Sackler Centre for Arts Education conference). London: Routledge, 2014.

Gianotti, C. "The Srin mo Demoness and her Submission to the Buddhist Tibetan Dharma: Some Different Modes of Her Transformation." In *Buddhist Asia* no. 2. Papers from the Second Conference of Buddhist Studies Held in Naples in June 2004, edited by G. Orofino and S. Vita. Italian School of East Asian Studies, 69–97. Kyoto: Università degli Studi di Napoli "L'Orientale" Centro di Studi sul Buddhismo, 2010.

Glueck, G. "Simon and India: Battle on Idol Widens." *New York Times* (December 30, 1974): 36.

Goepper, R. *Alchi: Ladakh's Hidden Buddhist Sanctuary*. London: Serindia, 1996.

Golding, V., and W. Modest, eds. *Museums and Communities: Curators, Collections and Collaborations*. London: Bloomsbury Academic, 2013.

Goswamy, B. N. "Another Past, Another Context: Exhibiting Indian Art Abroad." In *Exhibiting Cultures: The Poetics and Politics of Museum Display*, edited by I. Karp and S. Levine, 68–78. Washington, DC: Smithsonian University Press, 1991.

Goswamy, B. N. "About the Making of a Throne." The *Tribune*, July 9, 2000. http://www.tribuneindia.com/2000/20000709/spectrum/art.htm [accessed August 16, 2014].

Government Museum. *Centenary Souvenir (1851-1951)*. Madras: Government Museum, 1952.

Greenblatt, S. "Resonance and Wonder." In *Exhibiting Cultures: The Poetics and Politics of Museum Display*, edited by I. Karp and S. Levine, 42–56. Washington, DC: Smithsonian Institution Press, 1991.

Grewal, J. W. *Sikhs of the Punjab*. Cambridge: Cambridge University Press, 1990.

Griffin, Lepel H. *The Panjab Chiefs: Historical and Biographical Notices of the Principal Families in the Territories Under the Panjab Government*. Lahore: T. C. McCarthy-Chronicle Press, 1865.

Griffin, Lepel H. *The Rajas of the Punjab, Being The History of the Principal States in the Punjab and Their Political Relations with the British Government*. Reprint, Patiala, Punjab: Languages Department, Punjab, 1970 [1873].

Grimes, R. L. "Sacred Objects in Museum Spaces." *Studies in Religion/Sciences Religieuses* 21, no. 4 (1992): 419–30.

Guha-Thakurta, T. *The Making of a New "Indian" Art: Artists, Aesthetics, and Nationalism in Bengal, c. 1850-1920*. Cambridge: Cambridge University Press, 1992.

Guha-Thakurta, T. *Monuments, Objects, Histories: Institutions of Art in Colonial and Postcolonial India*. New Delhi: Permanent Black, 2004.

Gulacsi, Z. "Sacred Word and Image in Eastern Christian, Islamic and Jewish Contexts." In *Sacred Word and Image: Five World Religions*, edited by J. Baker, 82–127. Phoenix: Phoenix Art Museum, 2012.

Guru Gobind Singh Marg: The Great Pilgrimage (Mahan Yatra), n.d. Publication information unavailable.

Habib, I. "Jatts of Punjab and Sind." In *Punjab Past and Present, Essays in Honour of Dr Ganda Singh*, edited by H. Singh and N. G. Barrier, 92–103. Patiala: Punjabi University, 1976.

Hakeda, Y. S., trans. *Kukai: Major Works*. New York: Columbia University Press, 1973, 101–39.

Harlacher, S. M. "The Buddha's Footprint." In *Guardian of the Flame: Art of Sri Lanka*, edited by J. Baker, 168–77. Phoenix: Phoenix Art Museum, 2003.

Harris, C. *The Museum on the Roof of the World: Art, Politics, and the Representation of Tibet*. London and Chicago: University of Chicago Press, 2012.

Hasmath, R., ed. *Managing Ethnic Diversity: Meanings and Practices from an International Perspective*. Surry: Ashgate, 2011.

Heller, B. "Oral History Interview with Ben Heller," *Archives of American Art Journal*, 13, no. 3 (1973): 20–1, edited by P. Cummings. Washington, DC: Smithsonian Archives of American Art.

Hoving, T. *Making the Mummies Dance: Inside the Metropolitan Museum of Art*. New York: Simon and Schuster, 1993.

Huber, T. *The Cult of Pure Crystal Mountain: Popular Pilgrimage and Visionary Landscape in Southeast Tibet*. Oxford, UK: Oxford University Press, 1999.

Hughes, A. M., and C. H. Wood, eds. *A Place for Meaning: Art, Faith, and Museum Culture*. Chapel Hill: University of North Carolina Press, 2009.

Humes, C. A. "Wrestling with Kali: South Asian and British Constructions of the Dark Goddess." In *Encountering Kali: In the Margins, at the Center, in the West*, edited by R. F. McDermott and J. Kripal, 145–68. Berkeley: University of California Press, 2003.

Hunter, Dard. "Empress Shotoku and Her Million Printed Prayers." In *Papermaking: The History and Technique of an Ancient Craft*, 64–76. New York: Dover, 1978.

Huntington, J., and D. Bangdel. *The Circle of Bliss: Buddhist Meditational Art*. Columbus, OH: Columbus Museum of Art, 2003.

Huntington, S., and J. Huntington. *Leaves from the Bodhi Tree: The Art of Pala India (8th–12th centuries) and its International Legacy*. Dayton, OH: Dayton Art Institute, 1990.

Inada, K., and N. P. Jacobson. *Buddhism and American Thinkers*. Albany: State University of New York Press, 1984.

"Indian Sikhs furious after relics sent to Canada to raise funds." Agence France-Presse. October 8, 2003. ClariNet. http://quickstart.clari.net/qs_se/webnews/wed/cf/Qindia-canada-sikh.Rk_h_DO8.html [Accessed August 18, 2014].

Isaacs, R., and T. Richard Blurton. *Visions from the Golden Land*. London: British Museum, 2000.

Iyengar, B. K. S. *Light on Yoga*. New York: Schocken Books, 1966.

Jackson, D. *The Nepalese Legacy in Tibetan Painting*. New York: Rubin Museum of Art, 2010.

Jackson, D. *Mirror of the Buddha: Early Portraits from Tibet*. New York: Rubin Museum of Art, 2012.

Jacob, G. (Director, Khalsa Heritage Centre). Lecture and conversation, University of British Columbia, November 2, 2011.

Jain, A. R. "Who Is to Say Modern Yoga Practitioners Have It All Wrong? On Hindu Origins and Yogaphobia." *Journal of the American Academy of Religion* 82, no. 2 (June 2014): 427–71.

Jha, G. *The Yoga-Darshana. Comprising the Sutras of Patanjali, with the Bhasya of Vyasa*. Translated into English with Notes. 2nd edn. Madras: Theosophical Society, 1934.

Jolly, J. "India: Tibetan Exiles Walk on 'Home Soil' in Dharamsala." BBC News, October 28, 2011. http://www.bbc.com/news/world-south-asia-15490160 [accessed September 19, 2012].

Kaimal, P. "Shiva Nataraja: Shifting Meanings of an Icon." *Art Bulletin* 81 (1999): 390–419.

Kanna, R. *Manual on the Bronzes in the Government Museum, Chennai*. Chennai, India: Government Museum, 2003.

Kant, I. "Fourth Essay: Service and pseudo-service under the sovereignty of the good principle, or Religion and Pfaffentum," 2013. *Religion within the Limits of Bare* Reason, in the version by Jonathan Bennett presented at www.earlymoderntexts.com [accessed November 8, 2014].

Kapstein, M. *The Tibetans*. Malden, MA: Wiley-Blackwell, 2006.

Kapstein, M. "Remarks on the Mani Kabum." In *The Tibetan History Reader*, edited by G. Tuttle and K. R. Schaeffer, 89–107. New York: Columbia University Press, 2013.

Karp, I., C. M. Kreamer, and S. D. Lavine, eds. *Museums and Communities: The Politics of Public Culture*. Washington, DC: Smithsonian Institution Press, 1992.

King, R. *Orientalism and Religion: Postcolonial Theory, India, and the "Mystic East"*. London: Routledge, 1999.

Kinnard, J. N. *Imaging Wisdom: Seeing and Knowing in the Art of Indian Buddhism*. Richmond, UK: Curzon, 1999.

Kinnard, J. N. "The Polyvalent Padas of Visnu and the Buddha." *History of Religions* 40, no. 1 (August 2000): 32–57.

Kirschenbaum, M. "What is Digital Humanities and What's It Doing in English Departments." *ADE Bulletin* 150 (2010): 1–7. http://mkirschenbaum.files.wordpress.com/2011/01/kirschenbaum_ade150.pdf.

Kirti Tenshap, R. *Principles of Buddhist Tantra*. Somerville, MA: Wisdom, 2011.

Kisluk-Grosheide, D. "The Reign of Magots and Pagods." *The Metropolitan Museum Journal* 37 (2002): 177–97.

Klimburg-Salter, D. "A Thangka Painting Tradition from the Spiti Valley." In *Art of Tibet: Selected Articles from Orientations 1981–1997*, 258–65. Hong Kong: Orientations, 1998.

Knoke, C. "Sacred Spaces, Sacred Art: A New Installation of Asian Art at the Norton Simon Museum." *Arts of Asia* 30, no. 2 (2000): 56–69.

Kossak, S. *Painted Images of Enlightenment: Early Tibetan Thangkas, 1050-1450*. Mumbai: Marg, 2010.

Kratz, C., and I. Karp. "Introduction." In *Museum Frictions: Public Cultures/Global Transformations*, edited by I. Karp, C. A. Kratz, L. Szwaja, and T. Ybarra-Frausto, 1–31. Durham and London: Duke University Press, 2006.

Lachman, C. "Buddhism—Image as Icon, Image as Art." In *The Oxford Handbook of Religion and the Arts*, edited by F. B. Brown, 367–78. New York: Oxford University Press, 2014.

Launois (Sat Kaur), A-C. "The Khalsa Heritage Complex: A Museum for a Community?" In *New Insights into Sikh Art*, edited by K. Singh, 134–45. Mumbai: Marg Publications, 2003.

Leidy, D. P., and D. Strahan. *Wisdom Embodied: Chinese Buddhist and Daoist Sculpture in the Metropolitan Museum of Art*. New York: The Metropolitan Museum of Art, 2012.

Leonard, K. I. *Making Ethnic Choices: California's Punjabi Mexican Americans*. Philadelphia: Temple University Press, 1992.

Lerner, M. "Shiva, Lord of Dance." *The Connoisseur* 193, no. 777 (1976): 172–5.

Listopad, J. "The Cult of Relics." In *Guardian of the Flame: Art of Sri Lanka*, edited by J. Baker. Phoenix: Phoenix Art Museum, 2003.

Litt, S. "Kalighat painting at Cleveland Museum of Art illuminate 19th century life in India." *Plain Dealer*, July 17, 2011, p. 1. Section E. http://www.cleveland.com/arts/index.ssf/2011/07/kalighat_paintings_at_clevelan.html [accessed July 21, 2014].

Lopez, D. *Curator of the Buddha: The Study of Buddhism under Colonialism*. Chicago: University of Chicago Press, 1995.

Lopez, D. *Prisoners of Shangri-La: Tibetan Buddhism and the West*. Chicago: University of Chicago Press, 1999.

Luczanits, C. "On the iconography of Tibetan scroll paintings (*thang ka*) dedicated to the five Tathagatas." In *Art in Tibet: Issues in Traditional Tibetan Art from the Seventh to the Twentieth Centuries*, edited by E. LoBue, 37–51. Leiden: E.J. Brill, 2011.

Lüpken, A. *Religion(en) im Museum: eine vergleichende Analyse der Religionsmuseen in St. Petersburg, Glasgow und Taipeh*. Duits: LIT Verlag, 2011.

Mack, J. *The Museum of the Mind: Art and Memory in World Cultures*. London: British Museum Press, 2003.

Mann, R. D. "Material Culture and the Study of Hinduism and Buddhism." *Religion Compass* 8, no. 8 (August 2014): 264–73.

Masuzawa, T. *The Invention of World Religions Or, How European Universalism Was Preserved in the Language of Pluralism*. Chicago: University of Chicago Press, 2005.

Mathur, S. *India by Design: Colonial History and Cultural Display*. Berkeley: University of California Press, 2007.

McCarthy, C. "Sikhs Gather for a Miracle: Sacred Relic Attracts Thousands." *The Fresno Bee*, February 12, 1996, A1.

McLeod, W. H. *Popular Sikh Art*. Oxford: Oxford University Press, 1991.

Meister, M. W., and M. A. Dhaky. *Encyclopaedia of Indian Temple Architecture: Vol. 1, Part 1, South India, Lower Dravidadesa, 200 B.C.-A.D. 1324*. New Delhi: American Institute of Indian Studies, 1983.

Metcalfe, T. *Land, Landlords, and the British Raj: Northern India in the Nineteenth Century*. Berkeley/Los Angeles/London: University of California Press, 1979.

Minucciani, V., ed. *Religion and Museums: Immaterial and Material Heritage*. Torino: Umberto Allemandi, 2013.

Mitchell, T. *Colonising Egypt*. Berkeley/Los Angeles/London: University of California Press, 1991 [1981].

Mitchell, W. J. T. *Picture Theory: Essays on Verbal and Visual Representation*. Chicago: University of Chicago Press, 1994.

Mitchell, W. J. T. "Representation." In *Critical Terms for Literary Study*, edited by F. Lentricchia and T. McLaughlin, 11–22. Chicago/London: University of Chicago, 1995.

Mitchell, W. J. T. "What Do Images Really Want?" *October* 77 (1996): 71–82.

Mitter, P. *Much Maligned Monsters: A History of European Reactions to Indian Art*. Chicago: University of Chicago Press, 1992.

Morgan, D. *The Sacred Gaze: Religious Visual Culture in Theory and Practice*. Berkeley: University of California Press, 2005.

Morgan, D. *Religion and Material Culture: The Matter of Belief*. London: Routledge, 2010.

Morgan, D. *The Embodied Eye: Religious Visual Culture and the Social Life of Feeling*. Berkeley: University of California Press, 2012.

Morgan, D. "Art, Material Culture, and Lived Religion." In *The Oxford Handbook of Religion and the Arts*, edited by F. B. Brown, 480–97. New York: Oxford University Press, 2014.

Morris, S., and J. Stommel. "Hybrid Pedagogy, Digital Humanities, and the Future of Academic Publishing," 2014. http://www.hybridpedagogy.com/journal/hybrid-pedagogy-digital-humanities-future-academic-publishing/ [accessed August 12, 2014].

Moussouri, T. Buddhist Gallery Front-end Evaluation report, August 6, 2008, unpublished document.

Muchnic, S. *Odd Man In: Norton Simon and Pursuit of Culture*. Berkeley: University of California Press, 1998.

Mun, C. *The History of Doctrinal Classification in Chinese Buddhism: A Study of the Panjiao System*. Lanham, MD: University Press of America, 2005.

Murphy, A. "Mobilizing Seva ('Service'): Modes of Sikh Diasporic Action." In *South Asians in Diaspora: Religions and Histories*, edited by K. Jacobsen and P. Kumar, 337–72. Leiden: Brill, 2004.

Murphy, A. "Materializing Sikh Pasts." *Sikh Formations: Religion, Culture, Theory* 1, no. 2 (December 2005): 175–200.

Murphy, A. "The Guru's Weapons." *The Journal of the American Academy of Religion* 77, no. 2 (June 2009): 1–30.

Murphy, A. "March 1849 Lahore, Punjab, India." *The Victorian Review* 36, no. 1 (Spring 2010): 21–6.

Murphy, A. *The Materiality of the Past: History and Representation in Sikh Tradition*. New York: Oxford University Press, 2012.

Nagaswamy, R. "Chidambaram Bronzes." *Lalit Kala* 19 (1979): 9–17.

Nagaswamy, R. "Archaeological Finds in South India: Esalam Bronzes and Copper-Plates." *Bulletin de l'École française d'Extrême-Orient* 76 (1987): 1–68.

Nagra, P. Interview undertaken in Vancouver, British Columbia. November 14, 2014.

Narayana Rao, V. "When Does Sita Cease to be Sita? Notes toward a Cultural Grammar of Indian Narratives." In *The Ramayana Revisited*, edited by M. Bose, 219–41. Oxford: Oxford University Press, 2004.

Nielsen, R. "5 Religions, 1 Interconnected Message." *The Arizona Republic*, January 29, 2012.

Norbu, J. "Rakra Thubten Choedhar, In Memorium by Jamyang Norbu," 2013. http://www.phayul.com/news/article.aspx?id=33669 [accessed July 23, 2013].

Olivelle, P. *The Early Upanisads: Annotated Text and Translation*. Oxford: Oxford University Press, 1998.

O'Neill, M. "Keeping the Faith." *Museums Journal* 93, no. 5 (1993): 22.

O'Neill, M. "Making Histories of Religion." In *Making Histories in Museums*, edited by G. Kavanagh, 188–99. London: Leicester University Press, 1996.

O'Neill, M. "The St. Mungo Museum of Religious Life and Art." *Musées et Religions(s). Musées et Collections Publiques de France*, Nr. 219 (1998): 81–92.

O'Neill, M. "Religion and Cultural Policy: Two Museum Case Studies." *International Journal of Cultural Policy* 17, no. 2 (2011): 225–43.

Paine, C., ed. *Godly Things: Museums, Objects & Religion*. London: Leicester University Press, 2000.

Paine, C. "Militant Atheist Objects: Anti-Religion Museums in the Soviet Union." *Present Pasts* 1 (February 2010). http://presentpasts.info/index.php/pp/article/view/10/18 [accessed November 8, 2014].

Paine, C. "Museums and Religion." In *Encyclopedia of Religion*, 2nd ed., edited by Lindsey Jones, 6243a-6248b. Detroit: Macmillan Reference, 2005.

Paine, C. *Religious Objects in Secular Museums: Private Lives and Public Duties*. London: Bloomsbury, 2013.

Paine, J. *Re-enchantment: Tibetan Buddhism Comes to the West*. New York: W.W. Norton and Company, 2004.

Pal, P. *Asian Art at the Norton Simon Museum, Volume 1: Art from the Indian Subcontinent*. New Haven: Yale University Press, 2003.

Palaniappan, T. K. "A Year of Progress." In *The Thanjavur Art Gallery Bronze Sculptures*, edited by S. Rathnasabapathy. Thanjavur: Thanjavur Art Gallery Administration, 1982.

Patton, K. C., and B. C. Ray, eds. *A Magic Still Dwells: Comparative Religion in the Postmodern Age*. Berkeley: University of California Press, 2000.

Phillips, S. *Yoga, Karma, and Rebirth: A Brief History and Philosophy*. New York: Columbia University Press, 2009.

Piotrovsky, M., ed. *Lost Empire of the Silk Road: Buddhist Art from Khara Khoto*. Milano: Electa, 1993.

Plate, S. B. "The Skin of Religion: Aesthetic Mediations of the Sacred." *CrossCurrents* 62, no. 2 (June 2012): 162–80.

Pomian, K. *Collectors and Curiosities: Paris and Venice, 1500–1800*. Cambridge, UK: Polity Press and Cambridge, MA: Basil Blackwell, 1990.

"Portrayal of Piety and Splendour." The *Tribune*, March 19, 2000. http://www.tribuneindia.com/2000/20000319/spectrum/main1.htm [Accessed August 18, 2014].

Prakash, G. *Another Reason: Science and the Imagination of Modern India*. Princeton: Princeton University Press, 1999.

Qureshi, M. N. "A Museum for British Lahore." *History Today* 47, no. 9 (1997): 71–4.

Radde-Antweiler, K., ed. *Being Virtually Real?: Virtual Worlds from a Cultural Studies Perspective*. Vol. 03.1. *Heidelberg Journal of Religions on the Internet*, 2008. See http://www.ub.uni-heidelberg.de/archiv/8294 [accessed May 12, 2012].

Ramachandran, T. N. "The Nagapattinam and Other Buddhist Bronzes in the Madras Museum." *Bulletin of the Madras Government Museum* n.s. 7 (1954): 1–150.

Rana, H. S. Interview undertaken in Birmingham, United Kingdom. July 2002.

Rhie, M., and R. Thurman. *Worlds of Transformation*. New York: Tibet House, 1998.

Ridley, N. "A Special City." *Leicester Mercury* (August 2, 2002): 1, 3–5.

Robson, J. "Faith in Museums: On the Confluence of Museums and Religious Sites in Asia." *PMLA: Theories and Methodologies* 125, no. 1 (2010): 121–8.

"Sacred Trust: Followers of the Sikh Faith Flock to Fresno to View Centuries-old Relics on Loan from India." *The Fresno Bee*, February 21, 2000, A1.

Sandell, R. *Museums, Prejudice and the Reframing of Difference*. London and New York: Routledge, 2007.

Schopen, G. "Archaeology and Protestant Presuppositions in the Study of Indian Buddhism." *History of Religions* 31, no. 1 (August 1991): 1–23.

Schopen, G. (1997), *Bones, Stones, and Buddhist Monks: Collected Papers on the Archaeology, Epigraphy, and Texts of Monastic Buddhism in India*, Honolulu: University of Hawai'i Press.

Schopen, G. *Buddhist Monks and Business Matters: Still more Papers on Monastic Buddhism in India*. Honolulu: University of Hawai'i Press, 2004.

Schopen, G. *Figments and Fragments of Mahayana Buddhism in India: More Collected Papers*. Honolulu: University of Hawai'i Press, 2005.

Schopen, G. *Buddhist Nuns, Monks, and Other Worldly Matters: Recent Papers on Monastic Buddhism in India*. Honolulu: University of Hawai'i Press, 2014.

Schwindler, G. J. "The Dating of South Indian Metal Sculptures." PhD dissertation, University of California, Los Angeles, 1975.

Seager, R. H. *The World's Parliament of Religions: The East/West Encounter, Chicago, 1893*. Bloomington: Indiana University Press, 1995.

Seldis, H. J. "Simon Denies He Admitted Buying Smuggled Statue." *Los Angeles Times*, May 13, 1973.

Sewell, R. G. "The First Printed Text in the World, Standing Tall and Isolated in Eighth-Century Japan: *Hyakumantodarani*." *The Journal of the Rutgers University Libraries* 60 (2003): 117–28.

Sherman, J. "Quatremere/Benjamin/Marx: Art Museums, Art, & Commodity Fetishism." In *Museum Culture: Histories, Discourses, Spectacles*, edited by Sherman and Rogoff, 123–43. Minneapolis: University of Minnesota Press, 1994.

Shirey, D. L. "Norton Simon Bought Smuggled Icon." *New York Times*, May 12, 1973.

Shore, R. "Canadian Considers Himself Caretaker of Famed Sikh's Sword: Calgary Billionaire Buys Sword of Warrior King at Auction." The *Vancouver Sun*, online edition, April 6, 2014.

http://www.vancouversun.com/life/Canadian+considers+himself+caretaker+
famed+Sikh+sword/9706830/story.html?__federated=1 [Accessed August 16, 2014].

Simon, N. *The Participatory Museum*. Museum 2.0, First Printing Edition, 2010.

Simpson, M. *Making Representation: Museums in the Post-Colonial Era*. London and
New York: Routledge, 1996.

Singh, A. Interview at Sisganj Gurdwara Museum, May 2012.

Singh, B. *A History of the Sikh Misals*. Patiala: Publication Bureau, Punjabi University,
1993.

Singh, B. S., and R. Singh. *Sikh Heritage: Ethos and Relics*. New Delhi: Rupa & Co.,
2012.

Singh, K. "The Museum is National." In *India: A National Culture?*, edited by G. Sen,
176–96. New Delhi: Sage Publications and India International Centre, 2003.

Singh, M. "The Relics of the Tenth Master." In *The Khalsa: A Saga of Excellence*, edited
by Amrik Singh and Nalini Menon, 115–27. New Delhi: Media Transasia India Limited,
1999.

Singleton, M., and T. Fraser. "T. Krishnamacharya, Father of Modern Yoga." In *Gurus of
Modern Yoga*, edited by M. Singleton and E. Goldberg, 83–106. New York: Oxford
University Press, 2014.

Smith, B. R. "'With Heat Even Iron Will Bend': Discipline and Authority in Ashtanga Yoga."
In *Yoga in the Modern World: Contemporary Perspectives*, edited by M. Singleton and
J. Byrne, 140–60. Abingdon, UK: Routledge, 2008.

Smith, F. M., and J. White. "Becoming an Icon: B.K.S. Iyengar as a Yoga Teacher and
a Yoga Guru." In *Gurus of Modern Yoga*, edited by M. Singleton and E. Goldberg,
122–46. New York: Oxford University Press, 2014.

Smith, J. Z. "When the Bough Breaks." *History of Religions* 12, no. 4 (1973): 342–71.

Smith, J. Z. "The Bare Facts of Ritual." In *Imagining Religion: From Babylon to Jonestown*,
53–65. Chicago: The University of Chicago Press, 1978.

Smith, J. Z. *Imagining Religion: From Babylon to Jonestown*. Chicago: University of
Chicago Press, 1982.

Snellgrove, D. *Indo-Tibetan Buddhism: Indian Buddhists and their Tibetan Successors*.
2 Vols. Boston: Shambhala, 2002.

Snodgrass, J. *Presenting Buddhism to the West: Orientalism, Occidentalism and the
Columbian Exposition*. Chapel Hill and London: The University of North Carolina Press,
2003.

Sontheimer, G.-D. "Religious Endowments in India: The Juristic Personality of Hindu
Deities." *Zeitschrift fur Vergleichende Rechtswissenschaft* 67 (1964): 45–100.

"Special coverage of the Queen's visit." *Leicester Mercury* (August 2, 2002): 1, 3–5.

Srinivasan, P. R. "Rare Sculptures of the Early Chola Period." *Lalit Kala* 5 (1959): 59–67.

Srinivasan, P. R. *Bronzes of South India*. Bulletin of the Madras Government Museum.
Madras: India Press, 1963.

Starn, R. "A Historian's Brief Guide to New Museum Studies," *The American Historical
Review* 110, no. 1 (February 2005): 68–98.

Stevenson, J. *Sensational Devotion: Evangelical Performance in Twenty-first Century
America*. Ann Arbor: University of Michigan Press, 2013.

Subramanian, T. S. "Stunning Indicators of Nagapattinam's Buddhist Legacy." *The Hindu*,
December 25, 2011.

Sullivan, B. M. "Religions of the World at the Phoenix Art Museum." *Material Religion: The Journal of Objects, Art and Belief* 9, no. 4 (2013): 532–4.

Sullivan, L. E., and A. Edwards, eds. *Stewards of the Sacred*. Washington, DC: American Assn. of Museums, with Center for the Study of World Religions, Harvard University, 2004.

Sundaram, V. "Thousands Flock to Fresno to View Guru's Miracle Pitcher." *India-West*, March 1, 1996.

Swatmarama, Y. *Hatha Yoga Pradipika: The Classic Guide for the Advanced Practice of Hatha Yoga (Kundalini Yoga)*. New York: OM Lotus, 1987.

Ten Grotenhuis, E. *Japanese Mandalas: Representations of Sacred Geography*. Honolulu: University of Hawaii Press, 2009.

Tharoor, S. "Indiana Jones and the template of dhoom." *Times of India*, March 10, 2007. http://timesofindia.indiatimes.com/home/stoi/all-that-matters/SHASHI-ON-SUNDAY-India-Jones-and-the-template-of-dhoom/articleshow/1746623.cms [accessed July 21, 2014].

The Tribune XCIII, no. 101 (1973): 1.

Troeltsch, E. "The Place of Christianity Among the World Religions." In *Christian Thought: Its History and Application*, edited by F. von Hügel, 35–63. New York: Meridian Books, 1923 [1957].

Turchi, P. *Maps of the Imagination: The Writer as Cartographer*. San Antonio, Texas: Trinity University Press, 2004.

Tweed, T. *The American Encounter with Buddhism, 1844–1912: Victorian Culture and the Limits of Dissent*. Bloomington: Indiana University Press, 1992.

Urban, H. "India's Darkest Heart: Kali in the Colonial Imagination." In *Encountering Kali: In the Margins, at the Center, in the West*, edited by R. F. McDermott and J. Kripal, 169–95. Berkeley: University of California Press, 2003.

Van Schaik, S. *Tibet: A History*. New Haven and London: Yale University Press, 2011.

Vásquez, M. A. *More Than Belief: A Materialist Theory of Religion*. New York: Oxford University Press, 2010.

Vincent, F. *The Land of the White Elephant: Travel, Adventures, and Discoveries in Burma, Siam, Cambodia, and Cochin-China*. 4th edn. New York: Harper and Brothers, 1884.

Wachob, J. "Yoga for Kids: Q & A with Beth Reese of Yoginos." *MindBodyGreen Newsletter*, March 11, 2011. http://www.mindbodygreen.com/0-2095/Yoga-for-Kids-Q-A-with-Beth-Reese-of-Yoginos.html [accessed November 3, 2013].

Waghorne, J. P. "Engineering an Artful Practice: On Jaggi Vasudev's Isha Yoga and Sri Sri Ravi Shankar's Art of Living." In *Gurus of Modern Yoga*, edited by M. Singleton and E. Goldberg, 283–306. New York: Oxford University Press, 2014.

Wagner, R. *Godwired: Religion, Ritual and Virtual Reality*. London and New York: Routledge, 2012.

Wang, E. *Shaping the Lotus Sutra: Buddhist Visual Culture in Medieval China*, Seattle: University of Washington Press, 1995.

Wayman, A. *The Buddhist Tantras: Light on Indo-Tibetan Esotericism*. Delhi: Motilal Banarsidass, 1973.

Weinberger, S. "The Significance of Yoga Tantra and the Compendium of Principles (Tattvasamgraha Tantra) within Tantric Buddhism in India and Tibet." Unpublished Dissertation, University of Virginia, 2003.

White, D. G. "Yoga, Brief History of an Idea." In *Yoga in Practice*, edited by D. White, 1–23. Princeton: Princeton University Press, 2012.

White, D. G. *The Yoga Sutra of Patanjali*. Lives of Great Religious Books. Princeton: Princeton University Press, 2014.

Willis, M. "Sculpture from India." In *A.W. Franks: Nineteenth-century Collecting and the British Museum*, edited by M. L. Caygill and J. F. Cherry, 250–61. London: British Museum Press, 1997.

Wingfield, C. "Touching the Buddha: Encounters with a Charismatic Object." In *Museum Materialities: Objects, Engagements, Interpretations*, edited by S. H. Dudley, 53–70. London: Routledge, 2010.

Yogiños: Yoga for Youth. *The Story of Ganesha*, 2010. DVD.

Yogiños: Yoga for Youth. *Vishnu's OHMazing™ Journeys*, 2011. DVD.

Zizek, S. "Multiculturalism or the Cultural Logic of Multinational Capitalism?" *New Left Review* I/225 (1997): 28–51.

Zwalf, W. *A Catalogue of the Gandhara Sculpture in the British Museum*. 2 vols. London: British Museum Press, 1996.

Index